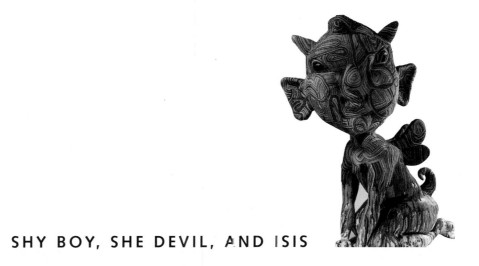

SHY BOY, SHE DEVIL, AND ISIS

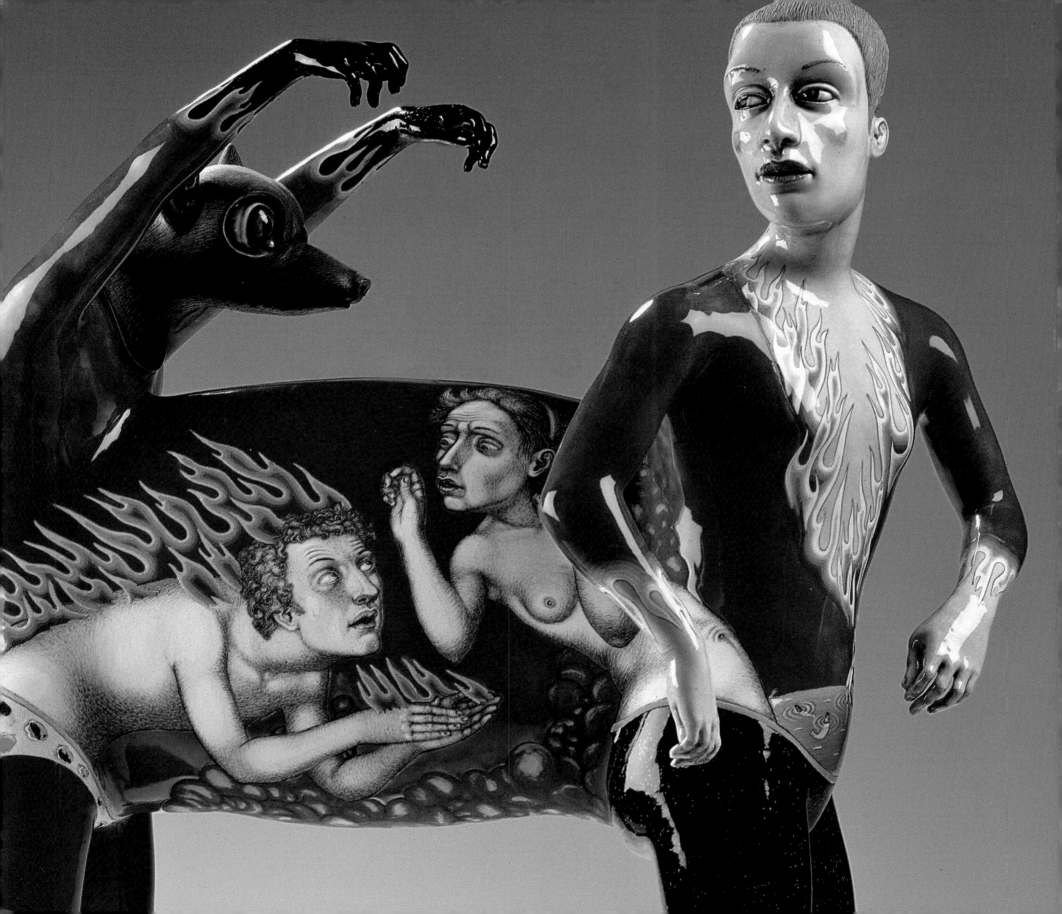

SHY BOY, SHE DEVIL, AND ISIS

The Art of Conceptual Craft

Selections from the Wornick Collection

Gerald W. R. Ward and Julie M. Muñiz

with contributions by Kelly H. L'Ecuyer and Nonie Gadsden

and an essay by Matthew Kangas

MFA PUBLICATIONS

a division of the Museum of Fine Arts, Boston

SHY BOY, SHE DEVIL, AND ISIS

The Art of Conceptual Craft

Selections from the Wornick Collection

Gerald W. R. Ward and Julie M. Muñiz

with contributions by Kelly H. L'Ecuyer and Nonie Gadsden

and an essay by Matthew Kangas

MFA PUBLICATIONS

a division of the Museum of Fine Arts, Boston

MFA PUBLICATIONS
a division of the Museum of Fine Arts, Boston
465 Huntington Avenue
Boston, Massachusetts 02115
www.mfa-publications.org

This book was published in conjunction with the exhibition "Shy Boy, She Devil, and Isis: The Art of Conceptual Craft, Selections from the Wornick Collection," organized by the Museum of Fine Arts, Boston, from September 11, 2007, to January 6, 2008.

For a complete listing of MFA Publications, please contact the publisher at the above address, or call 617 369 3438.

Front cover: Bennett Bean, *Triple on Base,* 1989, (p. 64, detail)
Back cover: Bertil Vallien, *Janus (Venice),* 2006, (p. 41, detail)

Designed and produced by Cynthia Rockwell Randall
Edited by Matthew Battles
Printed and bound at Graphicom, Verona, Italy

Trade distribution:
Distributed Art Publishers / D.A.P.
155 Sixth Avenue, 2nd floor
New York, New York 10013
Tel. 212 627 1999 Fax 212 627 9484

FIRST EDITION
Printed in Italy
This book was printed on acid-free paper.

CONTENTS

6 **Director's Foreword**

6 **Acknowledgments**

8 **Collectors' Statements**
Ronald C. and Anita L. Wornick

10 **Introduction**
Gerald W. R. Ward

13 **Material Matters**
Matthew Kangas

19 **Tradition Transformed:
Postmodernism in Studio Craft**
Julie M. Muñiz

25 **Substance and Structure:
The Creative Use of Materials and Techniques
by Artists in the Wornick Collection**
Gerald W. R. Ward

31 **Selections from the Wornick Collection**
*Julie M. Muñiz, Gerald W. R. Ward, Kelly H. L'Ecuyer,
and Nonie Gadsden*
The Human Figure, 33
Pattern • Ornament • Texture, 61
Ceremony • Narrative, 89
Organic • Abstraction, 113
Materials • Illusionism, 145

174 **Notes**

180 **Selected Bibliography**

182 **Index of Artists**

DIRECTOR'S FOREWORD

Great encyclopedic art museums such as the Museum of Fine Arts, Boston, are truly collections of collections. While many works of art are acquired individually, the gift of a major collection from farsighted and generous donors has the capacity to transform the Museum's very nature. In the realm of American art, for example, the MFA has been exceptionally fortunate to be the recipient of many such gifts; these have forever made the Museum a center for the display and interpretation of American art and material culture.

Ron and Anita Wornick are friends and collectors whose dual vision similarly promises to transform our understanding of an important era of contemporary art. Known initially as major collectors of wood objects, they have expanded their horizons in the last two decades to acquire sculptural works in a wide variety of materials, many of which are presented in this catalogue. Their collecting has captured the essence of an efflorescence in the American studio craft movement. Their gift of the Wornick Collection, including but not limited to the selections presented here, is only one aspect of their generosity to the Museum. Their financial support will also make possible the creation of the Ronald C. and Anita L. Wornick Gallery for the permanent display of contemporary works of art of all kinds. Such acts of beneficence place Ron and Anita firmly within the pantheon of the Museum's most significant benefactors. In addition, they have become strong advocates for the Museum within the collecting community, helping to ensure that the MFA will remain in the forefront of the collecting of contemporary craft in all media.

We thus welcome the opportunity to celebrate, in this exhibition and publication, the unique vision and philanthropic spirit of Ron and Anita Wornick.

MALCOLM ROGERS
Ann and Graham Gund Director
Museum of Fine Arts, Boston

ACKNOWLEDGMENTS

Many people have made this publication and the exhibition it accompanies a reality. Foremost among them are Ron and Anita Wornick. Not only have they collected the extraordinary works of art catalogued here—many of them specifically for this exhibition—but they have been gracious hosts who have tolerated and, furthermore, embraced the many necessary intrusions that curatorial research, new photography, packing and shipping, and other necessary but disruptive tasks have required of their time and patience. We are indebted to them for their vision, their guidance, and their assistance on every imaginable aspect of this project. Their manifold gifts to the Museum—represented only in part by the works of art included in this book—have transformed the MFA's presentation and interpretation of twentieth- and twenty-first-century craft.

Dawn Wilkins of the Seven Stones Winery and the Office of Ronald C. Wornick has also been an invaluable colleague, providing information about the collection and answering queries on nearly a daily basis. Through e-mails and telephone calls, she has been the project's West Coast administrative and curatorial presence while this book was taking shape. We are also indebted to Matthew Kangas, a well-known art critic from Seattle. Matthew participated in the earlier exhibition of wood objects from the Wornick Collection and thus was a natural choice for this volume. We are grateful to him for his willingness to revisit the Wornick Collection in its new dimensions, for his insightful essay included here, and for his assistance in many other ways.

At the MFA, this project has received the enthusiastic support of Malcolm Rogers, the Ann and Graham Gund Director, and Katherine Getchell, Deputy Director, Curatorial. Patrick McMahon, an alumnus of the Art of

the Americas department, skillfully piloted our efforts through the system in his new capacity as Director of Exhibitions and Design. Keith Crippen, Head Designer, and his staff members provided an elegant exhibition design that allowed the works of art—a disparate body in terms of scale and materials—to be shown to harmonious effect.

This book has been produced by MFA Publications in their usual exemplary manner, and we are grateful to Mark Polizzotti, Matthew Battles, and Terry McAweeney for seeing it through to completion. Dalia Geffen copyedited the manuscript with great care and expertise. Cynthia Randall provided her customary elegant design and typography. Dave Mathews and John Woolf guided the process of photographing the collection and preparing the images for publication.

We are especially grateful to Lee Fatherree of Oakland, California, who provided nearly all of the photographs in this book. With the assistance of Atthowe Fine Art Service, Lee was able to photograph the collection in a very short time while working "in the field" at several locations.

In the Museum's Department of the Art of the Americas, Elliot Bostwick Davis, the John Moors Cabot Chair, provided support and assistance at every step of the way. Kelly L'Ecuyer, Assistant Curator, and Nonie Gadsden, the Carolyn and Peter Lynch Assistant Curator, contributed entries to the catalogue, read the manuscript, and provided much help while they were deeply involved in many other projects. We are also indebted to our colleagues Katie DeMarsh, Michelle Finamore, Danielle Archibald Kachapis, Erin McCutcheon, and Toni Pullman. Leah Whiteside provided her research findings for some of the entries.

Dawn Griffin and Kelly Gifford of the Public Relations Department brought the exhibition and its accompanying programs to the attention of a wide audience. Pat Loiko, Registrar, and Elizabeth Solak coordinated the complicated shipment of the collection from California to Massachusetts and back again, while Julia McCarthy was, as always, unfailingly helpful.

Many other colleagues throughout the Museum provided crucial support, including Danielle Berger, Cheryl Brutvan, Joe Earle, Debra LaKind, Rachel Saunders, Lois Solomon, William Stover, Sarah Thompson, Ben Weiss, and Lauren Whitley.

This project celebrates the work of many artists from all over the world. They have all been unfailingly helpful when contacted for biographical information or facts about specific pieces in the Wornick Collection, as have the galleries who represent them. Many curators, scholars, collectors, and others have offered their assistance along the way, including Dale and Doug Anderson; Carmine Branigan, Executive Director, American Craft Council; Susan Ellerin; Daphne and Peter Farago; Jennifer Scanlan, Assistant Curator, Museum of Arts & Design; Megan Smith, Chihuly Studios; Habatat Galleries, Inc.; Signe Mayfield, Curator, Palo Alto Art Center; Julie Armistead and Thea Grigsby, Hearst Art Gallery, St. Mary's College; Heather Lineberry, Arizona State University Art Museum; Martha Lee, Laura Russo Gallery; Glenn Adamson, Victoria and Albert Museum; Sarah Fayen, Milwaukee Art Museum; Pat Warner and Barbara McLean Ward. Jonathan L. Fairbanks, the Katharine Lane Weems Curator of American Decorative Arts and Sculpture Emeritus at the MFA, and Edward S. Cooke Jr., the Charles F. Montgomery Professor of American

Decorative Arts at Yale University, have been instrumental in the growth and development of the Museum's collection of contemporary studio work and are always ready sources of counsel and encouragement.

In particular, this project would not have occurred without the invaluable assistance of Julie M. Muñiz, who came to the Museum in 2005 as Research Associate for this project. She swiftly demonstrated a mastery of the material and a keen eye for quality. Julie has contributed a fine essay to this catalogue, written the lion's share of the catalogue entries, gathered valuable research material for our other contributors, and coordinated every day-to-day aspect of the project from beginning to end. The exhibition and catalogue simply would not and could not have happened without her scholarship, eye for detail, generous nature, and cooperative spirit, for all of which I am very grateful.

GERALD W. R. WARD
The Katharine Lane Weems Senior Curator of Decorative Arts and Sculpture, Art of the Americas, Museum of Fine Arts, Boston

COLLECTORS' STATEMENTS

RONALD C. AND ANITA L. WORNICK

Ron and Anita Wornick were born and raised in Malden, Massachusetts, a modest working-class suburb north of Boston. They met while Ron was serving in the U.S. Army and began their family as Ron was finishing his graduate studies at MIT. Upon graduation, Ron went to work for United Fruit Company. He eventually acquired a division of the company and moved it to Oakland, California, where he transformed it into the largest supplier of military rations in the world. The Wornicks express their commitment to community through enormous personal activism and through the philanthropic activities of The Wornick Family Foundation. They have served on the boards of many cultural institutions in the Bay Area and beyond, including the San Francisco Symphony, the National Foundation for Jewish Culture, and the California College for the Arts. Their collectors' statements below express both the wonder they experience in their encounter with artists of abundant talent and the vision and connoisseurship with which they have collected the works of art they share with us in the pages that follow.

The train of events that brought us to this catalogue began in 1997, when a sculptural wood exhibition drawn from our collection, "Expressions in Wood," appeared at the Oakland Museum in California. It subsequently traveled to New York, where it was held over due to unexpectedly large audiences. Grace Glueck, art critic for the *New York Times*, visited the exhibition and wrote that wood sculpture and the wood-turning field had "come a distance, from a technically oriented process to one more concerned with esthetics." Wood artists, she wrote, had begun to produce more "artistically ambitious objects," sometimes with the "thrust of sculpture."[1]

It was probably only fortuitous, but our collecting in the early 1990s had coincided with a wave of new work by master wood artisans who were moving past an earlier obsession with the bowl, lathe turnings, and the centrality of the wood. In the years that followed we became interested in other sculptural materials, and in time the vague and needless separation between craft and art blurred for us. By the late 1990s, we had been drawn to work emerging from studio artists working not just in wood but in ceramics, glass, fiber, metal, and studio furniture. Our focus moved from wood to conceptual craft encompassing any material.

We were certainly not alone in noticing that while traditional craft was alive and well, something new and remarkable was emerging. Art writer Lydia Matthews recently observed that "unlike the rest of the art world which favors critical, cultural discourse, the craft world forums have been largely celebratory. As a result, many of the objects made within this tradition are eye-pleasing, tasteful, even innovative, but often fail to deliver a significant conceptual punch."[2] Matthews went on to suggest that a new wave of conceptually oriented art by trained artists was emerging, work that offered the kind of "conceptual punch" the tradition often lacked. We agree.

While pieces selected from our collection have evolved from traditional craft, we believe that the thrust of this exhibition is an early forecast of a new conceptual craft movement.

That the best of our collection will ultimately go to the MFA should surprise no one close to the museum world. In a remarkably insightful and scholarly essay on how museums function, MFA Director Malcolm Rogers wrote respectfully and warmly about "the freshness and originality that individual—and individualist—collectors bring to a museum."[3] Imagine, a museum that welcomes collections that might fall outside of prevailing curatorial orthodoxy—how wonderful for us all. Anita and I, Bostonians by birth, could not be more pleased to have been invited to collaborate with the Museum of Fine Arts, Boston, and with its visionary director Malcolm Rogers. Our genuine and enthusiastic thanks to him and his professional staff and board of directors for helping us bring this personal collection to the public.

A word about this catalogue. We hope that our exhibition will engage its audiences in a provocative, instructional, and possibly even emotional manner. But the audience for a special exhibition, no matter how large or how engaged, is of course finite. And so too is the duration of the exhibition. Exhibition details might later be explored on the Internet or in Museum storage vaults, but the art will be accessible primarily to scholars. This catalogue is our best hope for making a connection to a continuing audience. Furthermore, it may be argued that conceptual craft artists have not received sufficient critical attention. Collectors, critics, curators, and galleries from mainstream contemporary art are encouraged to visit the exhibition and share their views. Is a worthy body of work emerging, whether known as conceptual craft or not? Will it find a lasting place in the art world? We hope that this catalogue will encourage and contribute to that discussion.

Ron Wornick

In our experience, people become collectors by accident, not by intention or design. You buy a painting, an object, impulsively or deliberately—and then the acquisition bug bites, and soon you discover that you have a collection. You begin to recognize artists and their styles, and simultaneously you begin to develop your own aesthetic preferences. Then one day you realize your home is no longer suitable for display; the shelves or walls are full, and at the same time other collectors, museum groups, and art lovers are asking to see "your collection." And, perhaps most important, museum curators are interested as well. It's fun, it's stimulating, and it validates your taste.

Our original motivation was not to "show" what we had acquired but only to be surrounded by what we love. Then we realized that as collectors we felt an obligation to the artists, a conviction that their work should be shown and acknowledged by others. We thought that curators especially should see the work, as it is they who will ultimately consider it as worthy of a museum, where it will be seen by a wider audience and be judged critically. What a boon for an artist!

This exhibition is only a small sample of a collection that began serendipitously and became a life-enhancing activity, a passion that continues to this day. We hope it will inspire others to collect—or, if nothing else, to look at work such as this and pause to admire and appreciate what the artists have accomplished with their chosen materials.

Anita Wornick

INTRODUCTION

GERALD W. R. WARD

The works of art illustrated and discussed in this exhibition catalogue—each a promised gift to the Museum of Fine Arts, Boston, from Ron and Anita Wornick—capture an important moment in the evolution of three-dimensional contemporary art. Created almost exclusively since the mid-1980s, and many in just the last few years, they document an era in which materials-based artists in clay, glass, metal, wood, and fiber moved away from the production of vessels and other functional objects toward the creation of expressive sculptural forms essentially devoid of utilitarian purpose. Although this process had begun in the 1960s or earlier and not every maker, even within the Wornick Collection, participated to the same degree, this heightened burst of creativity, recognized by the Wornicks after a few years of collecting wood along traditional lines, underscores the concept that a work of art should not be judged based solely on the materials of which it is made. It further helped to eradicate the outdated division between "art" and "craft," or between "decorative arts" and "sculpture," diminishing the seemingly endless semantic debate over such terms, which seems to shed much heat but little light.

Thus it is entirely fitting that the Wornick Collection be exhibited and preserved in the context of a major encyclopedic art museum. International in scope, the Wornick Collection adds richness and depth to an institution that has had a long, although somewhat fitful, history of engagement with the art of its time. Although the MFA acquired many paintings by living artists such as Claude Monet and Winslow Homer, it did not officially establish a department of contemporary art until 1971 in recognition of the Museum's 1970 centennial. The department's focus has largely been on paintings and sculptures created since 1955 across the world. Today, in addition to the active Contemporary Art department, every curatorial department in the Museum—with the exception of Art of the Ancient World—can or does collect contemporary art to a greater or lesser degree.

When considering the place of the Wornick Collection within the context of the Museum, it is useful to recall the MFA's history of collecting, exhibiting, and publishing contemporary American decorative arts. This was a high priority at the Museum at the time of its founding in 1870, at the beginnings of the Arts and Crafts movement. Starting as early as 1877, the MFA acquired works by living American ceramic artists, including ceramists from the Chelsea Keramic Art Works, Newcomb Pottery, Rookwood Pottery, and Durant Kilns, and it even purchased some Tiffany *favrile* glass in 1899. In 1913 and 1914, the Museum acquired necklaces and other jewelry by Josephine Hartwell Shaw, a member of the Society of Arts and Crafts, Boston, and received a loan of metalwork by Elizabeth Ethel Copeland in 1912, which became a gift in 1919. Many of the Museum's earliest generations of trustees and curators were interested in promoting "Art, Education, and Industry," the Museum's first motto and "mission statement." Driven by philanthropical, nativist, and a host of other motives, these reform-minded individuals sought to provide Boston's citizens and manufacturers with models of good taste. Small exhibitions of works by members of the Society of Arts and Crafts, Boston, were held from time to time as well, bringing new and tasteful works to the attention of Museum visitors.

The collecting and exhibiting of contemporary three-dimensional works continued until roughly the entry of the United States into World War I, when it essentially ceased for more than half a century. By the 1960s, when artists were seeking to free themselves from traditional boundaries, the Museum had responded with a modest number of acquisitions. The gift from the Gardner family in 1965 of an extraordinary chalice by ceramic artist Beatrice Wood is the lone exception in the area of decorative arts, while a few abstract sculptures by American and Italian artists were acquired through gifts and purchases. A 1977 exhibition of works by the founders, faculty, and students of the School of the Museum of Fine Arts, Boston, included a significant number of sculptures as well as a few examples of pottery, furniture, silver, and jewelry. All of this activity was an exception to the Museum's primary focus on the so-called fine arts of the past.

An interest in American materials was intensified with the creation of the Department of American Decorative Arts and Sculpture in 1971. Within a few years, the department started its innovative (and now widely copied) "Please Be Seated" program, with acquisitions of seating furniture created by Sam Maloof, Tage Frid, Wendell Castle, George Nakashima, and Judy Kensley McKie. Over time, exhibitions organized by the Museum on American ceramics (1984), glass (1996–97), furniture (1989 and 2003), fiber arts (2002–3 and 2007), and jewelry (2007) would feature the work of American studio artists, as would a number of smaller installations, including ongoing rotations in a very small gallery on the Court Level of the East Wing devoted to contemporary American work. Recent displays in the Art of Asia, Oceania, and Africa galleries have reaffirmed that venerable department's interest in contemporary ceramics, baskets, and other materials.

With the principal exception of the major exhibition entitled "The Eloquent Object: The Evolution of

American Art in Craft Media Since 1945," which was organized by the Philbrook Museum of Art in Tulsa, Oklahoma, in 1987 and subsequently shown at the MFA, these exhibitions and installations have been materials-based and focused. Collecting contemporary three-dimensional objects, because it was based within the Department of American Decorative Arts and Sculpture from 1971 to 1999, tended to focus on objects that continued the trajectory of the historically based collections of the department, in other words, those that retained a vestige (no matter how remote) of functionality.

The Wornick exhibition thus expands the MFA's presentation of contemporary sculptural art in several ways. By combining furniture, wood, glass, ceramics, fiber, and metal works of art, it breaks away from the media-based focus of most of the Museum's earlier efforts. It also includes works of art produced around the world, including many areas of the United States, England, Australia, France, the Czech Republic, Scandinavia, Germany, and elsewhere—all part of an international network of artists, dealers, and collectors. Significantly, the exhibition emphasizes the expressive content of the works, rather than their function.

Perhaps most important, the Wornick Collection and exhibition reflect the vision of active collectors who, as the statements that appear in this book make abundantly clear, approach the material both instinctively and intellectually, and who are motivated by a generous desire to share their enthusiasm and love for this avenue of the arts with the public both now and in perpetuity.

The Wornicks have come to the conclusion that the term *conceptual craft* defines their area of collect-

ing. Many studio craft artists, after experimenting with traditional forms and materials, began to turn to new approaches in their work in the 1980s. These artists broke free from the restraints of functionality to create conceptually oriented work. *Conceptual craft* thus parallels the attitudes defined by the earlier term *conceptual art*. But conceptual craft also breaks away from the limiting nature of conceptual art; instead of eliminating the perceptual encounter by deemphasizing traditional skills, the art of conceptual craft emphasizes the qualities of the work by highlighting method and design. The result is often a complex blend of materials and concepts that challenge and stimulate the viewer.

In the essays and entries that follow, select highlights from the Wornick Collection are examined from a variety of perspectives. Matthew Kangas provides a broad visual overview that organizes this disparate body of works into visual and conceptual categories, allowing us to see relationships and points of connection between the works and to grasp some of the preoccupations that the artists share. His framework for analysis groups the objects into six large, occasionally overlapping, categories: the human figure, pattern and decoration, ceremony, organic form, illusionism, and abstraction. As a group, Kangas argues, the works—grounded in their materiality—move us toward a vibrant form of twenty-first-century modernism.

Julie M. Muñiz extrapolates outward from the Wornick Collection objects in order to place the studio craft movement within the context of the history of modern art, particularly its relationship to postmodernism. She indicates how the studio movement and postmodernism have shared many of the same origins, practitioners, and evolution. Tracing their simultaneous

development and its various phases—Pop, Funk, Photorealism, and so forth—allows us to understand the efflorescence of the studio movement in the 1980s and its close alignment with postmodernism in such areas as their mutual embrace of historicism and emphasis on (even indulgence of) personal expression.

In the third essay, I have provided a summary look at the creativity and energy with which many of the artists in the Wornick Collection select and handle innovative materials and develop new techniques. Because they are materials-based artists, many have sought to overcome the limitations seemingly imposed upon them by their chosen material, and others have sought to utilize and to express to the fullest the inherent characteristics of the media in which they work.

After these overviews, each object in the exhibition is discussed in a short entry.

As a whole, this catalogue and exhibition present an opportunity to examine, enjoy, and learn from the diverse works of art in the Wornick Collection—their forms, textures, materials, techniques, and narratives. Like all works of art, they reflect the personal abilities and expressions of their makers and the taste of their collectors, but to a considerable extent they also shed light on the attitudes and values of society as a whole. Thus they open a window onto a significant part of the artistic world during the last two decades in a unique, memorable manner. For that opportunity, among many other things, we are grateful to Ron and Anita Wornick.

MATERIAL MATTERS

MATTHEW KANGAS

1. Harvey Littleton (born in 1922), *Torso*, 1942. Vycor multiform fused glass.

The art in the Ronald C. and Anita L. Wornick Collection combines current contemporary art issues and concerns with ancient impulses. In examining the works on view, visitors may see how the collection both documents the contemporary scene and explores the past. By playing up the properties of clay, glass, wood, fiber, and metals, the art in the collection honors material heritages and traditions while commenting on the events of our period. This stands in high contrast to craft art made before World War II. For instance, the distance covered between Harvey Littleton's *Torso* (1942, fig. 1), in the collection of the Corning Museum of Glass, and Michael Lucero's *She Devil* (2005, p. 147), in the Wornick Collection, is vast, crossing from one millennium to the next, from one mentality to another. Considered the first work of the American "studio glass movement," Littleton's female figure looks back to classical Greek statuary, whereas Lucero's cross-sexual and cross-species hybrid looks forward to the environmental pollution and post-nuclear catastrophes of the future. With its wings like a griffin's, *She Devil* binds eschatology to mythology. It also represents the largest visual and conceptual category within the Wornick Collection, the human figure.

While many of the objects fall into the category of the human figure, their meanings involve the human condition and how artists have addressed this pressing eternal issue in Western art and literature. This figural subject matter and content is one of six main areas of emphasis (some of which blend into one another) that can be discerned in the works of art within the Wornick Collection presented in this exhibition and catalogue. The others include pattern and ornament, ceremony, organic form, illusionism, and abstraction. Seeing the works within this broad framework allows us to grasp some of the

major themes and concerns that artists in the late twentieth and early twenty-first century have addressed, and provides a matrix that enables us to see relationships and parallels, as well as divergences, within an otherwise seemingly disparate body of material. Each category includes works that, in most cases, are linked not only by characteristics of outward form but also by their expressions of content and meaning.

Thus, the persistence of the human figure becomes part of a broader conceptual realm, the human condition. As post–World War II artists and writers like Alberto Giacometti (1901–1966), Francis Bacon (1909–1992), Samuel Beckett (1906–1989), and Eugène Ionesco (1912–1994) reflected a reduced, humiliated image of humankind trying to attain dignity, so the figurative artists in the Wornick Collection seek different correspondences that reflect the hopes and circumstances of our own era. Together, the figurative artists in this exhibition invoke memory, gender, personal relationships, intercultural exchanges, art-historical allusions, materiality, and dream states.

At the opposite end of the spectrum, perhaps, are the works in the collection focused on pattern and ornament, a large second category. Rejecting humanist content, the artists who created these works project hedonistic, escapist tropes through the dizzying repetition of underlying linear structures and applied decoration. Mark-making, gestures, geometric shapes and forms, intersecting lines, and the layering of contrasting linear devices are all drawn upon by artists who deal with pattern and ornament. Pattern is usually an underlying structural device for an object's surface design. Ornament is applied either to an object, like a decorative handle on a pot, or to a body, like a brooch or an earring.

Artists who take pattern and decoration to extremes approach a third category, ceremony. Drawing upon prior traditions of pattern and ornament, the ceremonial artists use functional forms that present imaginary formalized behaviors for a secular age that has sacralized an individual, domestic life rather than a collective, religious one.

This area often takes functional forms—the birthright of craft artists—and goes beyond basic usefulness into realms of display, presentation events, and conspicuous consumption. Historical examples abound, and include elaborate silver centerpieces done for the U.S. Army and Navy, trophies fashioned for private New England sailing clubs in the late nineteenth century, and many other types of commemorative objects.

Much of the other work in the Wornick Collection made of such traditionally available materials as clay, wood, metals, glass, and fibers, plays off the suggestive forms present in organic matter like plants, microscopic life, planetary objects, and sources of natural growth. These works make up a fourth category, organic form.

Materials like wood, clay, and fiber particularly lend themselves to the appearance of organic form because in their original states—a tree, a clump of wet earth, or a ball of cotton—they have irregular, unique properties open to artistic manipulation and transformation. The artist's job is to master such properties and retain some of the original qualities that allude to organic origins. Other aspects of nature, like seed pods, leaves, and microscopic biological life forms, are sometimes summoned as well in the finished product.

By rejecting twentieth-century modernist critical dictates about art having to attain "truth to materials," artists working in a fifth area of meaning, namely illusionism, challenge the reliability of optical phenomena and undermine an empirical world, that of the old millennium, where "what you see is what you get" (to use painter Frank Stella's phrase). In its stead they propose a shaky, fluctuating world where long-held assumptions of reality are subverted by the virtuosic flaunting of the sculptural materials they use.

Here the dangers involve finding a balance between material sufficiency and material overkill. By going against inherent properties in a given material—

pliability, solidity, transparency, and earthiness—the artist must make sure that the means of making one material look like another are adequate to the desired illusion. Much of our delight as viewers can derive from the perception of such unexpected technical feats. Since clay, for example, can do anything and be anything visually, including resembling animal fur or cloth, it has a long history of illusionism. Some of the wood artists in the Wornick Collection also have taken illusionism to remarkable heights.

The final category, abstraction, retains some of the power it had in the past due to the proliferation of artists who resist readily interpretable and identifiable imagery. Whether abstracting from nature, architecture, or geometry, or employing completely non-objective forms, the abstract artists in the Wornick Collection bridge the old and the new. They have salvaged an aspect of twentieth-century modernism, the deep subjectivity of personal vision, and transferred it to a twenty-first-century modernism, dismissing the political, social, and personal content seen in much of the rest of the exhibition.

In doing so, they have affirmed claims that abstraction has outlived modernism and continues a life of its own in art, as it did before the last century. A stepsister of pattern and ornament, abstraction casts a wider net. Artists of the twenty-first century build on the rubble of modernism but exercise considerable freedom in seeking nonrepresentational or nonobjec-tive systems of construction, composition, and surface design.

The Human Condition

It is entirely possible that the first work of art was figurative, perhaps a devotional image of a god or goddess that was fashioned to be worshipped, with the hope that its worship would ensure a plentiful crop. Reflecting this august and ancient lineage, the figurative artists in the Wornick Collection have a generally somber and sober view of the human condition.

For example, Robert Arneson's twisted face in *From L and R* (1988, fig. 2) captures the widespread anguish resulting from chaotic social and political events at the end of the previous millennium. It is frozen in a vulnerable state. Other images of fragile,

fragmented anatomy include *Shy Boy* (2005, p. 38) by Clifford Rainey, with its golden wine bottle of emotional release buried within its chest.

The female figure is equally important as a comment on the human condition for the new millennium. Using photography, Lia Cook's *Half Seen* (2004, p. 150) is an ethereal, woven vision of the artist as a young woman; it complements *Olga* (1997, p. 170) by Paul Richard, set on a recycled door that beckons the viewer to open it. Also using photography, Mary Van Cline's untitled glass tableau (2002, p. 52) draws upon imagery of Asia, focusing attention on the conflict between rural peace and industrial development on that continent.

Marilyn R. Pappas's *Nike of Samothrace with Golden Wing* (2001, p. 49) evokes the legendary *Winged Victory* (about 190 B.C.) in the Louvre by transposing the marble robes of the original into supple folds of cotton, golden thread, and linen.

Three haunting figures, *Portrait of a Lover (Long Haired Girl)* (2004, p. 54) by John Morris, *Blues M21* (2006, p. 44) by Ann Wolff, and *Seated Figure with Striped Right Arm* (1984, p. 37) by Stephen De Staebler, round out the varied commentaries by artists on the human condition. De Staebler's allusions to crumbling Egyptian statuary are a potent reminder of the inevitable mortality with which even powerful and influential populations must contend. Wolff's half-concealed woman's face acts as a psychological ruin of sorts; it contrasts with an important historical work in the Corning Museum of Glass, *Uriel* (1968, fig. 3) by Edris Eckhardt (1910–1998), wherein the face is whole, contemplative, and absorbed in a meditative state.

Pattern and Ornament

Surface decoration is among the oldest of artistic strategies. To make a pattern or to create a superfluous ornament is to draw attention to the object for its own sake. If the first work of art was a figure, it's also likely that the first awareness of art making involved a decorative pattern—and perhaps it implies a higher level of social organization, one that allows the leisure to decorate and create objects for reverential and celebratory purposes.

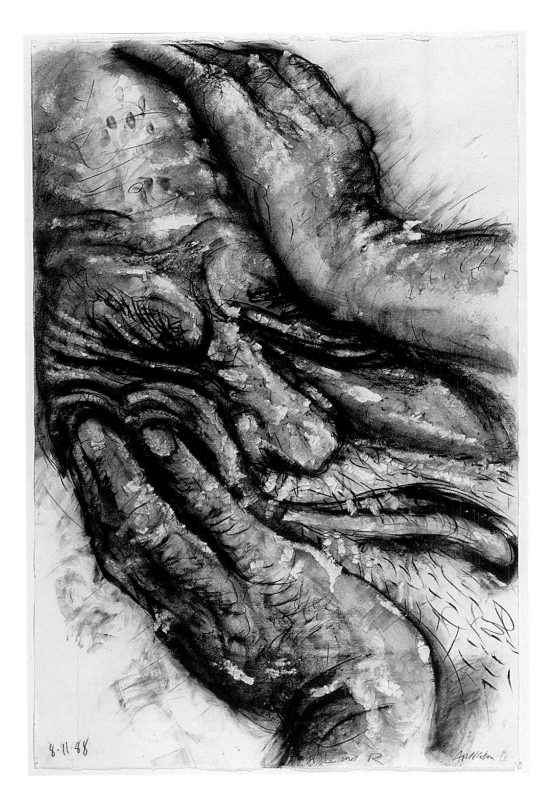

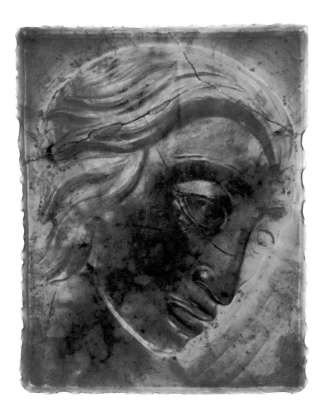

2. Robert Arneson (1930–1992), *From L and R*, 1988. Conte on paper.

3. Edris Eckhardt (1910–1998), *Uriel*, 1968. Glass cast in a *cire-perdue* mold.

At its simplest, however, decoration proceeds from making. Fiber art, especially, with its origins in the criss-cross system of woven warp and weft, is inextricable from pattern and ornament. From the humble spinning wheel to the loom to the insertion of contrasting colors, cloth is perfectly suited to this category.

At the same time, on its most sophisticated level, surface decoration evolved as pattern and ornament, as seen in the works of Bennett Bean, Stephen Johnson, Arlie Regier, and Lino Tagliapietra. Bean's *Triple on Base* (1998, p. 64) exults in gold, an ancient symbol of wealth and power, which drenches the otherwise humble pots. Johnson lifts the convention of a Native American vessel in his *Hopi* (about 2003, p. 163), completely constructed of interwoven pieces of paper and reed that create an overall pattern and, crucially, a visible record of its own making. Both Regier's stainless steel *Hemisphere* (about 1996, p. 85) and Tagliapietra's *Stromboli HG521* (2002, p. 74) use repeated circles as a uniting motif over the entire exterior surface of each piece. The eye follows the syncopated rhythm of placement and, in so doing, continually reassembles each work's totality. Regier's muted, metallic colors contrast with Tagliapietra's bold, engraved vase of red and black glass. The viewer's delight is related to the unraveling of process and the contemplation of pattern.

Ceremony

All art requires an active imagination on the part of the viewer to be appreciated fully. The depiction of ceremony takes many forms in the Wornick Collection and is not always immediately evident. When we look at the sculptures and other objects in the collection and attempt to read or interpret them, that is, project our own programs of meaning onto them, ceremony is revealed as a latent content. Such content can take an oversize form; it can be intensely and obsessively worked on a small scale to reflect aesthetic devotion as well. It can also imply a ritual or ceremonial object about to be used. Such artworks convey a mystery that is a crucial part of our enjoyment of them. For example, a distant, fallen civilization, Persia, is summoned in William Moore's pedestal-as-sculpture, *Persepolis* (1997, p. 100). Its upper bowl suggests ceremonies of initiation and purification. The container forms of

Richard DeVore (*Untitled No. 958*, 2000, p. 110) and John Garrett (*Between and Among [Spice Box]*, 2005, p. 96) symbolize, respectively, intact and disrupted ceremonial objects. Garrett's brittle conglomeration of metals cannot contain anything with its open side areas; any ceremony will require reassembly and repair of a ritual vessel. DeVore's "vessel as metaphor" may also allude to ancient cultures or to a kind of mock-archaeological relic that may stand in for ceremonies long forgotten. It is a conceit, a somber folly, like the pseudo-Classical ruins of eighteenth-century English architecture.

Albert Paley's *Millennium Floor Lamp* (1999, p. 139) may seem too tall for the average living room: its stature and vertical presence give it a ceremonial dimension. *Lamp* declares its purpose through highly wrought twists and turns of steel. The degree of elaboration suggests its presence in a baronial hall or even a legal chamber. Its vine and tendrils, similar to the undulating undersea motifs those on Ben Trupperbäumer's 1992 carved platter (p. 126), look back to the pattern and ornament of the nineteenth century, and its execution in stainless steel looks forward to the new millennium.

When something functional seems too ornate for conventional everyday use, chances are an unnamed ceremonial use is its mysterious purpose. Over time, this has becoame a central motivating force of art, its growing power to appeal to the aesthetic sense for its own sake.

Organic Form

Nature in all its infinite variety has long been the most fruitful inspiration for Paley, as well as two other artists of his generation, Dale Chihuly and Wendell Castle. In Castle's case, his father's work as an agricultural scientist in Kansas left an enduring mark on the son's art. The tables *Pisces* (1995, p. 122) and *Stealth* (1997, p. 123) have irregular star forms that perhaps allude to starfish or could have occurred in stages of plant germination. Locked in solid hardwoods, they defy the fluidity and fragility of incipient life forms.

Chihuly's byword has long been "Follow nature." His *Rembrandt Blue and Oxblood Persian* (1990, p. 132) instantly suggests the shape shifting of a sea

anemone unfolding under water. Chihuly's colors, on the other hand, often contrast with an otherwise natural form, as here. The thinness of the glass walls and the darker colors indicate the tribute he pays to ancient Persian glass.

David Groth, Matthew Harding, and Michael James Peterson more easily invoke organic forms by their choices of a natural material, wood. Yet both Groth and Harding use radical carving to shape solid blocks of wood into soft, curving forms. Groth's *Mobilis* (2001, p. 114) is among his most important and largest sculptures (nearly four feet wide), made of a type of myrtlewood that is available only on the Pacific coast of northern California and southern Oregon. Like Harding's *Fireseed* (2003, p. 117), Groth's forms also suggest dried, found driftwood or desiccated seedpods.

Michael James Peterson's *Earth and Stones II* (2004, p. 158) takes a solid madrone-burl wooden form and hollows it out, giving it great lightness of appearance. Wood grain always acts as surface ornament in Peterson's art. Much of the pleasure in his art entails the perception of an eviscerated sculptural volume that is ameliorated by irregular exterior carving effects. The four "stones" set on top of *Earth and Stones II* point toward our fifth category. They are stones made of African blackwood and, as such, completely illusionistic.

Illusionism

Technical tricks were stock-in-trade for nineteenth-century American trompe l'oeil painters like William Harnett (1848–1892) and John Frederick Peto (1854–1907), whose still lifes often included representations of wooden frames within the painting itself. Working in three dimensions, Garry Knox Bennett, John Cederquist, Tommy Simpson, and Tom Eckert toy with and subvert the viewer's expectations of verisimilitude. Bennett's *Ice Pail* (2001, p. 168) fills a galvanized steel bucket with dozens of cast-glass ice cubes, all illuminated from below, within the bucket. Forever on the verge of melting, the cubes flaunt time as well as matter. With its eerie glow, *Ice Pail* forestalls global warming and proposes an unlikely world where ice would never melt.

Cederquist's and Simpson's sculptures contain images of the tools of their own making. The former's

The Chair That Built Itself (2000, p. 165) is a metaphor for the construction of art: "tools" make up the whole set of chair sections, without which no single part is possible. A saw, a mallet, a chisel with a broken blade, and a screwdriver all assemble into the chair's back, seat, and legs. Simpson's *The Story Ladder* (1991, p. 103) was commissioned by Ron and Anita Wornick and contains references to Mr. Wornick's father Harry, a carpenter, such as an illusionistic saw and hammer that are cross-struts on the ladder. A black wooden plate alludes to the patron's background in the food industry. Used in the Wornicks' library at their home in Napa Valley, *The Story Ladder* also pretends to be a library bookshelf ladder.

Tom Eckert's *Floating Chimera* (1999, p. 148) defies conventional, material-based wisdom about what wood can and cannot do. The most illusionistic one of all, Eckert's work sets a ghostly white sheet on a severed tree branch. With both elements in an improbable relationship, the viewer is left to marvel over their purely imaginary—yet palpably real—status.

Abstraction

The rejection of illusionism was a major aspect of early twentieth-century art. Accepting the physical limitations of the two-dimensional canvas, cubism, for example, sought to use the flat surface to show all sides of an object at once, thereby drawing attention to the fallacy of three-dimensional perspective. By the middle of the century, perspective-based imagery was rejected totally, but deeper forms of meaning—spiritual, psychological, social, narrative—were also suspect.

Minimal art, chiefly a sculptural movement developing in the 1960s and 1970s, evacuated any content in favor of regulated sequences. Yet even minimal art, such as the wood sculptures of Carl Andre (fig. 4), cannot fully resist interpretation or the assignment of material matters such as shape, surface activity, and volume.

No matter how hard the minimalists tried to control and determine content—by arguing that none existed—they could not thwart the basic viewer's desire to seek out meaning as conveyed by materials.

Tom Joyce's *Inside Out* (2003, p. 87) uses regulated sequences—elements of equal size in an ordered format—but rejects Andre's comparatively authoritarian placement in favor of a jumbled pile of outcroppings. Joyce has unminimized minimal art while retaining minimal art's core of repeated elements.

Todd Hoyer's *Peeling Orb* (1987, p. 98) strives for an iconic or monumental character. Its single sphere is bifurcated by an irregular, thin slice of mesquite wood. With an edge of original bark left intact, *Peeling Orb*'s three separate elements—the two hemispheres and their separating wall—become indivisible. Also using a truncated base, Donald Fortescue's *PIP* (2002, p. 82) recalls the extension of time visible in tree rings, seen in the piece's concentric circles of birch plywood.

Works by Peter Voulkos and Betty Woodman embody abstracting tendencies of the old century. With his ties to Abstract Expressionism, Voulkos's *Isis* (2001, p. 143), completed a year before his death, envisions the Egyptian goddess of old, a veritable funerary monument for the artist whose art led to so many breakthroughs in the acceptance of ceramics as a contemporary art form. It encapsulates much of what is most daring and successful about Voulkos's achievement: the use of clay as a serious sculptural medium; the building up of scale despite the risk of explosion in the kiln; and the additive, accretive composition common to much modern sculpture.

Woodman's *Anemones* (2000, pp. 66–67) may draw upon the flowers and sea creatures in her title, but the sculptures are abstracted versions of flowerpots and vases. They typify vessel art, the chief forms of abstract ceramic sculpture from the 1970s onward. Like Voulkos, Woodman works within the continuum of styles of the past century and carries them through into the present with great verve and originality.

One final work, *Downpour* (2004, p. 83), by British sculptor David Nash, also alludes to past and present with possible hints toward the future. Taking great care to select appropriate pieces of wood to convey the desired sculptural statement, Nash has burned the base of a single piece of lime wood, the material used by Northern Renaissance artists in the cathedral altarpieces of Germany. *Downpour*, with its slanted angles of deep gouges across the work's surface, suggests torrential raindrops, while its blackened base evokes both forest fires and oil spills. Leaning against a wall, its slightly torqued, twisted overall shape, mean-

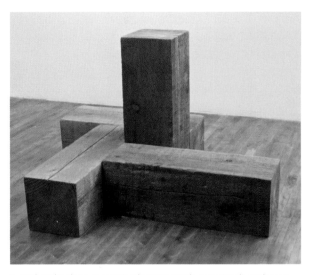

4. Carl Andre (born in 1935), *The Way North, East, South, and West (Uncarved Blocks)*, 1975. Western red cedar.

while, implies natural forces of tremendous power. Nash has created the simplest, plainest shape of all in the Wornick Collection and turned it into a potent symbol of nature, art making, and ecological implications for the current millennium. By embodying its varied material matters—wood, carving, staining—as keys to a central meaning, *Downpour* points toward an apocalyptic view of nature. Through the appreciation of the making of art that is heavily involved in its own materiality, viewers may meditate on the present and see into the future.

TRADITION TRANSFORMED:

Postmodernism in Studio Craft

JULIE M. MUÑIZ

"Postmodernism and ceramics is a marriage made in artworld heaven."[4] So writes Garth Clark in his introduction to *Postmodern Ceramics*. The concept of postmodernism and its link to the studio crafts is not new. Many authors have alluded to its presence, but few have taken on the subject fully to describe how and why this elusive concept appears in the work of many of today's studio artists.[5] The collection of Ron and Anita Wornick consists primarily of art made after 1985, the height of postmodern architecture and design. Many of the objects in the collection demonstrate elements of postmodernism. Indeed, late twentieth-century craft artists responded to the same influences as artists in other media, embracing and even contributing to many of the dominant trends of the era. Yet even today, studio artists still struggle to be included as artists of merit in the art hierarchy. Because of this struggle, the contributions of the studio craft movement have not been fully recognized and placed into the greater art historical continuum. When studied in this larger context, however, the studio craft movement clearly developed alongside postmodernism and in fact shares its origins, principles, and development.

The word *craft* has come under much scrutiny in recent years as academics and artists struggle to redefine the field of studio arts. Though relevant, this debate is not the topic of this essay. For ease in understanding, I shall use the term *craft* to mean both the artistic realm inhabited by professional artists working in the traditional media of clay, wood, fiber, glass, and metal and the one-off works they produce. Although these objects contain design elements, I will use the noun *design* strictly in reference to the mass production of industrial design, as distinct from the one-off production of craft.

The term *postmodernism* is also key to understanding the works discussed here. This elusive concept is most often defined reductively in terms of what it is not—postmodernism is a reaction to, and a move away from, the confines of modernism. To fully understand postmodernism, a brief discussion of the modern movement is in order.

Much has been written on the modern movement. Christopher Wilk concisely defined modernism not as a specific style but as a collection of core ideas that encompassed a variety of movements and styles throughout a range of countries.[6] Paul Greenhalgh described twelve of these core ideas, which included truth, function, progress, and antihistoricism.[7] Modernists espoused design that was true to function in its construction and form. Decoration and illusionism only hid construction and belied materiality and were thus seen as dishonest and immoral. The modernist maxim "form follows function" dictated how an object's design needed to be directly related to its ultimate purpose. In addition to truth and function, modernists believed that in order to progress toward a greater future, they must eliminate references to historical styles from all design.

Like modernism, postmodernism comprises a collection of core ideas rather than a singular style. Modernists sought unity through the death of artistic conventions such as decoration, ornamentation, illusionism (all seen as nontruthful), and historicism (seen as nonprogressive); postmodernists returned to all these approaches, but with a new and vigorous attitude. While modernism abandoned figural representation in favor of abstract and biomorphic forms, postmodernism embraced both the human figure and abstraction. The hallmark of modernism, the International

Style, gave way to individual expression and personal narrative. These changes began to emerge in the 1960s as artists and architects grew tired of the rigid dictums of modernism and began exploring new options; their initial experiments eventually grew into what is now called postmodernism.

Architect Robert Venturi provided the mantra for postmodernism in 1966 when he declared, "Less is a bore"—a twist on Mies van der Rohe's statement "Less is more"—in his *Complexity and Contradiction in Architecture*. This "gentle manifesto" urged a "non-straightforward architecture" and a rebellion against the rational purity of modernism, becoming one of the first major discourses that would contribute to post-modernism.

Pop, which began to emerge in the late 1950s, was perhaps the first manifestation of postmodernism in art. Spearheaded by artists such as Andy Warhol and Roy Lichtenstein, who assimilated images from popular culture, advertising, and comic strips into their work, Pop was as much about consumerism as it was about breaking down hierarchies.[8] Its decorative, trite, and often figural imagery deviated from many of the fundamental tenets of modernism, thus shepherding in postmodernist thought. The Pop movement gained momentum throughout the sixties and continued to be a strong presence in the art world well into the 1970s. Pop artists worked in a variety of styles and media, including craft media, and craft's participation in Pop is central to its postmodernist development.

Avant-garde ceramic artists turned to Pop expressions via a movement called Funk in the 1960s. Up to this time, the teachings of English potter Bernard Leach—who preached for "pure" and "ethical" pots with little or no decoration and clear function—held dominance. In the early 1960s, however, American ceramist Robert Arneson broke new ground.[9] Tired of ceramics being marginalized from the rest of the art world and viewed as merely decorative and noncritical, Arneson began making ceramic sculptures of everyday objects such as toilets and beer bottles, transforming them into caricatures of modern life. Funk, as it was called, paralleled the attitudes and subject matter of Pop but in a dark and crude manner. Both used humor to comment on everyday culture, but where Pop was clean, lighthearted, and ironic, Funk was messy, raw, and perverse.[10]

Pop and Funk also appeared in jewelry at this time. Since the late 1940s, jewelry makers followed the tenets of modernism, using abstract and biomorphic elements in their designs. This changed in the 1960s, when a group of artists such as Christian Schmidt and Ken Cory, fighting to make themselves noticed, aligned themselves with the Pop and Funk movements, creating wearable art using found objects, plastics, and other nonprecious materials.[11]

Furniture makers also rebelled against modernism in the 1960s, rejecting the functionalism and truth to materials that had dominated the 1950s.[12] Rebuffing the idea that furniture was merely a commodity, makers pushed to have their work viewed as one-of-a-kind works of art worthy of collection.[13] Wendell Castle and Tommy Simpson emerged as two pioneers during this period. Castle, who developed stack lamination techniques to free his furniture forms from planar confines, also worked in fiberglass-reinforced polyester (fig. 5). Simpson created whimsical furniture that exuded a personal narrative, much like *The Story Ladder* (p. 103) created for the Wornicks decades later. While three dimensional, the work of both Castle and Simpson exhibited elements of Pop in their tongue-in-cheek attitude, especially in the way they transformed common objects—commercial plastic or the carpentry tools of a woodworker—into works of art.

While the fields of ceramics, jewelry, and furniture held long studio traditions, studio glass was just starting to emerge in the 1960s. Inspired by the strides made by the emerging studio craft movement, ceramist Harvey Littleton looked for ways to work glass outside of industrial production, thus returning it to the hands of independent artists. In this early period, glassmakers focused more on experimentation and technical innovation than conceptual, artistic ideas. By the mid-1970s, however, with the technical knowledge firmly in hand, artists could finally focus their attention on ideas rather than skill.[14] In an effort to align themselves with the fine arts, glass artists began moving away from the utilitarian vessel toward more sculptural, less functional pieces. Glass during this period also took its voice from its Pop

5. Wendell Castle (born in 1932), *Leotard Table*, Rochester, New York, 1969. Reinforced plastic.

and Funk forebears, using pictorial imagery to comment on the political and social upheavals of the day.[15]

Throughout the 1970s, Pop continued to be the dominant expression of what would later be called post-modernism, but it was joined by another movement called Photorealism or Super-Realism. Eschewing the modernist ideal of "truth to materials," Photorealism paralleled Pop and Funk in its use of banal subject matter, which it depicted in a hyper, photograph-like reality. Both ceramic artists and furniture makers participated in the Photorealism movement by producing trompe l'oeil "superobjects." Wendell Castle was among the best-known artists to put Photorealism into three dimensions, creating a series of "illusion" still lifes intricately carved into tabletops and chair seats. This technique of hyperrealism continues today in the work of artists like Tom Eckert (p. 148), whose work challenges the viewer's perceptions.

The 1970s saw the advancement and broadening of postmodern ideas and practices. Architect Robert Venturi was again a leader, along with his future wife, Denise Scott Brown, and associate Steven Izenour. Together they published *Learning from Las Vegas* in 1972, described as "a full-frontal assault on the cardinal principles of architectural modernism."[16] Feeling that modern architecture had lost touch with its historical roots, Venturi, Scott Brown, and Izenour argued that architects should instead look at and learn from the everyday vernacular. The concepts and concerns Venturi and his partners described continued to percolate in architectural circles. In 1975 architect Charles Jencks published an article entitled "The Rise of Post-Modern Architecture," giving these ideas the form and coherence needed to move forward as a recognized artistic concept.[17]

As it continued to flourish, postmodernism went beyond Pop, Funk, and Photorealism in its rejection of modernism. In response to the modernist dictums "Truth to materials" and "Form follows function," post-modern artists returned to illusionism and decoration by producing trompe l'oeil designs or wildly painted surfaces. Objects became more and more sculptural, often belying their true function or becoming nonfunctional altogether. In addition, artists returned to historicism, particularly classicism, as a way to reunite themselves

with their artistic past—though artists now borrowed from a variety of sources, including popular culture and art history. Historicism and pastiche at times gave way to parody as artists used humor to create social and historical commentary.[18] This humor was an example of individualism, as artists focused more on their own personal experiences and aesthetics. An object's meaning in turn became tied to each viewer's individual experiences.[19] Furthermore, where modernism touted geometric and biomorphic abstraction as a way to reduce composition to pure form and thus universal meaning, individualism allowed artists to return to figural and representational art to express their ideas which in turn led to a resurgence of narrative.

The 1980s saw both postmodernism and the studio craft movement reach maturity. In architecture, postmodernism was heralded by Michael Graves's 1982 building for Portland Public Services in Portland, Oregon, commonly referred to as the Portland Building (fig. 6) and considered the first monument to post-modernism. With its geometrized columns and painted keystone, the Portland Building references classical architecture in a way that is both modern and traditional, secular and divine. According to Jencks, the Portland Building "is the first to show that one can build with art, ornament and symbolism on a grand scale and in a language the inhabitants understand."[20] The year 1984 saw the rise of Phillip Johnson's new headquarters for AT&T. Topping his modern New York City skyscraper with a classical pediment akin to a Chippendale-style high chest, Johnson authoritatively spoke to the death of the International Style. Today the building is still considered an icon of postmodern architecture.

By the 1980s, postmodernism had completely overtaken the International Style and had begun filtering into the world of industrial design. Design was a logical extension of postmodern architecture, since virtually all designers producing these consumer goods were also architects. In 1981 a group of designers in Milan, led by architect-designer Ettore Sottsass, began producing furniture and household goods under the name Memphis. In 1983 Italian design manufacturer Alessi established a line of tea and coffee services designed by some of the leading postmodern architects of the day, including Michael Graves (fig. 7), Robert

6. Michael Graves (born in 1934), The Portland Building, Portland, Oregon, 1982.

7. Michael Graves (born in 1934), *Tea & Coffee Piazza*. Manufactured by Alessi, 1983.

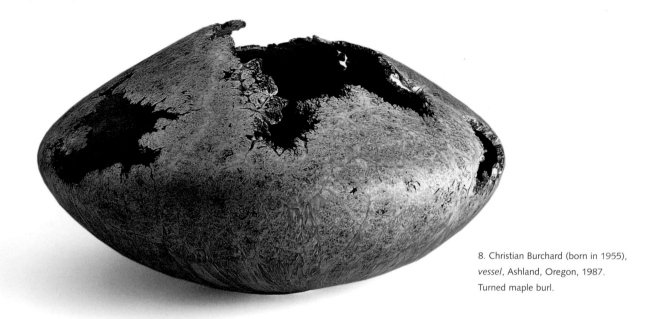

8. Christian Burchard (born in 1955), *vessel*, Ashland, Oregon, 1987. Turned maple burl.

either redefine it or to depart from it altogether. In trying to do the latter, many artists have merely ended up by highlighting its power as a basic concept in glass."[22] Artists such as Marcus Tatton (see *Shard*, p. 107) consciously choose the vessel because of its historical connotations: "As society's rate of change accelerates, we connect less with our surroundings. But by having timeless form in our midst, we can continue to grow with awareness and knowledge of who we are and where we come from."[23] This adherence is far from outdated—by consciously choosing the vessel, artists actively engage in postmodern historicism.

Historical associations alone, however, do not make studio craft postmodern. Indeed, these associations were noted and employed by artists during the Arts and Crafts movement at the turn of the twentieth century. While studio craft developed in the postwar era out of the Arts and Crafts tradition, it has consciously moved beyond it toward more nonfunctional objects based in conceptualism, a theoretically driven movement that has affected the practice of artists across media. Conceptual craft artists differ from their Arts and Crafts counterparts on several key levels. First,

Venturi, Hans Hollein, and Alessandro Mendini. In 1984 Knoll started producing furniture designed by Robert Venturi and Denise Scott Brown, authors of some of the earliest postmodern discourse. Such mass-produced objects, although important to the discussion of postmodernism, have received greater attention than the work of contemporary studio artists, whose work also came of age during the height of the postmodern movement. The link between these industrially designed objects and their architectural forebears may be easier to see, given their architectonic nature and the fact that they were produced by architects—Michael Graves's tea set for Alessi bears a striking resemblance to the Portland Building, for instance. Though the rubric of postmodernism has come to be applied to all aspects of art and design, including literature and music, its application to the studio arts has yet to be fully recognized.

Studio craft is an excellent partner for postmodernism because the two share certain philosophies—mainly a return to historicism and personal expression. The rejection of modern mass production in favor of handcraftsmanship is essentially a form of postmodern historicism. By its very nature, craft is linked to its mat-

erials. Hand-worked pieces possess a connection with their creators that transcends an object's physical form. Craft artists "get their hands dirty" and in the process of creation often leave their fingerprints in the form of marks left by the hand, hammer, punty, or chisel. The materiality of handcraftsmanship links the studio arts to a historic tradition, and many artists are quick to comment on this connection. Despite the sculptural qualities of his work, for instance, fiber artist John McQueen (see *Mire*, p. 101) insists his pieces are baskets, not sculpture: "Baskets have an enormous variety, history and distance. To me, my work is in the basket tradition, no matter how far I push the edge of its traditional definition."[21]

McQueen's insistence on working in the basket tradition is akin to other studio artists who have adhered to the traditional vessel form because of its historical connotations and connections. Clearly not all studio craft vessels are postmodern. However, a significant group of avant-garde artists consciously work with the vessel in a postmodern vein. Dan Klein comments on glass artists' early devotion to the vessel, explaining: "Vessel form became the subject matter of intense philosophical debate, and there was an attempt to

9. Betty Woodman (born in 1930), *Pillow Pitcher*, New York, 1980. Earthenware.

their work has progressively become more sculptural and less functional. Despite holding on to the vessel form, today most studio craft vessels only echo their functional Arts and Crafts counterparts. One need only look at a studio wooden bowl, complete with burl holes and inclusions, to understand this distinction (fig. 8). Second, studio craft utilizes traditional media and techniques in new conceptual ways. Conceptual art initially developed in the mid-1960s as artists sought to disengage from visual aesthetics in favor of creating art about ideas. Gord Peteran, who staunchly positions himself as a conceptual artist and not a furniture maker, is an excellent example of this. His table for the Wornicks (*A Table Made of Wood*, p. 166) is more a study of form and construction than a piece of furniture.

The emergence of glass, wood, fiber, and ceramics as vehicles for conceptually based art is a new development attributable to the studio craft movement. This conceptualization of studio art has allowed for greater personal expression by artists of traditional media. Historian Jorunn Veiteberg described this intersection between the traditional function of craft objects and the emerging poetic function of conceptual craft as a third space. These new objects, he writes, "are not asking to be judged on their usefulness or on how much technical skill has gone into their production, but on their poetic power., i.e. their ability to rise above the level of the ordinary clichés and to create new visual metaphors and forms of expression."[24] In addition to providing the basis of conceptual craft, all these elements—nonfunctionalism, conceptualism, and personal expression—are elements of postmodernism.

Ceramist Betty Woodman actively practiced in postmodernism throughout her professional career. Inspired by trips to Italy, where she had seen Etruscan pottery in Florence's Archaeological Museum, Woodman began making pots that echoed these ancient models. By painting her "pillow pitchers" in bold colors and free-flowing designs, Woodman rejected the modernist dictums of truth and antihistoricism (fig. 9). As her career continued, Woodman's work became progressively less functional, but still retained the appearance of functionality. Her *Anemones* depict planar facades supported by traditional vessels that stand behind. Although they recall pots, the vessels are more sculptural than functional (pp. 66–67).[25]

Studio furniture also became increasingly postmodern, owing much to the success of the Memphis Group in the 1980s. Postmodernist irony and appropriation infiltrated the furniture field as artists pushed their work toward more personal statements. In America, craftsman John Cederquist poked fun at modernism with his whimsical trompe l'oeil furniture that appropriated imagery with both art historical and banal references (pp. 164–65). Artist Michael Hosaluk incorporated advanced turning techniques with painted, colorful surfaces that disguised the natural elements of the wood underneath (p. 167). To furniture maker Garry Knox Bennett (p. 168), even the field of studio furniture was appropriate fodder for ironic commentary when he drove a bent nail into the pristine surface of a completed cabinet (fig. 10).

The field of studio wood art did not move into the world of professional craftsmanship until the late 1970s. Once there, however, artists quickly embraced postmodernism as a means of self-expression.[26] Like Bennett, maverick Giles Gilson poked fun at his field with his *Point of View* (p. 162). At a time when many turners were avidly embracing the beauty of wood and its natural flaws, Gilson laminated his vessel and carved a natural-looking burl hole through the secondary woods. With its interior painted bright blue, Gilson's small, innocuous-looking piece became a postmodern tour de force.

These examples merely scratch the surface of postmodern craft. What they show, however, is that the studio crafts have actively participated in postmodernism since their early incarnations as Pop and Funk. Elements of postmodernism appeared in the studio crafts as early as the 1960s, paralleling developments in the fine arts, architecture, and design. Unfortunately, the one-off, singular-production nature of the studio arts meant it could not be nearly as ubiquitous. Nevertheless, studio craft has made a strong presence in the art world, actively breaking new ground and influencing artists across media. Acknowledgment of studio artists as participants in the avant-garde can help return craft to the deserved status of high art.

10. Garry Knox Bennett (born in 1934), *Nail Cabinet*, Oakland, California, 1979. Paduak, glass, lamp parts, copper.

SUBSTANCE AND STRUCTURE:

The Creative Use of Materials and Techniques by Artists in the Wornick Collection

GERALD W. R. WARD

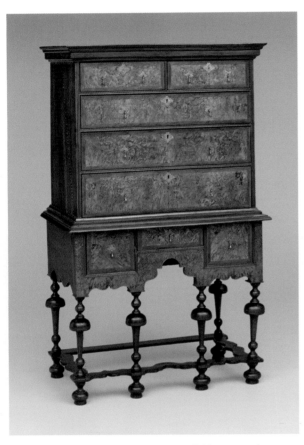

11. High chest of drawers, Massachusetts, probably Boston, about 1700–1720. Maple, walnut, walnut veneer, burl maple veneer, pine.

In the past, part of learning the "art and mystery" of a craft—perhaps the largest part—was understanding the capabilities of a given material and mastering the skills necessary to work and manipulate that material in specific, traditional ways. Medieval guilds were often organized to provide expertise in a material, be it silver, pewter, iron, leather, or any other type. Apprentices could spend up to seven years learning all aspects of their trade before becoming journeymen in another man's employ or establishing their own shop. Thus craftsmen generally became known by the material with which they worked (a silversmith, a pewterer) or the techniques they practiced (a joiner, turner, or carver). The taxonomy of materials literally defined the craft world. You were what you made.[27]

Each material presented its own limitations and opportunities. Silver, for example, is a remarkably responsive material. Malleable, ductile, and easily engraved, it lends itself to a wide range of techniques, and it challenges the maker's creativity each time he sets out to make an object.[28] Pewter, on the other hand, is usually cast in brass molds and is not as receptive to fine detail. Styles in pewter therefore tend to change more slowly and to rely for their visual success on simple, elegant forms often embellished with architectural moldings.[29] Furniture makers often used a variety of woods for their objects, each chosen for its special characteristics. A Windsor chair maker, for example, usually selected maple—which could be crisply turned—for the legs, easily shaped pine or yellow poplar for the seat, and tough, wiry ash, oak, or hickory for the spindles.[30] Similarly, the maker of a Boston high chest of drawers (fig. 11) in the early baroque manner might again use maple for the turned legs and stretchers; beautiful burl maple, with its

swirling, optical effects, for the drawer fronts; walnut for moldings and other veneers; and inexpensive, readily available eastern white pine for the carcass.[31]

Craftsmen in the past were thus judged by their command of material, and also by their ability to produce functional (or at least nominally functional) objects. Many of what are now considered some of the best examples of decorative arts of the past, especially high-style European objects but also many American works, were objects made principally for show and display purposes—to be as decorative as paintings—and to be used only on rare occasions. But the association with a functional object had to be maintained, at least formally and usually visually.

When the Wornicks started collecting three-dimensional works in the mid-1980s, they began with contemporary wooden objects, many of which paid homage to the vessel form. Almost all of the sixty-two objects included in the "Expressions of Wood" exhibition and catalogue of 1996 documenting the Wornick Collection at that time are, at one level, vessels, containers, platters, or some other type of recognizable object (even though, as Ron Wornick points out in conversation, no one in his or her right mind would use one of these expensive objects as a salad bowl).[32]

Within a short time, however, the Wornicks expanded their vision beyond these functional objects, magnificent as they are, in a search for something less formulaic and even more creative. They soon sought the work, and have continued to do so, of artists whose main interest is expressive sculptural form—in short, in what the Wornicks refer to as conceptual craft. The transition in the focus of their collecting is neatly signified by two of David Groth's objects in their collection. *Cock's Comb Oyster Series No. 2* of 1984

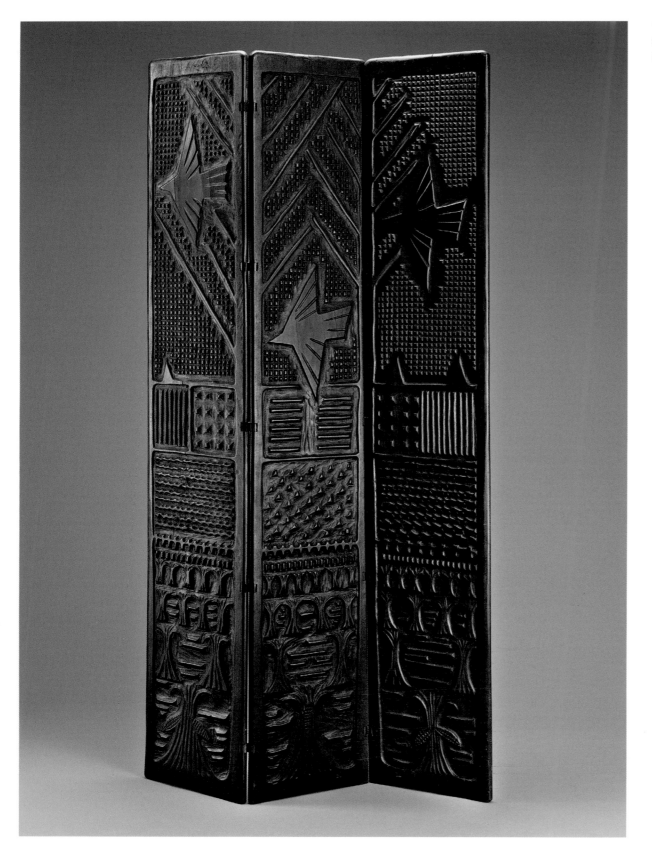

12. Wharton Esherick (1887–1970),
three-panel folding screen, Paoli,
Pennsylvania, 1927. Walnut, ebony.

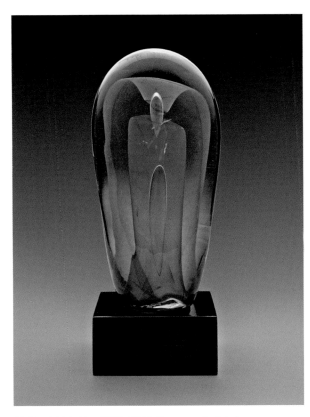

13. Dominick Labino (1910–1987), *Emergence in Polychrome with Gold and Silver Veiling,* Grand Rapids, Ohio, 1970. Glass, mahogany base.

words, "a turned object 'could' be, or 'should' be." Within the context of the Wornick Collection, *Machel* foreshadows the burst of creativity and expressive work that the Wornicks have assiduously sought to collect and document. As time has passed, they have expanded beyond wood to collect glass, ceramics, fiber, metal, and mixed-media works made during the last two decades by artists from around the world. Those new acquisitions reflect their desire to enjoy and share pieces that are, foremost, works of art, expressing what they see as a pivotal point in materials-based creativity.

Indeed, many of the people whose work is represented in the Wornick Collection might be classified initially as materials-based craftsmen or -women. However, many regard themselves as artists, following the work of numerous pioneers. In furniture, Wharton Esherick of Pennsylvania is almost universally regarded as the founder of the studio movement; his direct-carved three-part folding screen of 1927 (fig. 12) is an early example of his individualistic, idiosyncratic work. Esherick's sculptural approach to furniture exerted a profound influence on many people in the succeeding generations. Harvey Littleton and Dominick Labino are also customarily seen as the founders of the American studio glass movement in the early 1960s; Labino's work in the Museum's collection (fig. 13) achieves success simply through form and color. Similarly, in ceramics, Robert Arneson (fig. 14), Peter Voulkos (fig. 15), and many others have consciously strived to create works of art rather than craft.

Although a few of the woodworkers are essentially self-taught, many of the artists represented in the Wornick Collection have learned their skills through study in undergraduate and graduate academic programs in the manner characteristic of twentieth- and twenty-first-century art. In this type of environment, shielded from the demands of the factory or shop, makers are no longer constrained by the need to work in one material or to have their objects (so to speak) hold water. Toshiko Takaezu (fig. 16), for example, was one of the first potters to close off her vessels, preferring to deal with pure form. This freedom from functional constraints allows for experimentation and new explorations in both materials and techniques while also honoring those who wish to refine and perfect

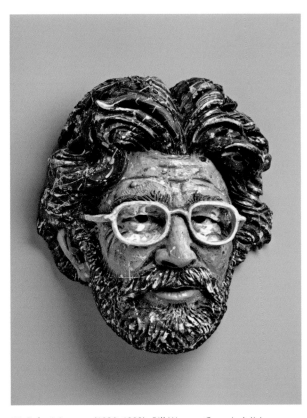

14. Robert Arneson (1930–1992), *Bill Wyman, Ceramic Artist, 1922–1980,* Benecia, California, 1981. Glazed stoneware.

(p. 114), their first wood acquisition, is a rejection of the typical rounded object popular at the time among turners, innovative for its time and a major object. Still, it can be construed at one level as a spiky vessel—a container. Groth's *Mobilis* of 2001 (p. 115), on the other hand, is a large myrtlewood masterpiece, carved with chain saw and chisel. It is purely an essay in sculptural form.[33]

David Ellsworth's *Machel* of 1991 (p. 161)—selected for the cover of *Expressions in Wood* and also included in this volume—perfectly represents the direction the Wornicks have taken with collecting in recent years. Ellsworth's incredibly thin-walled work of turned, cut, burned, and painted ash references the vessel form, but it is a perforated and thus impractical object that shattered preconceptions of what, in Ellsworth's

long-established traditions. Many sides of this evolution are revealed in the diverse works included in the Wornick Collection.

Materials: Reverence and Irreverence, Rejection and Combination

Historically, craftsmen exploited the characteristics of their material to their best advantage. In the case of wood, for example, craftsmen often give priority to revealing its beautiful grain, color, sheen, and figure, treating the material with a devotion bordering on reverence.[34] This attitude is evident in several objects in the Wornick Collection. For example, Ron Fleming's *Reeds in the Wind* of 1988 (p. 124), made of boxelder burl, takes full advantage of the properties of the wood. Matthew Harding's curvilinear *Fireseed* (p. 117)

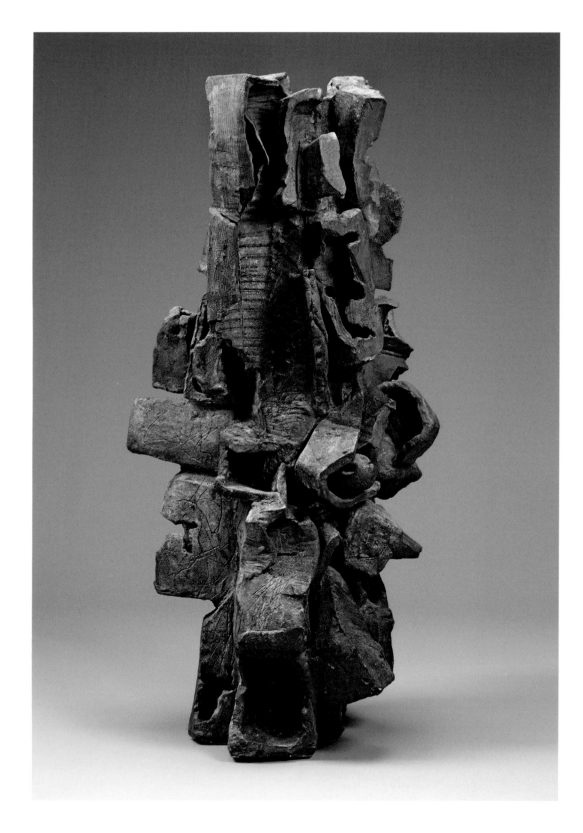

15. Peter Voulkos (1924–2002), *Camelback Mountain*, probably Berkeley, California, 1959. Stoneware.

16. Toshiko Takaezu (born in 1922), *Three-Quarter Moon*, Quakertown, Pennsylvania, 1985. Stoneware.

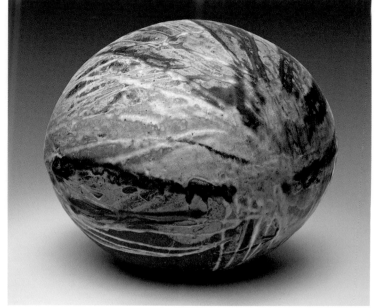

similarly is an homage to New South Wales rosewood, among other things, and Grant Vaughan's *Split Form* (p. 119) is an exquisite object in beautiful Australian red cedar. William Hunter's *From the Heart* (p. 125) revels, like so much of his work, in the intrinsic visual delight of vera wood, highly finished and polished to a gleaming appearance.[35]

Other woodworkers reveal their reverence for wood by recycling scrap pieces or fallen wood, particularly from rare and endangered species. David Groth's *Mobilis*, mentioned earlier, made of salvaged myrtlewood found near his home in the American Northwest, is a tribute to reclaimed wood, as is Michael James Peterson's *Earth and Stones II* (p. 158), featuring Pacific madrone. Stephen Hughes's *Manta* (p. 120) likewise makes use of found pieces of Huon pine, an ancient and extraordinary tree from New Zealand. Marcus Tatton of Australia also elevates the reuse of scraps of myrtlewood, left behind by loggers, in works such as *Shard* (p. 107).[36]

Many woodworkers take advantage of such natural imperfections as burls or spalted wood to achieve expressive effects. Robert M. Hamada's enormous turned vessel (fig. 17) in the Museum's collection, for example, exploits the visual appeal of the piece of milo wood's jagged edges, eight perforations, and thin-knot area. Giles Gilson takes a gentle jab at this reverence-for-wood sensibility in his *Point of View* (p. 162). At first glance, his vessel looks like a beautiful turned bowl that is perforated by a hole in the burl that forms its midsection. Upon close examination, however, one notes that the perforation extends up into the laminated section, illogically and impossibly.

Hank Murta Adams, at the opposite end of the spectrum, takes pains to avoid the traditional beauty and qualities of his material, glass. He mars, sandblasts, and otherwise alters the surface of his works, such as *Yellow Head* (p. 169), to create a ghastly visage.[37] The result is far removed from what one might expect of a glass object, such as Christopher Ries's *Desert Flower* (p. 135), which exploits the optical qualities of crystal-clear glass to create cubist-like reflections. Similarly, Michal Zehavi, in *Shell #4* (p. 153), makes white clay appear to be a matte, soft, spongy, and somehow organic substance. For *Downpour* (p. 83), David Nash

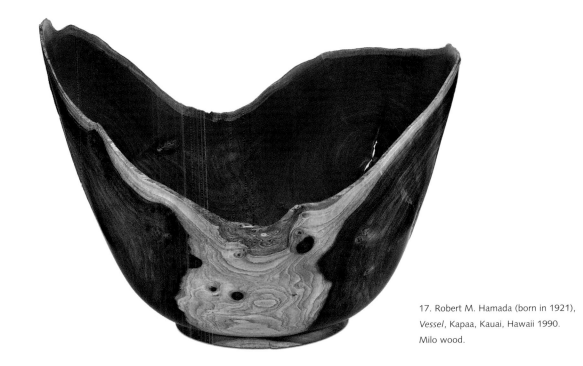

17. Robert M. Hamada (born in 1921), *Vessel*, Kapaa, Kauai, Hawaii 1990. Milo wood.

selected lime wood, a material used to extraordinary effect by figurative carvers since the Middle Ages, but employed a chain saw, blowtorch, and other tools to gouge and scar it, and then accentuated the cracks and warps that resulted from this harsh treatment. George Peterson's rough, jagged, and irregular wooden objects look like they were just extracted from a quarry (see p. 159), and Robyn Horn's works in wood similarly evoke associations with stone (see p. 79).

Following their muse, several artists represented in the Wornick Collection completely reject traditional materials while simultaneously mimicking them. Although Gord Peteran's *A Table Made of Wood* (p. 166) is indeed true to its name: it is a demi-lune side or pier table made from assembled scraps of wood, rather than the fine mahogany a traditional cabinet-maker might have used. Gugger Petter uses one of the lowest types of paper—newsprint, woven together with hemp—to make her extraordinary trompe l'oeil wall hangings that echo textiles such as quilts and coverlets (see p. 149). Similarly, the basket *Hopi* by Stephen

Johnson (p. 163) is fashioned from ephemeral pieces of paper colored with shoe polish. His "temporary" basket series includes related works made of raffle tickets, business cards, and other inexpensive, every-day materials.

A significant number of artists in the Wornick Collection combine materials in unusual ways to achieve their results. David Bennett, for example, in such objects as *Blue Suspended Man* (p. 42), traps blown blue glass within a bronze framework, encapsulating a fragile, colorful material within a rigid, dark one. José Chardiet, another glassmaker, electroplates portions of his glass objects, such as in *Silver Turquoise Metropolis* (p. 73). Alex Gabriel Bernstein often incorporates fused steel in his glass (although not in the Wornick Collection example, p. 75), much as French artist Thierry Martenon includes a passage of slate in many of his maple objects (see p. 81). Daniel Clayman, in *Emerge* (p. 136), houses a delicate glass form within a separate, protective, and enveloping bronze husk. Mary Van Cline's untitled tableau of photosensitive

glass and wood (p. 52)—replete with a fully articulated small boat model and a carved hand emerging from the wall—creates an enigmatic environment that speaks on several levels, allowing the viewer to draw his or her own conclusions.

One of the most recent additions to the Wornick Collection, Michael Lucero's *She Devil* of 2005 (pp. 146–47), indicates the inventiveness and flexibility that many artists in the collection strive to achieve. An American artist, Lucero was inspired by the colorful wool produced in an Italian factory that he encountered while living in Italy. He decided to wrap wool yarn around a ceramic body, blending strange bedfellows that nevertheless bond together to form a powerful image.

Techniques: Tradition and Innovation

Although materials-based techniques have been developed and refined for millennia, artists and craftsmen have continually sought to find new ways to improve and expedite the making of their works. Craftsmen, in particular, readily adopted labor-saving devices as soon as they could, employing steam- and water-powered tools whenever possible. Moreover, rather than just being the passive recipients of new developments, artists and craftsmen themselves, as argued by the famed materials historian Cyril Stanley Smith, in their search for new means of expression, have often been in the forefront of developments in technology and science.[38]

Many modern artists still find ways to embrace ancient techniques in an innovative fashion. Even those artists, such as Dale Chihuly and Lino Tagliapietra (see pp. 132, 74), who basically make use of the venerable history of glassblowing, find subtle ways to improve on age-old techniques. The ceramist Edward Eberle uses the ancient technique of *terra sigillata* in his own way on his porcelain vessels such as *White Blackbird #9724* (p. 106). Hervé Wahlen's copper vessel (p. 65) is a modern interpretation of the equally venerable brass-working technique of *dinanderie*, which flourished in France in medieval times but was known much earlier. Similarly, Tom Eckert's trompe l'oeil carving in *Floating Chimera* (p. 148) and Michelle Holzapfel's *Scarf Bowl*

(p. 154), utilizing both traditional turning and carving, extend into our own age the ability of the wood carver to achieve an incredibly high degree of illusionistic verisimilitude. Colombian artist Olga de Amaral has spent more than forty years mastering all the techniques associated with fiber production in her native land to produce her own unique works, which are simultaneously traditional and innovative (see pp. 62–63).

Despite the long history of most craft techniques, several of the artists represented in the Wornick Collection have expanded the boundaries of technical knowledge within their given field. Xavier Toubes, for example, is known worldwide for the sophistication and computer-assisted methods he has brought to the modern ceramic workshop and kiln; he is admired as much for his developments in shop-floor technique and practices as for his massive heads like *Astrol 2.04* (p. 36) and other sculptures. Peter Voulkos's *Isis* of 2001 (p. 143) is a late example of his innovative large stacked forms that revolutionized ceramic production when he introduced them in the 1950s (fig. 15), and they had an impact on a whole generation of artists, including, for example, Stephen De Staebler (see p. 37).

David Ellsworth's *Machel* of 1991, discussed earlier, is widely regarded as one of the breakthrough pieces that allowed wood turners to move away from the vessel form in order to explore sculptural themes. Its incredibly thin wall "astounded" woodworkers at the time, and although it received mixed reviews, it helped revolutionize the genre.

Ellsworth is only one member of the current generation of woodworkers who are expanding the age-old world of wooden vessels. Jean-François Escoulen of France developed his own tools for "de-axising" his work, allowing him to produce irregular and asymmetrical forms. Some of them, like *La cruche en folie* (The Crazy Pitcher, p. 156), earn their name through their eccentric, off-balance stance. Ron Gerton, who began his professional life as an engineer, uses the lathe to create enormous hollow forms, some as large as four feet in diameter. In *Out on a Limb No. 2* (p. 157), one of his "Bronzais," he incorporates a hollow-vessel form of spalted curly maple with a bronze support created through his "lost wood" process. Bob "Bud" Latven's

Hyperboloid Fragment in Bubinga (p. 77) expands upon the traditional technique of segmented turning to create a sculptural, almost helix-like work seen to advantage from many angles.

The use of two-dimensional techniques on three-dimensional objects has a long history in the decorative arts, but it continues to be explored in new ways. John Cederquist of California may well be the most innovative studio furniture maker active today. In pieces such as *The Chair That Built Itself* (p. 165), he uses painting on an actual furniture form to create illusionistic objects that confound the eye while delighting the imagination. California artist Lia Cook, in works such as *Half Seen* (p. 150), utilizes photography in her textile works. Taking a photographic image, she weaves a detail from it into cloth with the aid of a computer-assisted Jacquard loom. Paul Richard similarly created *Olga* (p. 170) by combining photography techniques with another medium. He first applied a light-sensitive photo emulsion onto the surface of an old wooden door. Once the emulsion set, Richard projected a negative onto the door and developed it like a black-and-white print. He then finished the object with oil paint and varnish, creating a haunting image that is more than a painting or a picture.

Personalized and innovative techniques are thus spread across the spectrum of the Wornick Collection. In the final analysis, however, the collection is about more than mute materials and changing techniques, and about more than academic schemes of classification and nomenclature. It is about vision and creativity. Ultimately, it is about ideas. It is about how artists use wood, glass, ceramics, fiber, steel, or any other material to go beyond the workmanship of certainty to the workmanship of risk, creating works of art that speak to us in an affective, ineffable way, enhancing our lives and enriching our souls.

SELECTIONS FROM
THE WORNICK COLLECTION

The Wornicks have actively collected what they have come to recognize as conceptual craft since the mid-1980s, as revealed by the 120 objects illustrated in this exhibition catalogue. Each of these objects—along with more than one hundred additional works not included here because of space limitations—is a promised gift from the Wornicks to the Museum of Fine Arts, Boston. Although the range of ideas engaged by conceptual craft objects is limited only by the artist's imagination, for the purposes of this exhibition and catalogue we have arranged these selections from the Wornick Collection into several groups, largely (although not precisely) following the analysis offered by Matthew Kangas in his essay earlier in this volume. This broad thematic approach is not meant to establish any sort of rigid taxonomy, or to narrowly define or pigeonhole a given artist's work. Rather, it offers some interesting visual juxtapositions between works of art that seem to speak to one another.

More information about the artists and individual works illustrated and discussed here is contained in object files and artist files maintained in the Department of the Art of the Americas, Museum of Fine Arts, Boston (here abbreviated as "AoA files"). Unless otherwise noted, the dimensions given are overall or "outside" dimensions. Materials have been identified by eye or from information supplied by the artist. Many of the wood objects in the Wornick Collection have been published previously in a 1996 catalogue accompanying a traveling exhibition that also contains a great deal of biographical information about each artist. This book—*Expressions in Wood: Masterworks from the Wornick Collection*—is cited in the references to the entries here simply as *Expressions*.

Julie M. Muñiz, Gerald W. R. Ward, Kelly H. L'Ecuyer, and Nonie Gadsden

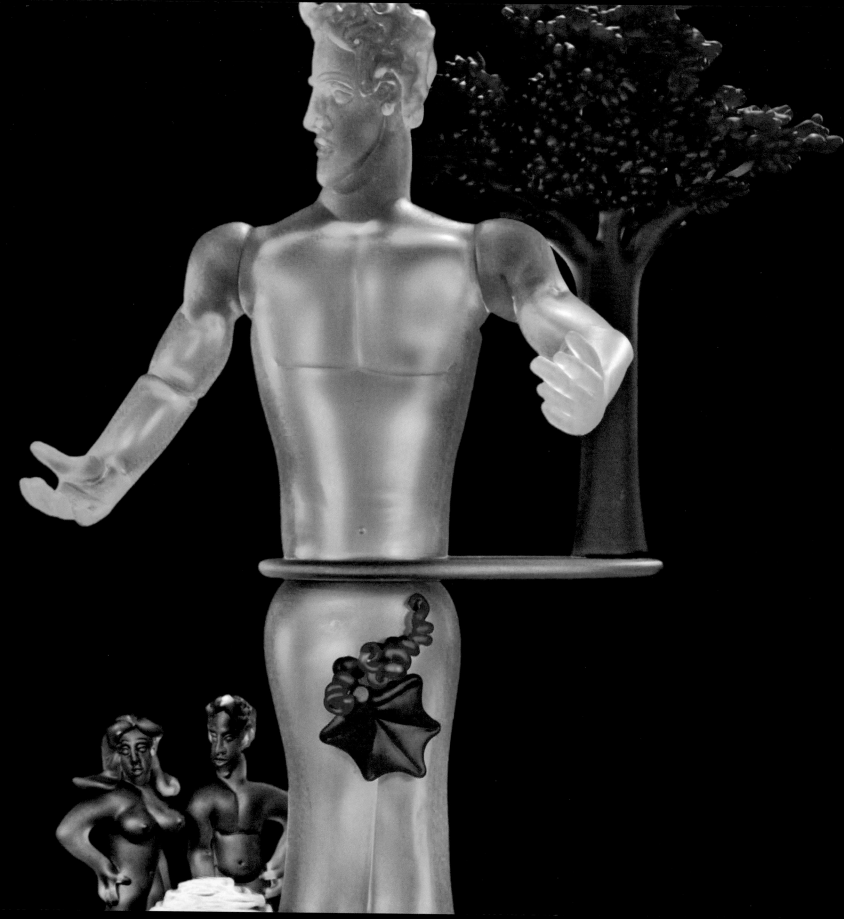

THE HUMAN FIGURE

Viola Frey

American, 1933–2004

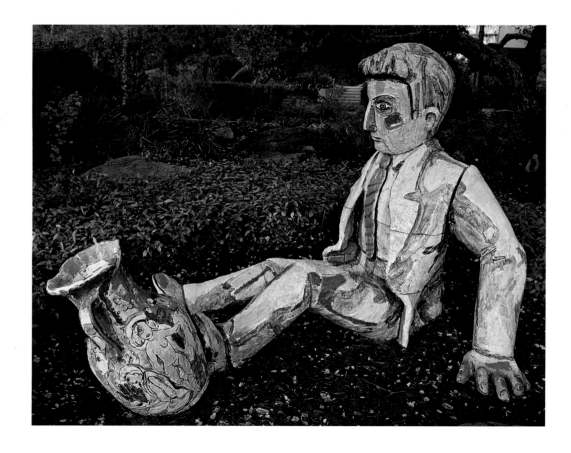

Man with Jar II
Oakland, California, 1999
Ceramic
H. 198.1 cm, w. 222.8 cm, d. 157.5 cm
(H. 78 in., w. 90 in., d. 62 in.)

One of the most important ceramists of the twentieth century, Viola Frey was born and grew up in the rural farming town of Lodi, California. Far from the artistic and cultural influences of city life, Frey "had to make her own culture" through the creativity of her imagination.[39] Frey dabbled with ceramics early in her education, but focused her studies on painting, learning to manipulate light, color, and surface texture. Turning her attentions fully to clay after graduate school, Frey applied this knowledge to her sculptural surfaces.

Frey was known to obsessively collect small, dime-store figurines that she found in the flea markets she visited religiously. Using these as inspiration, Frey created bricolage assemblies from figures either hand modeled or directly molded from these finds. In the 1980s, Frey's work grew in scale as she created large, commanding figures, at times reaching up to ten feet. Drawing upon her training as a painter, Frey embellished her sculptures with a free pallete, creating a visual field of light, color, and texture. *Man with Jar II* depicts a seated figure kicking an urnlike jar that tilts precariously as though it is about to fall. Despite its imposing height, *Man with Jar II* still reveals elements of its flea-market inspiration in its stiff posture, stylized pose, and faceless expression.

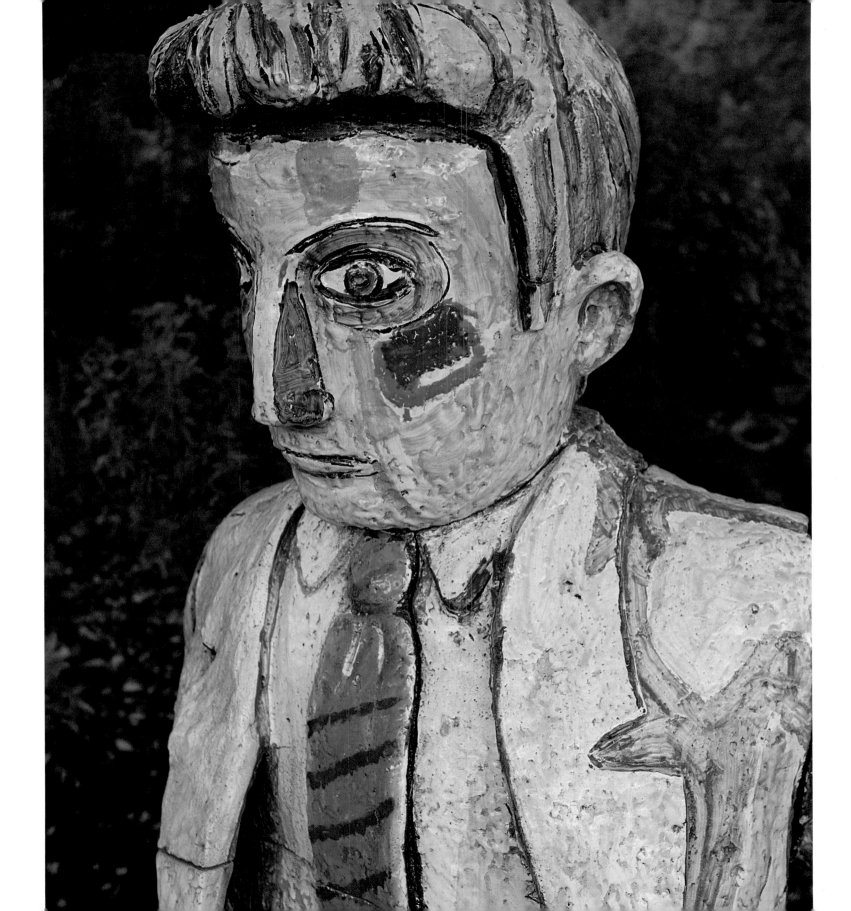

Xavier Toubes

Spanish, born in 1947

Astrol 2.04
Chicago, Illinois, 2003–5
Glazed ceramic
H. 71.1 cm, w. 54.6 cm, d. 48.3 cm
(H. 28 in., w. 21½ in., d. 19 in)

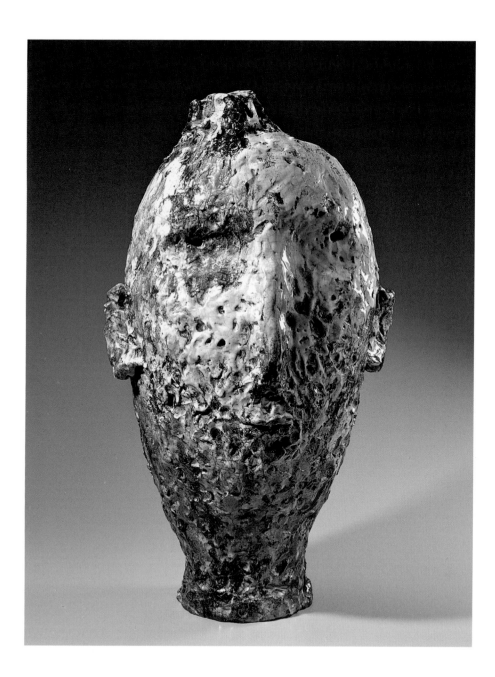

The career of Xavier Toubes vividly demonstrates the international nature of the arts community in modern times. Born in Spain, his education and career have taken him to Great Britain, Spain, the Netherlands, New York State, North Carolina, and, currently, Illinois. From 1991 to 1998, Toubes was the artistic director of the European Ceramics Work Centre in 's-Hertogenbosch, and in 1999 he accepted his current faculty position at the School of the Art Institute of Chicago. He has lectured and exhibited his work throughout the world.

After attending Goldsmith's College in London, Toubes was apprenticed to Ray Finch at the Winchcombe Pottery in Gloucestershire, England. He remains committed to the possibilities inherent in the ceramic medium: "Ceramics is very contemporary, it has a lot to say to us as physical beings—it is this intention of making those very simple, very accessible, heavy familiar things in the world that communicates ideas and involves technology and the body and the mind."[40]

The large head seen here—characteristic of, yet more restrained than, many of Toubes's related head sculptures that have been a part of his oeuvre since 1983—has a totemic presence, although one that appears to be almost dissolving due to the heavy dripping glazes that obliterate almost all traces of anything resembling a recognizable feature on the pockmarked face.[41] Toubes has noted: "The interest is in what the eyes see, also what is concealed, what I cannot see; the invisible and what I can imagine. The heads contain in themselves as much as they are containers that have a physical as well as mental interior. They are looking, waiting, with intention like anonymous poets."[42]

While *Astrol 2.04* is fashioned with the most venerable and basic of ceramic techniques, it also reflects Toubes's international reputation as a leader in the application of cutting-edge technology, including computer-controlled kilns and advancements in firing and chemistry.[43]

Stephen De Staebler
American, born in 1933

"We are all wounded survivors, alive but devastated selves, fragmented, isolated—the condition of modern man. Art tries to reconstruct reality so that we can live with the suffering."[44]

This dark reflection by the distinguished American sculptor Stephen De Staebler provides a window into un-derstanding the large body of work he created during his lengthy career. As an undergraduate at Princeton, De Staebler studied theology and began his quest to under-stand some of the fundamental questions of existence, metaphysical themes that would find articulation in his three-dimensional sculptures. In 1960, as a graduate student in Peter Voulkos's Berkeley studio—"the devil's own work-shop," in Dore Ashton's memorable phrase—he gained the confidence to manipulate and assemble large clay forms outside the conventions of traditional ceramics.[45] He like-wise drew inspiration from the compositional, spontaneous approach to figural painting taken by Willem de Kooning.

Clay became his principal medium by choice. *Seated Figure with Striped Right Arm*, created in the mid-1980s, fully represents his mature work. As here, De Staebler often fashions vertical, slab-built works evocative of ancient, almost fossilized, ruins, subtly colored. His figures are frag-mentary, as if weathered by nature and destabilized by the passage of time. The result is a somber, yet moving, essay on human longevity and survival in the face of the corrosive effects of deep, nearly geological, time and the meaning of existence.[46]

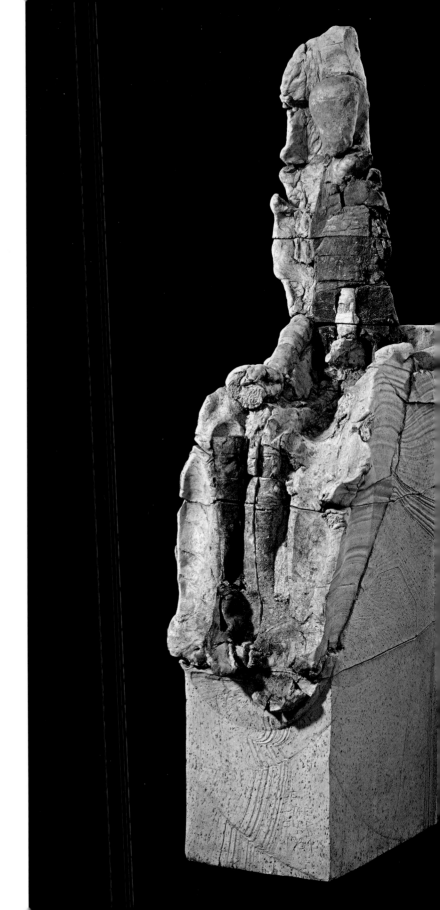

Seated Figure with Striped Right Arm
Berkeley, California, 1984
Fired clay with pigment
H. 182.9 cm, w. 43.2 cm, d. 73.7 cm
(H. 72 in., w. 17 in., d. 29 in).

Clifford Rainey

Irish, born in 1948

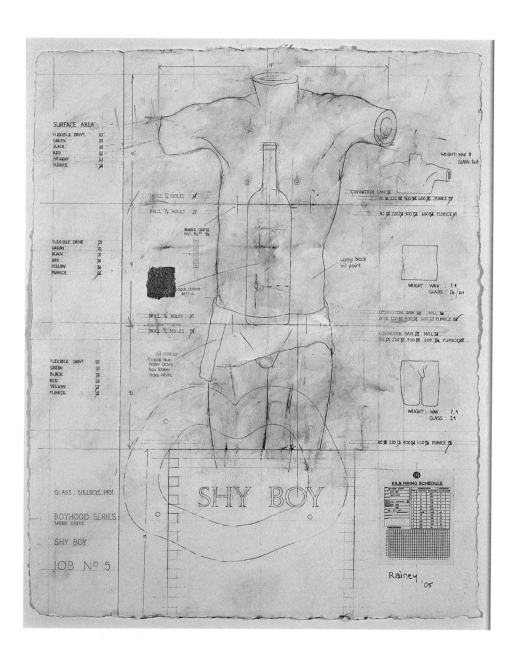

Shy Boy is the fifth "job" in an autobiographical series entitled Boyhood by Irish artist Clifford Rainey that includes *War Boy*, *Broken Boy*, *Ghost Boy*, *Philosophical Boy*, *Nature Boy*, *Art Boy*, *Literate Boy*, and *Gaia's Boy*. Each began with a modeling of the torso of Rainey's ten-year-old godson, Alexander Georges, and each in its own way is a commentary upon Rainey's life as a child in Northern Ireland, where he was born in 1948 in Whitehead, County Antrim.

Maria Porges draws attention to the golden wine bottle at the heart of *Shy Boy*. As a child, she notes, Rainey "was deeply shy, to the point of having difficulty speaking. Alcohol, he reminds us, can encourage conviviality and break down inhibitions, allowing words to flow freely. Like the apple, however, its consumption can lead to both good and bad consequences."[47]

While the Boyhood pieces are emotionally laden with personal detail, they are also technically accomplished, utilizing a complicated process of modeling, casting, cold-working, constructing and reconstructing, and a variety of surface treatments. Many of the steps and materials used in the making of the piece are detailed in the accompanying drawing (at left).[48]

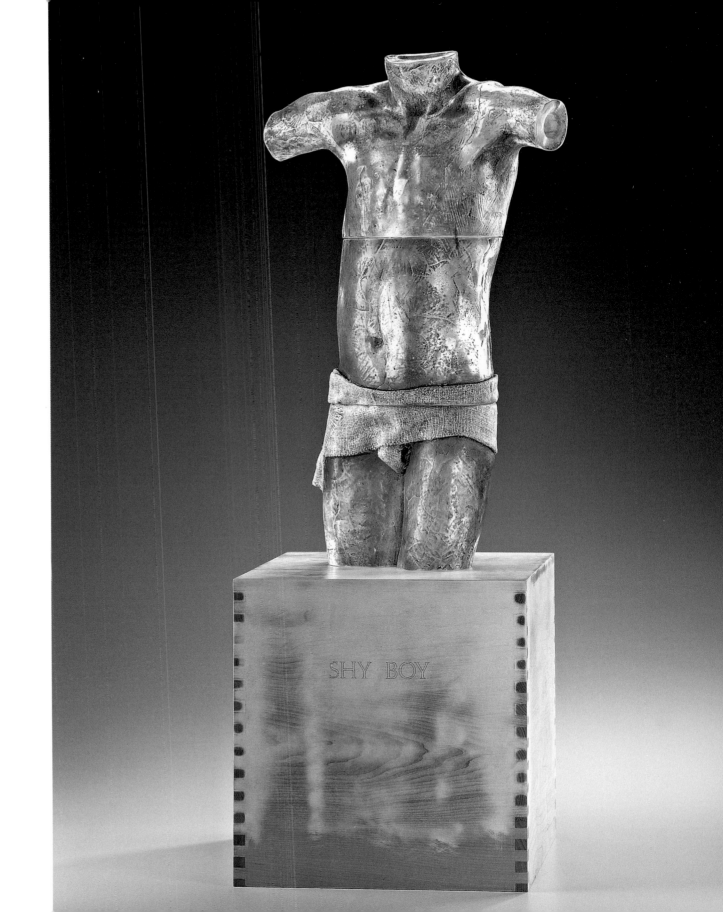

Shy Boy
Oakland, California, 2005
Cast glass, pigment, gold-leafed bottle,
pins, gesso, maple plinth
H. 109.2 cm, w. 38.1 cm, d. 38.1 cm
(H. 43 in., w. 15 in., d. 15 in.)

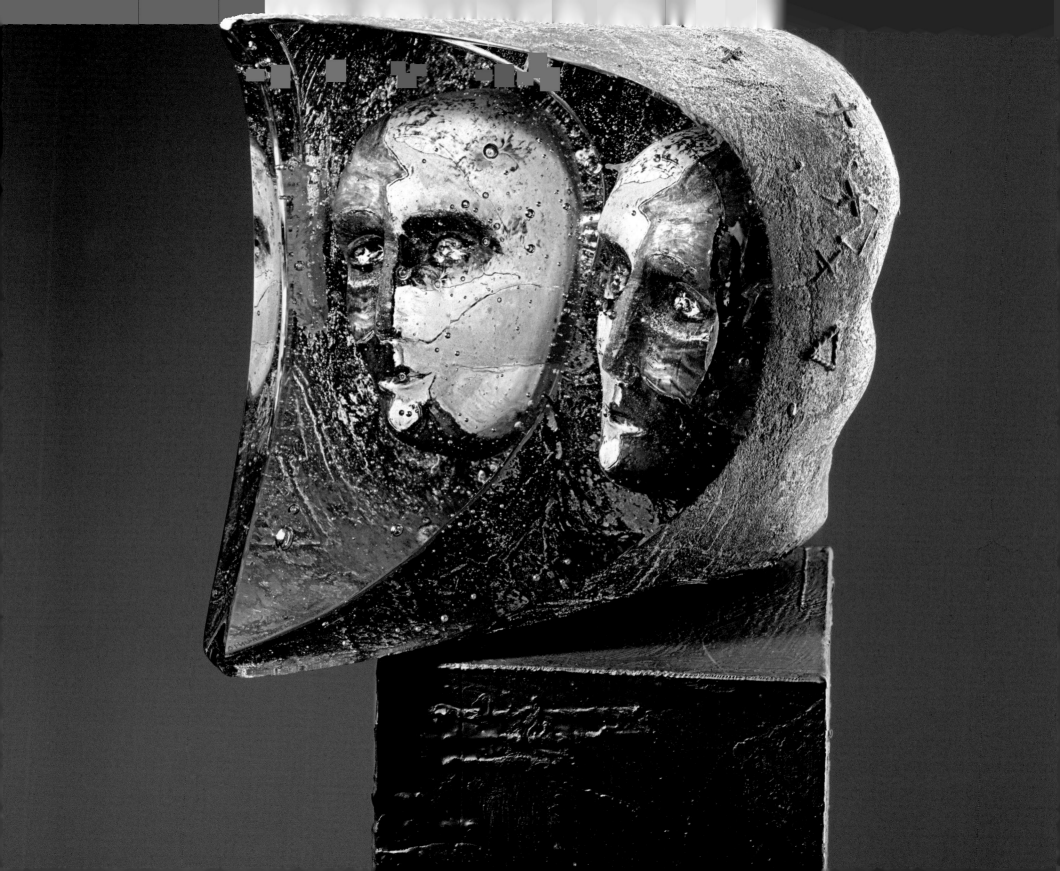

Bertil Vallien

Swedish, born in 1938

Janus (Venice)
Åfors, Sweden, 2005
Sand-cast glass
H. 38.1 cm, w. 18.1 cm, d. 39.1 cm
(H. 15 in., w. 7⅛ in., d. 15¾ in.)

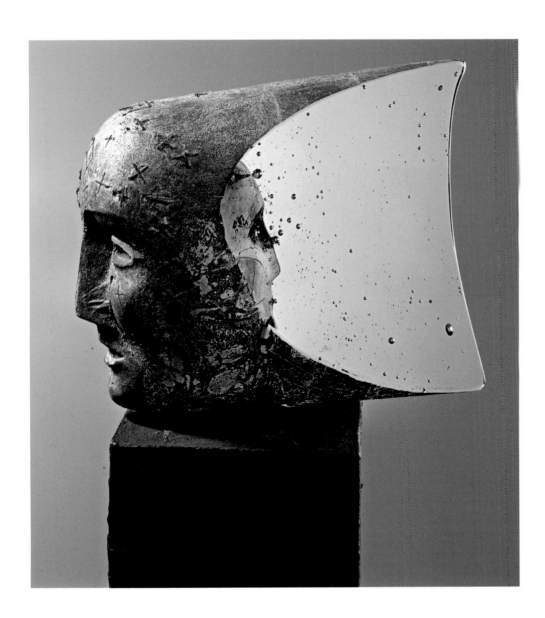

Working exclusively with sand-cast glass, Bertil Vallien has emerged as one of the world's preeminent glass artists. The technique of sand-casting requires the artist to work backward—first creating a reverse mold in compressed sand, then pouring in the molten liquid glass. As the glass and sand meet, each tries to either melt or cool the other, creating a pitted, crusted surface—battle scars from the war for formation. This blemished skin lends emotional power to Vallien's work, which he amplifies with haunting imagery held within a limited range of forms; heads, boats, and houses are his most common. "I believe I have been creating an alphabet of symbols that are actually very easily understood by anybody," explains Vallien. "I chose them very carefully. The objects have meaning."[49]

Vallien named his Janus series after the Roman god of gates and doors for whom the month of January is named. Typically depicted with two faces, Janus represents change and transition, such as the progression of past to future. *Janus (Venice)* depicts a colorful, mask-like face peering from the back of a larger gray head. The reference to Venice both recalls the colorful masks of the city's annual carnival, as well as pays homage to the historic glass capital.

David Bennett

American, born in 1941

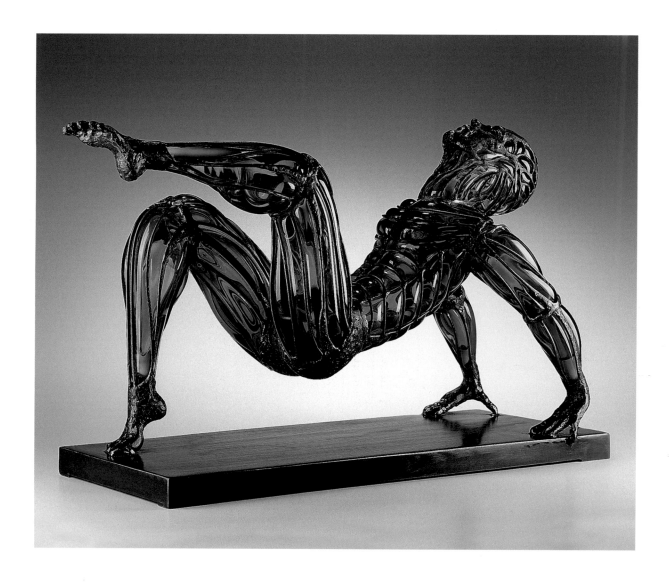

David Bennett utilizes the fluid appearance of glass to great advantage in such works as *Blue Suspended Man*. Here, striking blue glass serves to represent the inner body—the mass of flesh and blood—contained within a skeletal bronze framework. The tension between these materials is heightened by the figure, which is balanced only on its fingers and the toes of one foot, frozen eternally in this delicate but stress-inducing position. "My art is the capture of the emotion and in moving hot glass that will continue that emotion after the glass cools and becomes fragile. Then I make the steel [*sic*] graceful to support that emotion."[50] Other recent works by Bennett done in collaboration with his son Drew feature standing figures and galloping or rearing horses, all expressing the crystallized sense of movement and emotion. According to Bennett, they are "like a photograph of water frozen for a second in the air."[51]

Bennett opened his own glass studio in 1992, after a long career as an attorney. He is closely affiliated with the Pilchuck Glass School, serving as its president in 1998–99 and a member of the board of trustees since 1994.

Blue Suspended Man
Poulsbo, Washington, 2005
Blown glass, bronze
H. 43.2 cm, w. 63.5 cm, d. 25.4 cm
(H. 17 in., w. 25 in., d. 10 in.)

Latchezar Boyadjiev

Bulgarian, born in 1959

Trained under the guidance of Stanislav Libenský at the Academy of Applied Arts in Prague, Latchezar Boyadjiev defected to the United States in 1986. After spending the next ten years using cold-work techniques on optical glass, Boyadjiev became frustrated by the size limitations of the medium and eventually switched to cast glass. Like his mentor Libenský, Boyadjiev works mainly in monochrome glass, but varies the surface texture between high-polished gloss and acid-etched frost. Boyadjiev's sculptural work is evocative of the human figure, abstracted and elongated to minimalist lines. For *Creation,* Boyadjiev created the mold in the United States but cast the piece in the Czech Republic. The work highlights the sensual lines of the female torso, which serve as a framework for the creative powers that lie within all women.

Creation
San Francisco, California, and Prague,
Czech Republic, 2006
Cast glass
H. 58.4 cm, w. 63.5 cm. d. 12.7 cm
(H. 23 in., w. 25 in., d. 5 in.)

Ann Wolff

German, born in 1937

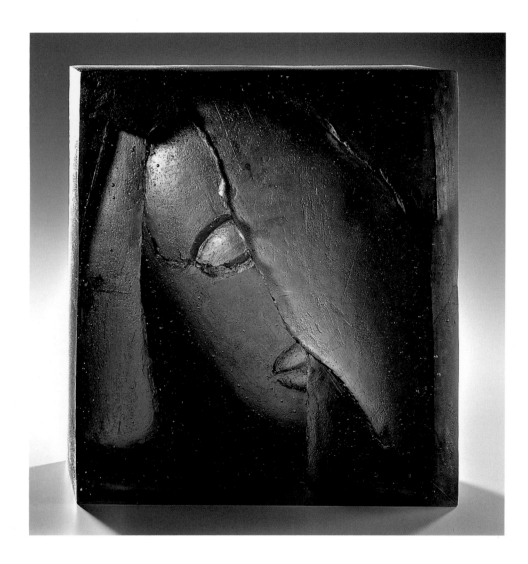

Born in Germany on the cusp of World War II and educated there in the 1950s, Ann Wolff moved to Sweden in 1960 and stayed there until 1993. During that time, she worked as a designer for Kosta Boda, the well-known Swedish glass factory, before opening her own studio in 1978. In 1993 she returned to Germany as professor of design at the Hochschule für bildende Künste in Hamburg. Since 2000 she has maintained studios in Berlin and Sweden.

Over time, Wolff has created paintings, works on paper, and sculptures in bronze and clay, in addition to her sculptures in glass.[52] Her evolving work defies easy categorization, although, whatever the medium, she has most often focused on portraits of women and the female form, through which she explores the trajectory of women's lives. The half-moon face seen in the Wornick Collection work is a somber, enigmatic visage presented in the context of a large rectangle of glass. The imperfections in the material add to the complexity and texture of the image.

Blues M21
Larbro, Sweden, 2006
Cast glass
H. 58.4 cm, w. 50.8 cm, d. 21 cm
(H. 23 in., w. 20 in., d. 8¼ in.)

Richard Jolley
American, born in 1952

Translating Substance No. 24 is a recent example of
Richard Jolley's longstanding interest in utilizing the human
form to explore issues of humanity and the environment.
Although the meaning of this sculpture, either manifest or
latent, is not necessarily abundantly clear, it is not enig-
matic or mysterious. Rather, it seems to present a puzzle—
cheerful, colorful, humorous, and almost cartoonish in
some exaggerated passages—that lends itself to a wide
range of interpretation. The tall central figure is seen with
his almost classical head in profile, with his right arm and
hand outstretched and ending with a welcoming open
palm. The balanced composition features a tree to one
side, and the torsos of a buxom woman and man at the
other. Bright contrasting colors, with focal points in red
and yellow, animate the ensemble.

A native of Kansas, Richard Jolley moved to Tennessee
at an early age and was educated there, receiving his BFA
from Vanderbilt University. He did his graduate work in
1974 at the Penland School of Craft in North Carolina,
and now lives and works in Knoxville, Tennessee. Although
best known for his sculpture in glass, Jolley also creates
bronze sculptures, paintings, drawings, and prints.

Translating Substance No. 24
Knoxville, Tennessee, 2006
Pipe-formed and sculptured glass
H. 144.8 cm, w. 61 cm, d. 50.8 cm
(H. 57 in., w. 24 in., d. 20 in.)

Martin Blank

American, born in 1962

Known for his abstractions of the human form, Martin Blank has emerged as one of North America's premier figurative sculptors. Working with hot glass, Blank layers the molten substance bit by bit, reheating and shaping the sculpture with steel tongs throughout the process. "The human form is pulled and pushed, twisted, cut and bent into being, into a presence that leaves a distinct emotional imprint," explains the artist.[53] Blank prefers to work with the human figure, for which he pulls inspiration from classical counterparts. Yet Blank's work is not about classical perfection or the idealized body. Rather, it speaks to the expressionistic quality of form and figure. *Scarlet* exemplifies the way Blank manipulates the form to achieve a heightened emotional response. Its graceful, sinuous lines play on the subtle yet powerful elements of femininity. The name *Scarlet* recalls the fieriness of both its color and the personality of the famous heroine who shares the name.

Scarlet
Seattle, Washington, 2006
Hot-worked glass
H. 106.7 cm, w. 55.9 cm, d. 27.9 cm
(H. 42 in., w. 22 in., d. 11 in.)

Robin Grebe

American, born in 1957

Sea Drift
Newton, Massachusetts, 2004
Cast glass, stone, wood
H. 45.7 cm, w. 33 cm, d. 12.7 cm
(H. 18 in., w. 13 in., d. 5 in.)

Massachusetts artist Robin Grebe began her career in the ceramics field at the Massachusetts College of Art in Boston, where she received her degree in 1980. During additional graduate study at the Tyler School of Art near Philadelphia, she began to work in glass as well. Much of her work over the years, like *Sea Drift,* has been essentially figural in nature, often enigmatic and mysterious in tone.

In *Sea Drift,* Grebe has fashioned a female torso with an oval in the center of its chest embellished with a depiction of an empty boat riding the waves. Surrounding this small vignette are several combinations of dots and lines depicting, apparently, constellations. The result is a haunting statement about the human condition and our search for direction and meaning.

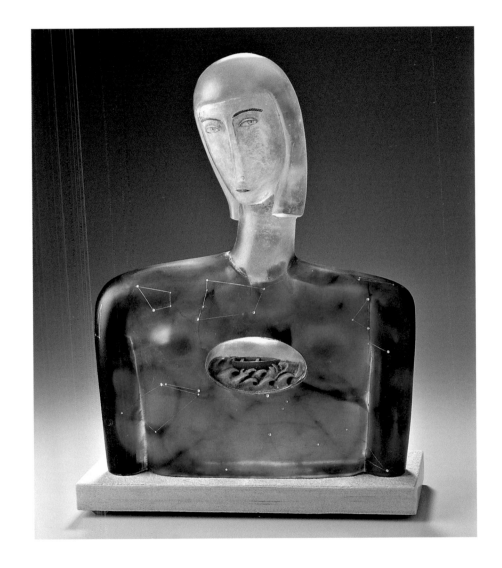

Joey Kirkpatrick
Flora C. Mace

Americans, born in 1952 and 1949

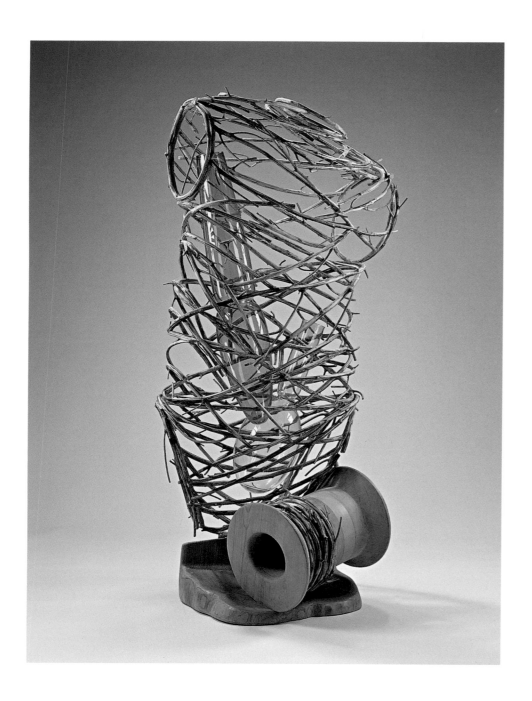

Best known for their giant glass fruit, Joey Kirkpatrick and Flora Mace have been collaborating since they first met at the Pilchuck Glass School in 1979. Kirkpatrick is generally responsible for the concept of their sculpture, while Mace works on its realization. Breaking barriers in the traditionally male-dominated field of glass, the team draws inspiration from nature and the domestic realm. *Spooled Torso* takes its imagery from an object that is most commonly associated with "women's work"—the sewing spool. Alder-wood branches entwine to form a torso that balances atop a large spool, while blown glass vessels are encased inside. Mace and Kirkpatrick celebrate the domestic object as a sacred element of everyday life. "With these forms, to us innately beautiful, we embrace tradition and distinguish ourselves within it," explains the couple.[54] While the imagery in their sculpture may seem to draw on a specific meaning, the pair denies such intention but rather prefers the viewer to draw his or her own interpretation of each piece.

Spooled Torso So Made
Seattle, Washington, 1998
Fabricated hand-blown glass, alder wood, steel
H. 149.9 cm, w. 68.6 cm, d. 66 cm
(H. 59 in., w. 27 in., d. 26 in.)

Marilyn R. Pappas

American, born in 1931

Michelangelo once said, "I saw the angel in the marble and I carved until I set him free." To Marilyn Pappas, the goddesses from classical mythology call to her in the same way. "You could say that the statue is there in the fabric and I'm just revealing it, slowly, tediously."[55] Hand-stitching in a monochromatic palette on linen, Pappas re-creates classic sculptures in her Muses series. The subjects of the series, which also includes representations of Artemis, Aphrodite, Athena, and others, are all female; though not true Muses, they are indeed Pappas's muse and inspiration. Venerable yet vulnerable, Pappas's *Nike* stands as a symbol of female empowerment and homage to womankind. To Pappas, the tactile drapery is "a magical repository of power" and represents culture, while the body underneath represents nature.[56] While Pappas selects classic sculpture as her starting point, her work, as she is quick to point out, merely interprets the original, not copies it. Drawn in freehand with each stitch, Pappas's Muses seem alive, as if proudly reemerging after years of having been forgotten.

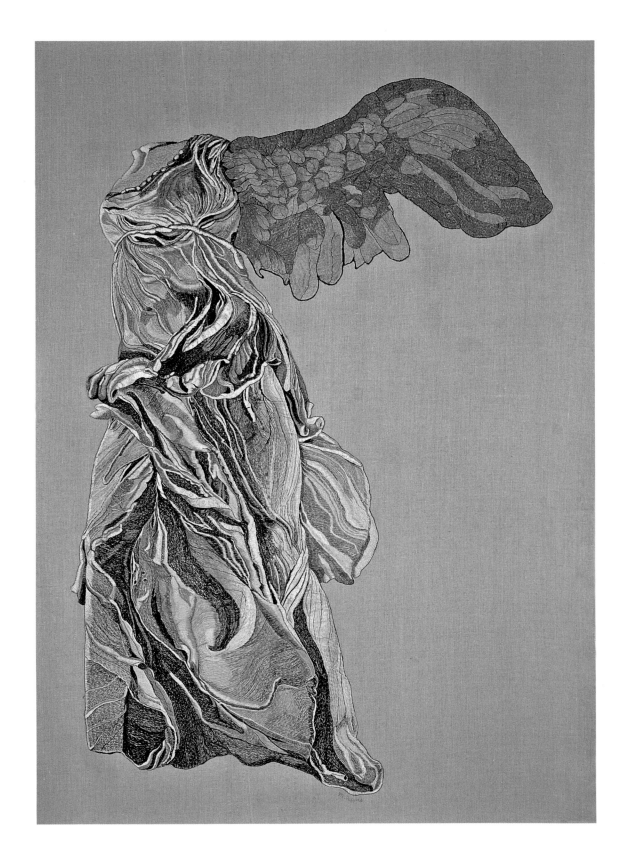

Nike of Samothrace with Golden Wing
Somerville, Massachusetts, 2001
Cotton and 2 percent gold threads
embroidered on linen
H. 396.2 cm, w. 148.8 cm
(H. 156 in., w. 58½ in.)

Akio Takamori

Japanese, born in 1950

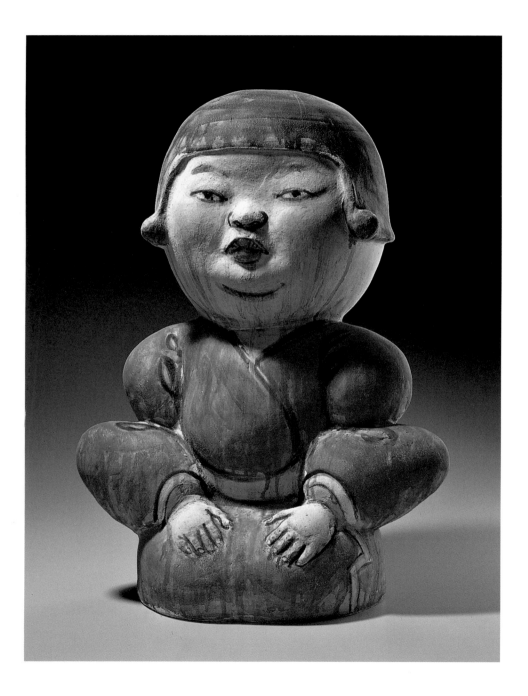

Akio Takamori follows in the footsteps of ceramics pioneers Robert Arneson, Viola Frey, and Stephen De Staebler by breaking free from the vessel format to create figurative sculpture in clay. Takamori draws on his Japanese heritage, modeling figures from the cultural history of his homeland—peasants, workers, the emerging postwar middle class, and other subjects. In 2005 Takamori began his *Karako* series, named after the Chinese child figures found in Japanese painting and artwork from the Edo period. "Karako" means "Chinese child," but Takamori "learned that the word 'Karako' became [the] meaning of children's hair style that was influenced by the Karako painting. . . . My attentions are more about [the] proportion of the body as a child and exaggeration of the form of the body and the hair-do."[57]

In *Little Yellow Karako,* Takamori simplifies and exaggerates the figure's kimono to mimic the round baldness of his head. *Little Red Karako* similarly uses the exaggeration and repetition of form and shape throughout the composition. Although not made as an intended pair, the two pieces engage in a dialogue of circular form and color. Takamori intends his figures to be shown in groupings to better express this relationship.

Little Red Karako
Seattle, Washington, 2006
Stoneware
H. 68.6 cm, w. 48.3 cm, d. 38.1 cm
(H. 27 in., w. 19 in., d. 15 in.)

Little Yellow Karako
Seattle, Washington, 2006
Stoneware
H. 63.5 cm, w. 63.5 cm, d. 30.5 cm
(H. 25 in., w. 25 in., d. 12 in.)

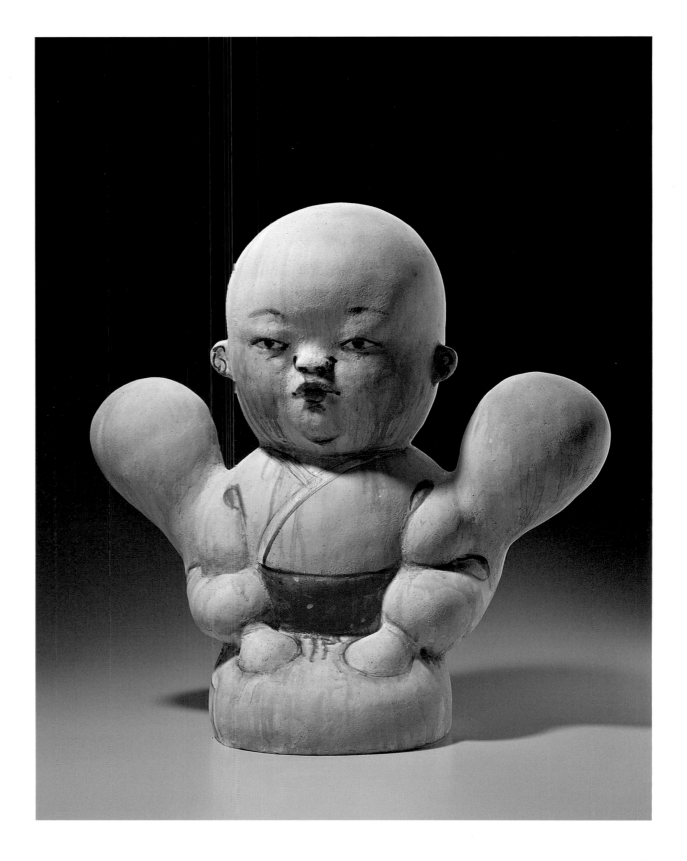

Mary Van Cline

American, born in 1954

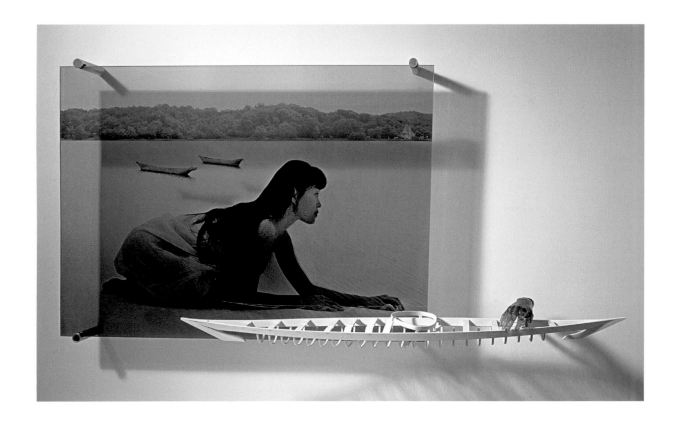

The haunting images of Mary Van Cline depict surreal landscapes and unearthly figures that comment on time and space. Van Cline travels extensively as part of her research, taking pictures of barren and often isolated landscapes, which she imprints on large sheets of photosensitive glass. Figural pictures taken in her studio are often superimposed onto the landscape image via a process of double exposure. In this work, commissioned by Ron and Anita Wornick in 2002, Van Cline skillfully uses light to enhance its already ethereal qualities. As light passes through the glass, the image is shadowed on the wall behind, creating a ghostlike effect. The attached skeletal kayak speaks to the temporality of the image and the passage of time.

Untitled
Seattle, Washington, 2002
Photosensitive glass, wood
H. 92.7 cm, w. 207 cm, d. 20.3 cm
(H. 36½ in., w. 81½ in., d. 8 in.)

Soonran Youn

Korean, born in 1967

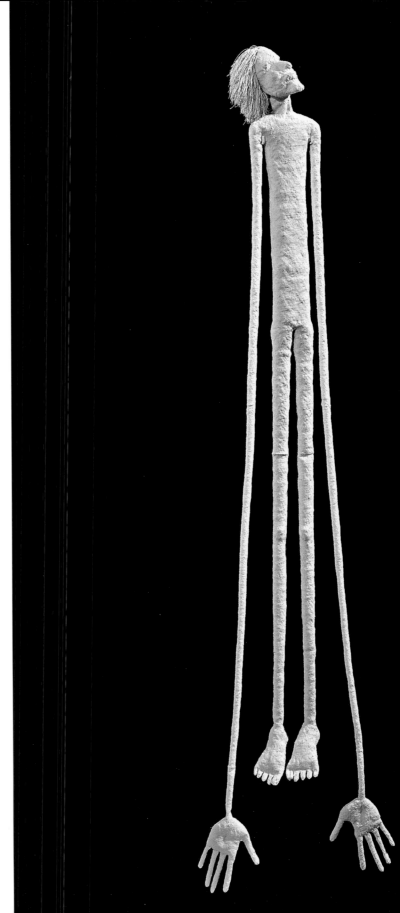

Soonran Youn focuses her work almost exclusively on
the human figure, abstracting, minimizing, and distort-
ing its features into emotionally charged forms of grief,
isolation, joy, and adoration. The title of her current
series of figures, Island, evokes images of the body
as an isolated vessel: "I see a human as being an isle
locked in and eventually swallowed by the mysterious
ocean. . . . As being a particle in the infinity, it seems
unbearably painful and even empty to think of the
human desire to be oneself, that is, to be an individual
divided from others."[58] Youn tilts the head of her Island
figures upward, as if hopeful and full of dreams, while
their bodies elongate toward the reality of earth. This
elongation and reaching toward opposite realms touch
on the essence of humanity's struggle between hope
and pragmatism.

Island No. 3
Santa Fe, New Mexico, 2000
Knotless netted cotton thread
H. 208.3 cm, w. 68.6 cm, d. 24.1 cm
(H. 82 in., w. 27 in., d. 9½ in.)

John Morris

English, born in 1963

A native of Sheffield, England, John Morris is considered to be one of Australia's leading contemporary wood carvers. After receiving his initial artistic training at Queensland College of Art in graphic design, he pursued a career as an independent illustrator and sculptor.[59]

Morris's wood sculpture, which he began to produce in 1996, is notable for its exploration of the human, usually female, form, as with *Portrait of a Lover (Long Haired Girl)*. Able to stand on its long, straight hair or to be mounted on a wall, this portrait presents an almost mannerist visage of a young woman with an unblinking, enigmatic, and somewhat disturbing gaze.

Morris, self-taught in woodworking, has been described as being a "painfully shy" artist who "lives in an intensely private world populated by his dreams and fantasies."[60] Reflecting his early training, his work process begins with detailed, careful drawings and sketches, often enlarged on a photocopier. Many of his early works were assembled from multiple small pieces of wood. His oeuvre includes sculptures drawn from the animal and insect worlds, in addition to his human figural work.

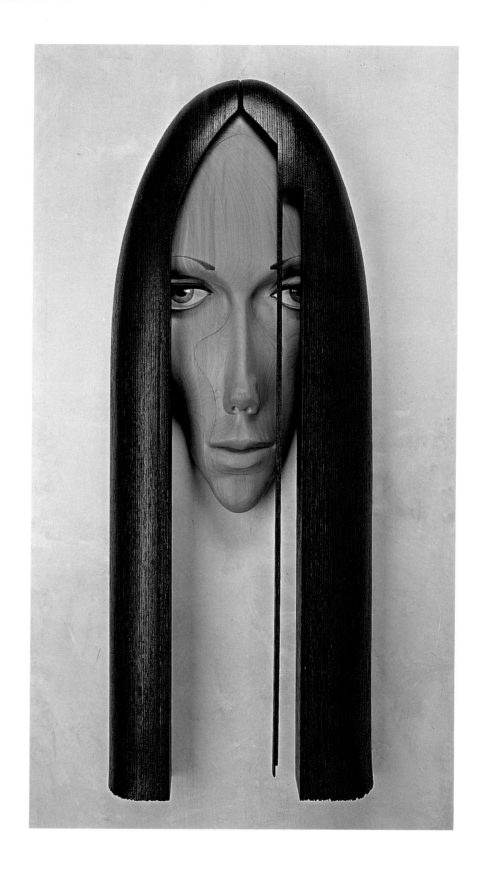

Portrait of a Lover (Long Haired Girl)
Brisbane, Queensland, Australia, 2004
Carved and painted East Indian kauri and
laminated plywood
H. 129 cm, w. 48.3 cm, d. 6.6 cm
(H. 50¹³⁄₁₆ in., w. 19 in., d. 2⅝ in.)

Christine Federighi

American, 1949–2006

Originally a producer of functional vessels, Christine Federighi turned toward more sculptural work as her career matured. Greatly influenced by her love of the American West and folk art traditions, Federighi decorated her surfaces with landscapes and extensive patterns. Although typically known as a ceramist, Federighi was not afraid to explore other media. Tall, slender, and doll-like, *Canyon Catcher* is typical of Federighi's other figural work done in clay.[61] The minimalism of this armless, faceless figure forces the viewer to reflect inward, while the carved trees and juxtaposed stone ground the piece and remind the viewer we are all of this Earth.

Canyon Catcher
Miami, Florida, about 1990
Wood, stone
H. 221 cm, w. 30.5 cm, d. 30.5 cm
(H. 87 in., w. 12 in., d. 12 in.)

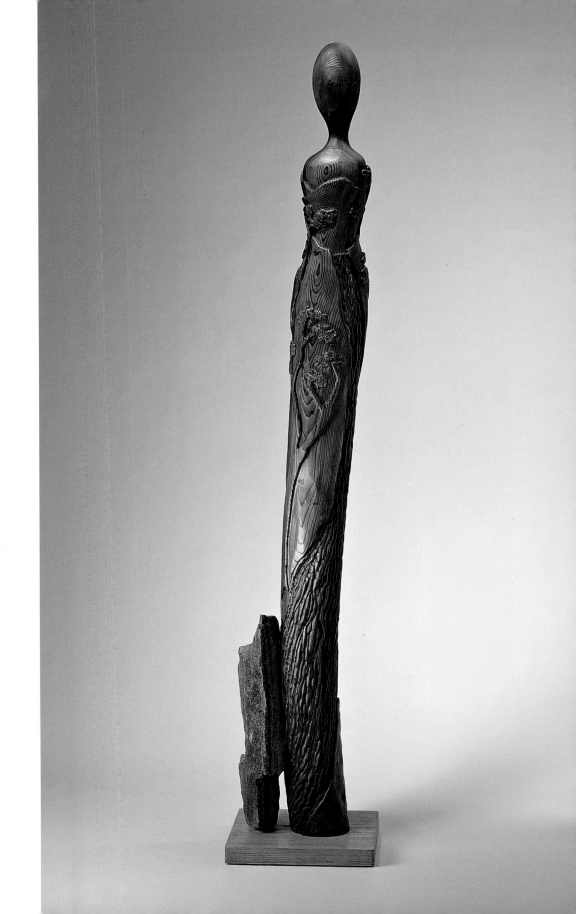

Jean-Pierre Larocque

Canadian, born in 1953

Untitled
Montreal, Quebec, Canada, 2002
Glazed stoneware
H. 95.3 cm, w. 55.9 cm, d. 54.6 cm
(H. 37½ in., w. 22 in., d. 21½ in.)

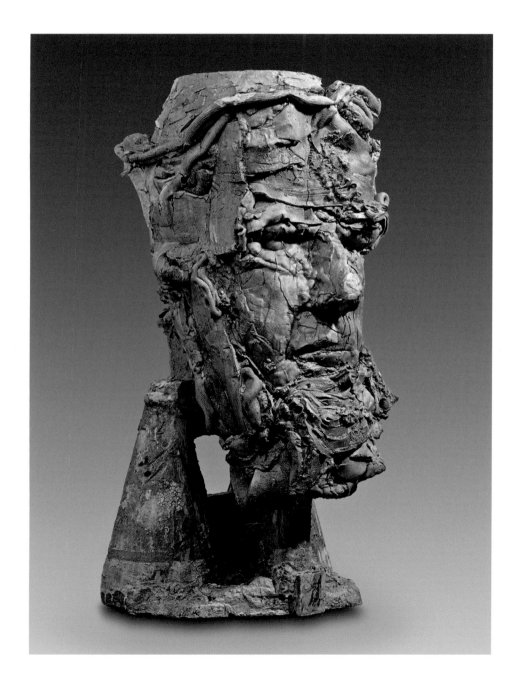

The unfinished, work-in-progress quality of Jean-Pierre Larocque's sculpture speaks to his artistic process. "My work is something better experienced than explained," comments the artist. "It is the embodiment of a concept, a record and a witness. It is layered with clues, evidence of erasures and traces of numerous adjustments which provide some transparency to the means of representation."[62]

Originally trained as a painter and printmaker, Larocque creates large, abstracted heads that are in essence sculptural sketches, rushed renderings of the artist's immediate impressions built through a furious process of adding and subtracting, molding and reshaping. The pieces speak to the duality of creation and deconstruction. Left raw, incomplete, and ambiguous, Larocque's work forces the viewer to form his own narrative and meaning based on his own personal history. By mirroring the personal experience of the viewer, each piece is ripe with emotional intensity.

Gib Singleton

American, born in 1936

Trained at Southern Illinois University and the Art Institute of Chicago, Gib Singleton found his career transformed by the time he spent as a Fulbright fellow at the Accademia di Belle Arti in Florence, Italy, in the 1960s. While there, he was called upon to assist in the conservation of works of art damaged in the catastrophic floods of 1966, a moving and almost spiritual experience. During his long career, much of his work has been religious in nature, although he is also noted for his animal and "Western" works.

Tall and impossibly thin, the biblical Eve reflects the attenuated and Giacometti-like nature of many of Singleton's sculptures, with their elongated proportions and irregular, textured surfaces. Eve clutches a large gilt apple of paradise hidden behind her back; perhaps the sculptor has captured her at the moment of decision, as she ponders whether or not to partake of the knowledge of good and evil.

Eve
Santa Fe, New Mexico, 1998
Bronze
H. 274.3 cm, w. 27.9 cm, d. 33 cm
(H. 108 in., w. 11 in., d. 13 in.)

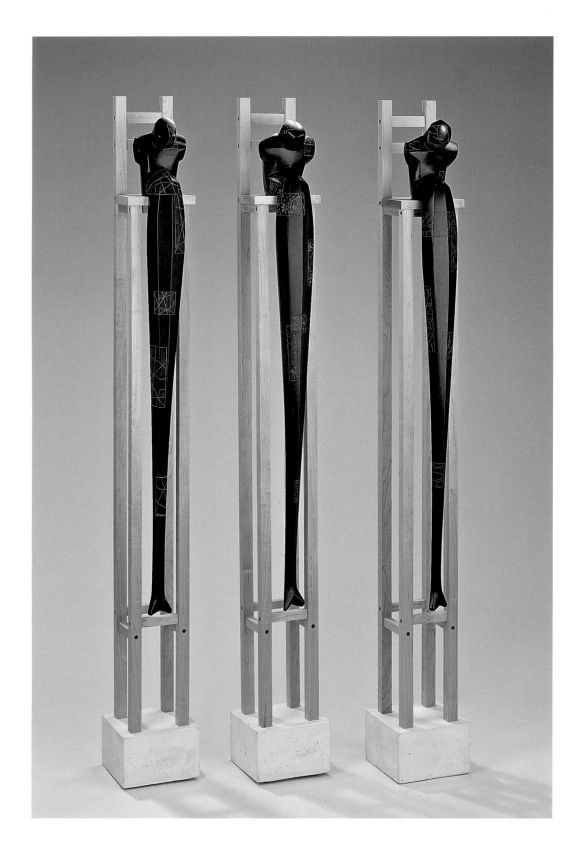

Joël Urruty
American, born in 1968

Joël Urruty studied at San Francisco State University before receiving his master of fine arts from the Rochester Institute of Technology in 1996. Studying furniture design and woodworking, Urruty has since developed a repertoire of wood and bronze sculpture. His *Seated Figures* plays on the form and line of the human body. Simplifying the figure to its essential core, Urruty emphasizes its grace and beauty. Posed in tall chairs, the figures elongate toward the earth, further emphasizing their line. Urruty prefers to work in wood because of its tactility and warmth. "The rawness of the material and the primitive geometric shapes play off of the fluid lines of the figures, creating an exciting visual composition," explains the artist.[63] To his surfaces, Urruty applies various techniques that include scarring and painting to bring each piece to life.

Seated Figures
Middletown, New York, 2006
Textured and painted mahogany, maple, concrete
H. 157.5 cm, w. 91.4 cm, d. 25.4 cm
(H. 62 in., w. 36 in., d. 10 in.)

Robert Brady

American, born in 1946

Born in Reno, Nevada, Robert Brady attended the California College of Arts and Crafts and received his master's degree from the University of California, Davis, in 1975. Since that time, he has taught at California State University, Sacramento. In the late 1970s and 1980s, he became well known for his ceramic figures, many of which evoked the darker side of the human psyche and emotions. After a retrospective exhibition of his ceramic sculpture at the Crocker Art Gallery, Brady began to produce painted wood sculptures starting in 1989. This untitled sculpture is an early example of his work in this medium.

Attenuated like many of his wooden pieces, the Wornick figure depicts a female form, with her oval face painted white and her hair, pulled back in a tight bun, painted black. The figure's long oval face and exaggerated nose resemble a mask that is almost fully frontal, and the face's features are not readily seen from the side. Like some of the carved furniture of Kristina Madsen, Judy Kensley McKie (see p. 104), and others, this work by Brady references so-called primitive art from Africa, Oceania, and elsewhere, as well as Cubist interpretations of the same.[64]

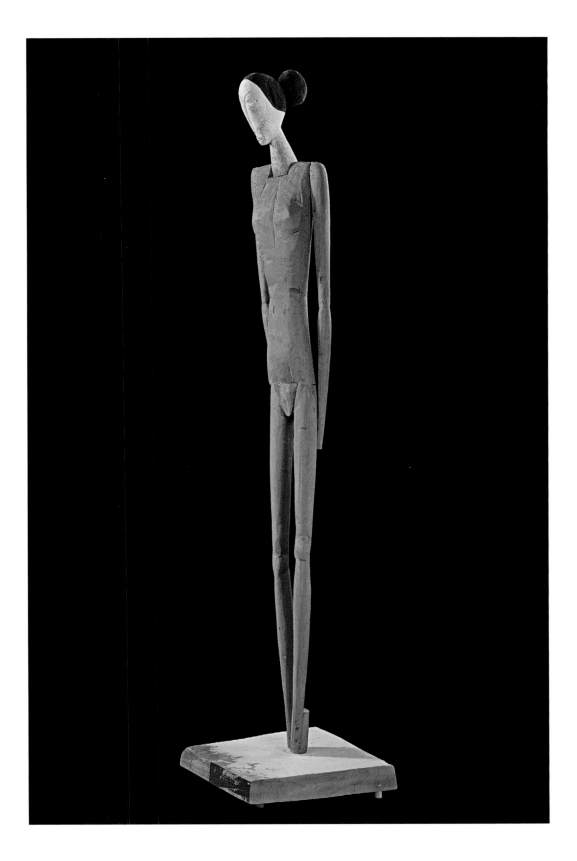

Untitled (Standing Woman)
Sacramento, California, 1990
Painted and carved wood
H. 215.9 cm, w. 45.7 cm, d. 50.8 cm
(H. 85 in., w. 18 in., d. 20 in.)

PATTERN ▪ ORNAMENT ▪ TEXTURE

Olga de Amaral
Colombian, born in 1932

Cesta Lunar 64 (Lunar Basket 64)
Bogotá, Colombia, 1998
Linen, gesso, gold paint, acrylic paint
H. 185.4 cm, w. 152.4 cm
(H. 73 in., w. 60 in.)

Colombian artist Olga de Amaral's work defies classification; it is at once fiber art, painting, and sculpture, without comfortably sitting in any of these individual categories. Trained in Bauhaus tenents at the Cranbrook Academy of Art in Michigan, de Amaral has matured and evolved over the more than forty years she has spent exploring fiber, but she has always remained loyal to the formalist qualities of expressive structure and clear process, as well as to elements of her native Colombian culture, artistically blending the traditions of North and South America.[65]

In both *Lienzo Ceremonial* and *Cesta Luna 64*, de Amaral starts with a handwoven fiber grid revealing her intense interest in structure and process. She then rebels against this regular geometry by obscuring the structure of *Lienzo Ceremonial* behind a thick waterfall of loose, flowing threads that seep out of the grid and by consciously manipulating the structure of *Cesta Luna 64*. In the latter piece, de Amaral breaks the grid, pulling strips away from the flat surface into three-dimensional space.[66]

Color, light, and texture are used to emphasize these subtle but bold deviations from the grid, such as the muted pewter of the tightly woven structure of *Lienzo Ceremonial* in contrast with the vibrant, energetic loose red threads that call to mind the colorful peasant weaving of Colombia. The fiber structure of *Cesta Luna 64* was stiffened with white gesso, then covered in radiant gold leaf and highlighted with green acrylic paint. De Amaral's use of gesso, gold, and acrylic reflects her love of native architecture, which consisted of a bamboo structure covered with adobe (mud) and whitewashed, and evokes the glittering gold interiors of Spanish colonial churches that twinkled in candlelight. To de Amaral, "Fiber is just fiber. Gold can show blood, pain, patriotism, mysticism, things that fiber alone cannot express."[67]

Lienzo Ceremonial 21. Granate
(Ceremonial Cloth 21. Garnet),
Bogotá, Colombia, 1992
Linen, acrylic paint
H. 274.3 cm, w. 121.9 cm
(H. 108 in., w. 48 in.)

Bennett Bean

American, born in 1941

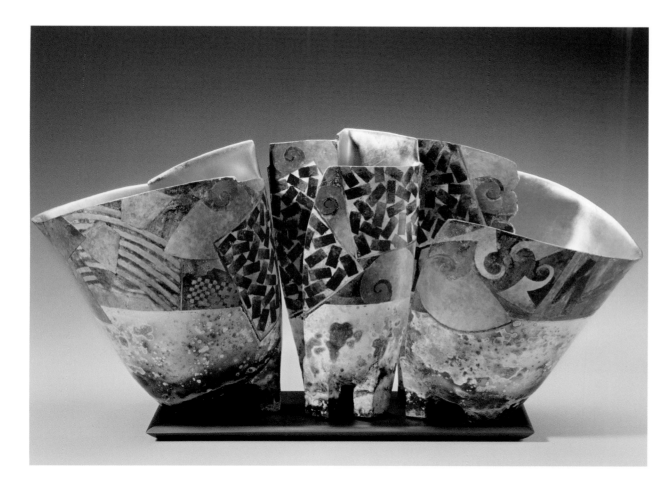

Bennett Bean is one of the leading ceramic artists in the United States. Educated at the State University of Iowa and the Claremont Graduate School in California, where he studied with Paul Soldner, he has worked full-time as an artist since 1980. After experimenting with several different types of ceramic, he focused on the exploration of surfaces, for which he is widely known today.

In the late 1990s, Bean began to produce segmented pieces, featuring two, three, or four units. The three sections here, each supported by small feet and resting on a separate base, are nestled together in their presentation and could easily be mistaken for a single object. Each is glazed and hand painted in its upper section with rectangles, scrolls, volutes, checkerboard designs, parallel lines, and other forms and gilt inside. Using a complicated process involving numerous techniques, Bean achieves unique results that revel in the beauty and refinement of his patterned ornament and bright colors.[68]

Triple on Base
Blairstown, New Jersey, 1998
Pit-fired earthenware, gilt and painted
H. 35.6 cm, w. 71.1 cm, d. 30.5 cm
(H. 14 in., w. 28 in., d. 12 in.)

Hervé Wahlen

French, born in 1957

Born in French Algeria, French sculptor Hervé Wahlen first exhibited his work in the United States at Barry Friedman Ltd. in New York City in 1999. Entitled "Dinanderie," the exhibition featured Wahlen's work in sheet copper, which he manipulates by hand in numerous ways—hammering, welding, shaping, cutting, soldering—and through gilding and patination. An ancient technique, *dinanderie* is named for the Flemish town of Dinant, where the craft was practiced in medieval times. It was revived by Jean Dunand in the art deco period, and was adopted by Wahlen in the early 1980s.[69]

Au fil du temps reflects Wahlen's mastery of his craft, as well as his interest in balance and movement, in solids and voids. Delicately poised and counterbalanced, the object in the closed position shows a rounded lower section below two parallelogram-shaped elements whose upper, inner edges meet to form a triangular void. Within the triangle is a small gilt depression, evoking a protected, nearly sacred area. The two upper sections are hinged to the body of the object and can be lifted to reveal larger, lidded compartments inside. In all, the work demonstrates Wahlen's concerns with "balance and counterweights; the hinges; the play between openings/closures," open passages, and the play of light upon his golden surfaces.[70]

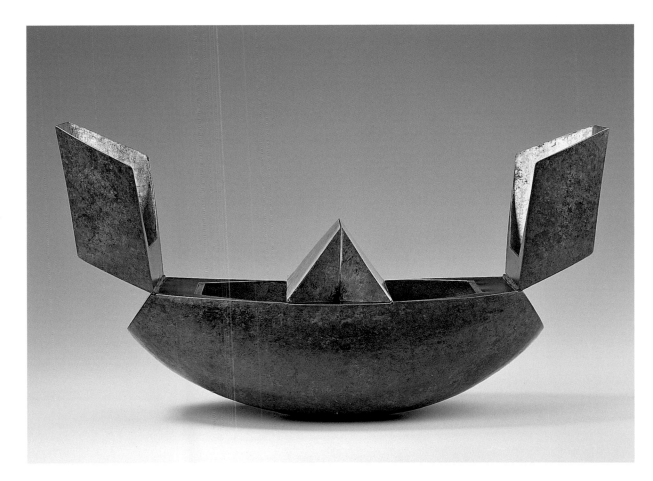

Au fil du temps (With the Wire of Time)
Paris, France, 1999
Hammered copper
H. 28.3 cm, w. 53.3 cm, d. 15.2 cm
(H. 11⅛ in., w. 21 in., d. 6 in.)

Betty Woodman

American, born in 1930

Anemones
New York, New York, 2000
Earthenware, epoxy, lacquer, paint
(Left opposite) H. 86.4 cm, w. 40.6 cm, d. 24.1 cm
(H. 34 in., w. 16 in., d. 9½ in.)
(Right opposite) H. 74.9 cm, w. 63.5 cm, d. 12.7 cm
(H. 29½ in., w. 25 in., d. 5 in.)

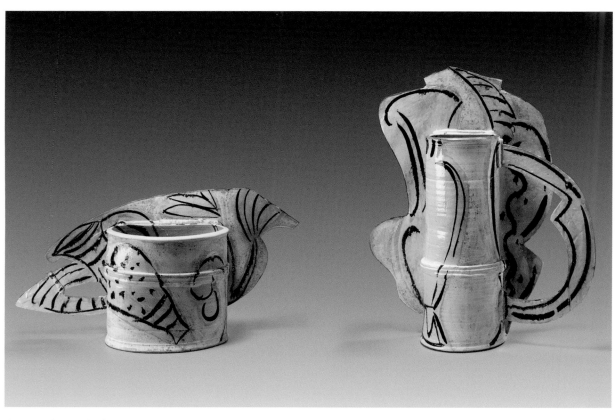

Anemones (reverse view)

Recognizing the importance of the vessel in ceramic history, Betty Woodman pays homage to the form while still moving the medium in new directions.[71] Her work dances the line between tradition and innovation. A member of the Pattern and Decoration movement of the 1970s, Woodman boldly painted colorful designs onto her forms at a time when convention dictated that true art was not supposed to be "decorative." While Woodman's vessels are not necessarily functional, they represent the practical vessels that are a central part of ceramic's history. In essence, they are not vessels per se, but sculptures of vessels.

In her *Anemones*, Woodman plays with the dichotomy between the second and third dimension by attaching flat, irregular facades to the fronts of two large pots. While the pieces stand independently, their shapes and decoration interplay, creating movement even outside their individual borders. To Woodman, who often creates pieces to be displayed in multiples, the negative space is just as important as the form and pattern.

While the flat surface provides a canvas on which she lavishes bold decoration, the vessels remain sparsely painted with black-and-white line drawings of vases and squiggles. The pieces can be seen as a commentary on the bridge between painting and craft—perhaps even suggesting that without craft, the fine arts cannot stand.

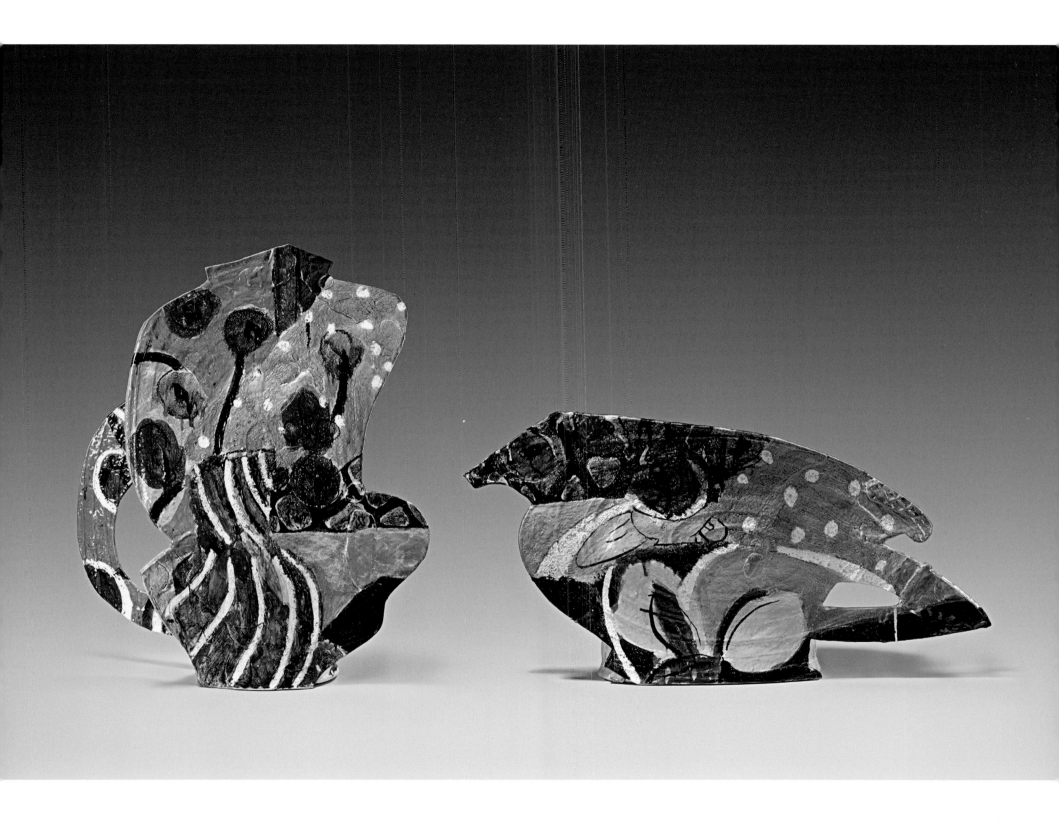

Robert Cooper

English, born in 1949

Cross My Heart
London, England, about 1990
Earthenware, slab built with slip decoration and glaze
H. 71.1 cm, w. 36.2 cm, d. 8.9 cm
(H. 28 in., w. 14¼ in., d. 3½ in.)

Robert Cooper's ceramic sculpture is a creative essay in color and pattern, almost textilelike in feeling and regularity, overlaid upon a markedly irregular, asymmetrical body of clay. As such, it is in keeping with other examples of Cooper's ceramics, in which, as he states, he uses a "collage approach of making with hand building techniques in a magpie sort of way; layering with slips, glaze on glaze, lustres, slip screen printing and ceramic transfer, making a narrative however obscure."[72] In this way, Cooper attempts "to create pieces which have a dialogue with the participant to touch and make a connection with the history of ceramics, the urban landscape, [and the] geological landscape."[73] *Cross My Heart* is indebted to Hmong textiles, which the artist encountered while on a visit to Los Angeles.[74]

Born in Sheffield, England, Cooper attended the Kingston-upon-Thames College of Art and the Royal College of Art. He lives and works in London.[75]

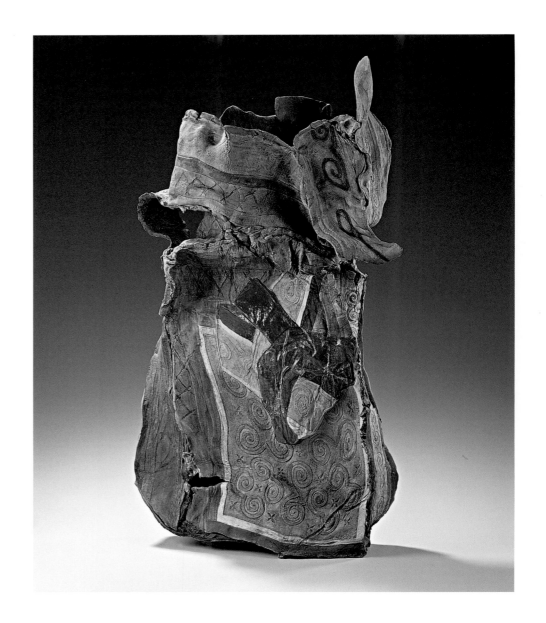

Jun Kaneko

Japanese, born in 1942

Many significant moments of Jun Kaneko's career can be described as happy accidents. When the artist first arrived in the United States in 1963 to study painting, serendipity allowed him to house-sit for contemporary ceramic collectors Fred and Mary Marer while the couple was on vacation. Surrounded by the work of Peter Voulkos, Ken Price, John Mason, and others, Kaneko tried a ceramics class the next semester. The large scale of much of this work had an impact on Kaneko, whose objects can reach up to ten feet in height. Despite their monumentality, Kaneko's pieces have a tangible approachability about them. The patterned surfaces of his Dangos, named after a Japanese steamed dumpling, are similar to textures one might find in domestic objects. From stripes to weaves and polka dots, these massive "dumplings" are anything but intimidating.[76]

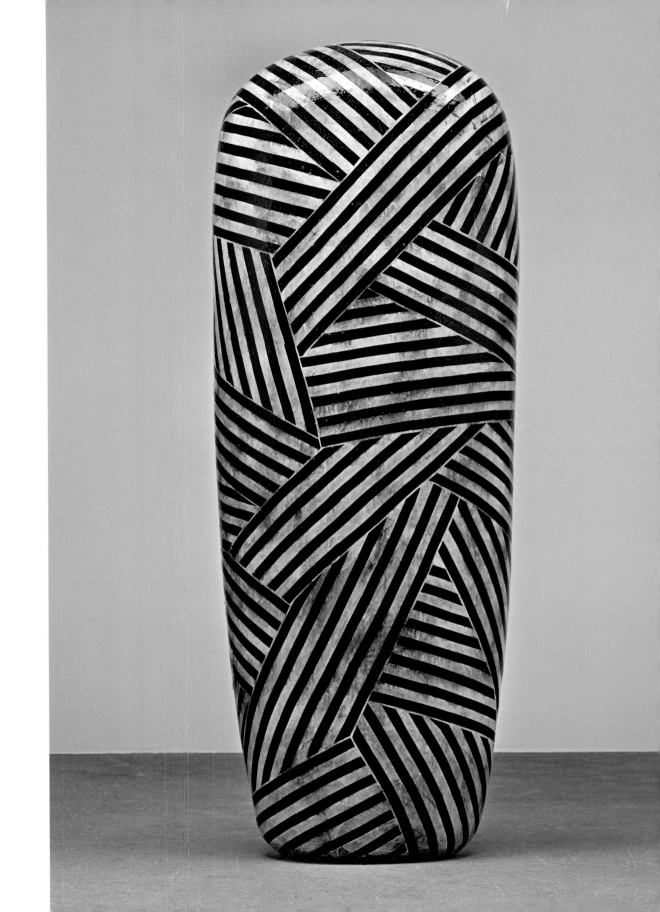

Dango (00-10-2)
Omaha, Nebraska, 2000
Glazed ceramic
H. 210.8 cm, w. 83.8 cm, d. 50.8 cm
(H. 83 in., w. 33 in., d. 20 in.)

Hap Sakwa

American, born in 1950

PBX Vessel
Sebastopol, California, 1986
Constructed poplar, acrylic lacquer
H. 90.8 cm, w. 8.6 cm, d. 8.6 cm
(H. 35¾ in., w. 3⅜ in., d. 3⅜ in.)

Hap Sakwa's *PBX Vessel* is assembled from many small blocks of poplar, fashioned together in an irregular manner to form an eye-catching pattern of solids and voids. Colored with a blue-green acrylic lacquer, the resulting tall, vaselike form appears to be constructed of stepped architectural masonry or stonework. This constructed appearance, with the object's surface alternately but irregularly extending into and retreating from space, relates to sculptural theories and concerns of the 1920s as well as to the work of other contemporary wood artists, such as Todd Hoyer.[77]

Primarily interested in sculptural form, like many artists represented in the Wornick Collection, Sakwa's artistic career has followed a variety of paths since its beginnings in the mid-1970s, as he experimented with wood and then recycled materials.[78] In recent years, he has worked as a commercial photographer for artists, specializing in images of three-dimensional works.

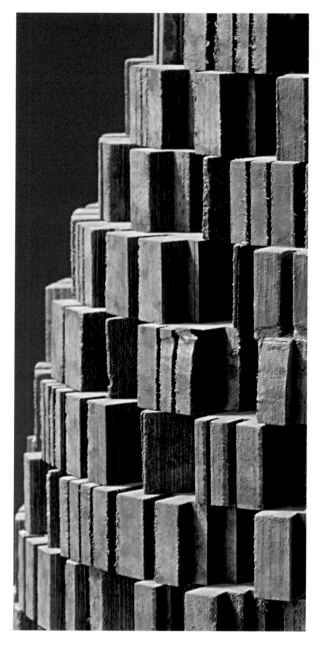

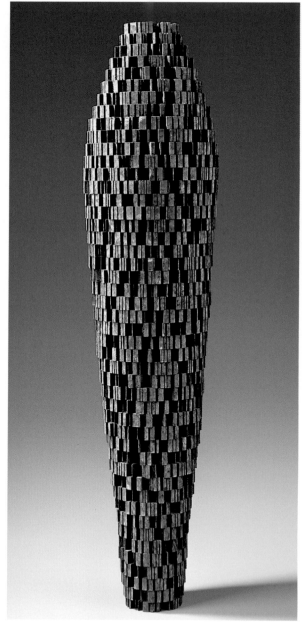

Danny Perkins

American, born in West Germany, 1955

Working with glass like a painter, Danny Perkins utilizes his intellect but also follows his intuition in creating his tall, columnar forms, assembled from colorfully painted segments, such as *Majestic.* The palette of this piece includes shades of green, yellow, red, and violet, all varying in intensity and hue depending on the available light.

Perkins fashions his sculptures by initially blowing a large amount of clear glass (weighing thirty pounds or more) into a mold to establish the basic shape. Perkins then manipulates it with heat to its final form. After annealing, Perkins breaks the object in a specific, considered manner. The pieces are sandblasted or carved, and then colored with oil paints, before being reassembled and glued together. A coat of varnish finishes the piece.

Perkins, born in Germany but a resident of the United States for many years, "started working with broken vases," as he put it, "when I was still doing production work in California" in the early 1980s. He became attracted to the shards of broken pieces in the shop, regarding them as valuable, but he found that most other people and clients initially did not share his enthusiasm and fascination with them. "In the craft world, breaking glass, painting it, and putting it back together are all wrong things to do. If the glass is broken, it is garbage; if it is painted, it is more than glass and has lost its purity."[79] However, his vertical, painterly, and abstract works found acceptance, enabling him to open and maintain his own studio.

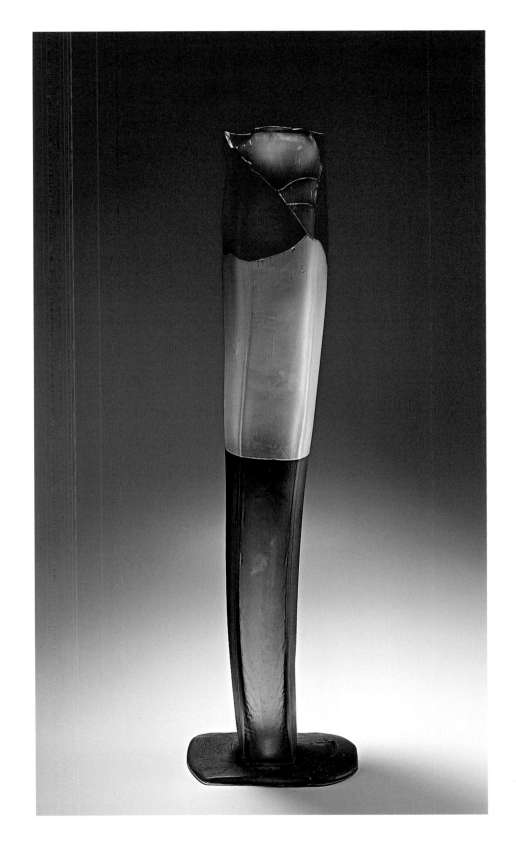

Majestic
Seattle, Washington, 2005
Blown, cut, assembled, and painted glass
H. 147.3 cm, w. 38.1 cm, d. 30.5 cm
(H. 58 in., w. 15 in., d. 12 in.)

Tomáš Hlavicka

Czech, born in 1950

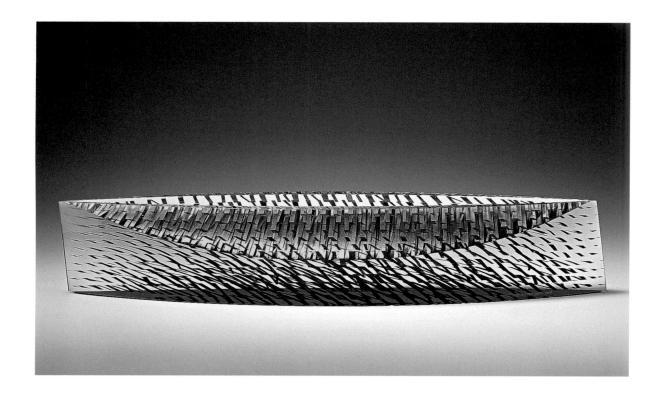

Born in Prague, Tomáš Hlavicka was trained as an architect at the Prague Technical Institute. His father-in-law, Pavel Hlava, widely recognized as one of the seminal artists in the modern Czech glass movement and also represented in this catalogue, was his mentor and initial master. Under Hlava's direction, Hlavicka learned the technical skills of glassmaking from beginning to end while also working as an architect. In the mid-1980s, Hlavicka began working independently, and in 2000 and 2001 he received awards and recognition at major international exhibitions in Japan, Brussels, and Prague, establishing him as an important member of the current generation of Czech masters.

Like many of his works, *Claire* is an elegantly simple form, a boatlike ellipse. Its interior glows with gold foils, which appear to float and even sway, giving the essentially stable and static form a sense of dynamism and movement. The use of metallic foils of various types is characteristic of Hlavicka's current work.

Claire
Prague, Czech Republic, 2006
Laminated and polished glass with various metals
H. 12 cm, w. 18 cm, d. 68 cm
(H. 4¾ in., w. 7⅟₁₆ in., d. 26¾ in.)

José Chardiet

Cuban, born in 1956

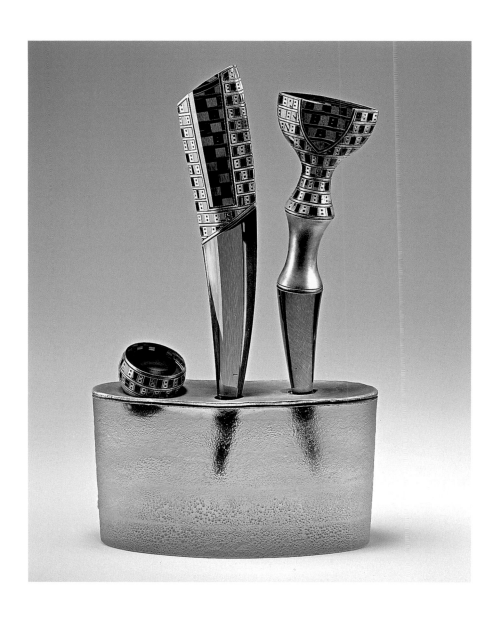

A native of Havana, José Chardiet came to the United States and received his undergraduate education at Southern Connecticut State University in New Haven and his master of fine arts degree from Kent State University. After a stint as artist in residence at Kent State, Chardiet opened his studio in New Haven and worked there for several years before becoming professor of glass sculpture at the University of Illinois at Champaign-Urbana (1991–2002). He has also taught at the Pilchuck Glass School (1989–90), Penland School of Crafts (1997), and Haystack Mountain School of Crafts in Maine (1999–2001). Since 2000 he has operated his own studio in Providence.[80]

Many of Chardiet's works feature, as with *Silver Turquoise Metropolis,* three or more elements embedded into a base or supporting structure. While earlier examples were a modern interpretation in glass and other materials of the traditional still life genre, this recent work is more architectural in nature, evoking skylines and even fenestration in their electroplated checkerboard pattern.

Silver Turquoise Metropolis
Providence, Rhode Island, 2006
Cast, blown, and electroplated glass
H. 61 cm, w. 35.6 cm, d. 12.7 cm
(H. 24 in., w. 14 in., d. 5 in.)

Lino Tagliapietra

Italian, born in 1934

Stromboli HG521
Seattle, Washington, 2002
Blown glass with wheel-engraved surface
H. 42.5 cm, w. 24.1 cm, d. 11.4 cm
(H. 16¾ in., w. 9½ in., d. 4½ in.)

The Italian glass artist Lino Tagliapietra was born in 1934 on the island of Murano in the Venetian lagoon. Murano, since the thirteenth century, has been the spiritual home of glassblowing. Trained there by Archimede Seguso and others, Lino (as he is generally known) plied his craft in Italy for several decades, achieving a high degree of technical competence and slowly developing his own designs.

In 1979 Lino traveled to the United States and began an ongoing international career featuring frequent collaborations with noted European and American artists. Dale Chihuly and Benjamin Moore were instrumental in arranging for Lino to come to America for the first time, bringing him to Pilchuck Glass School in the state of Washington. Since that time, Lino has traveled every year to the United States to teach and create works of art. Today, he is known "by common consent . . . [as] the world's foremost glassblower," according to David Whitehouse, director of the Corning Museum of Glass.[81]

Like many artists in glass and other materials, Tagliapietra often produces objects in series, each example representing a subtle variation on an overall theme. The large vessel offered here is from the artist's Stromboli series of colorful, essentially vase-shaped forms enhanced with wheel-engraved surfaces.

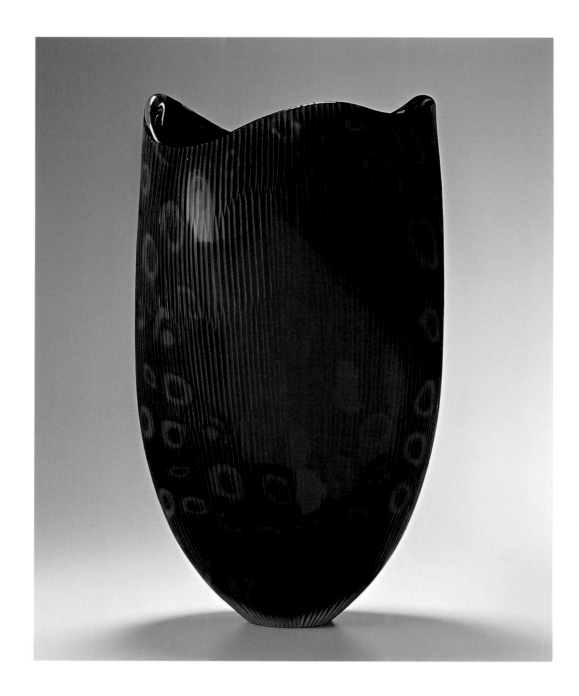

Alex Gabriel Bernstein

American, born in 1972

Radiant Mountain
Worcester, Massachusetts, 2006
Cast and cut lead glass
H. 48.3 cm, w. 24.8 cm, d. 14.6 cm
(H. 19 in., w. 9¾ in., d. 5¾ in.)

Born to an artistic glassmaking family in North Carolina, Alex Gabriel Bernstein has been described as "a child of the American glass studio movement."[82] In addition to the studio experience he gained as a young child watching his parents at work, Bernstein received professional training at the Penland School of Crafts before obtaining his master's degree from the Rochester Institute of Technology in 2001. Having taught for several years at the Cleveland Institute of Art, he accepted a position as head of the glass department at the Worcester (Massachusetts) Craft Center. *Radiant Mountain* expresses the combination of loveliness and lethality that characterizes much of Bernstein's glass. Made of bull's-eye glass, the work is cast as a smooth and roughly columnar shape, in subtle shades of pleasing colors that result from the ability of the raw material to be mixed. However, the gently rounded edges of the top are dramatically cut to form a series of irregular crevasses, descending to various depths in the body of the form. As Bernstein notes, "The cuts on the top give the piece a light feel almost like feather floating in the glass. It was an interesting discovery that I made during my process."[83]

The surfaces of *Radiant Mountain* are alternately cut, polished, and matte, providing visual variety. When blasted with light from above, the form becomes radiant and projects a rugged, mountainous, and mysterious monumentality that belies its relatively small size.

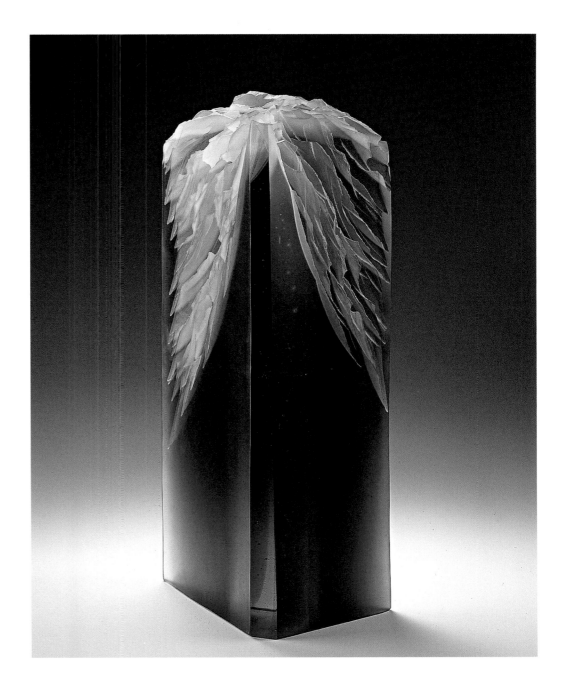

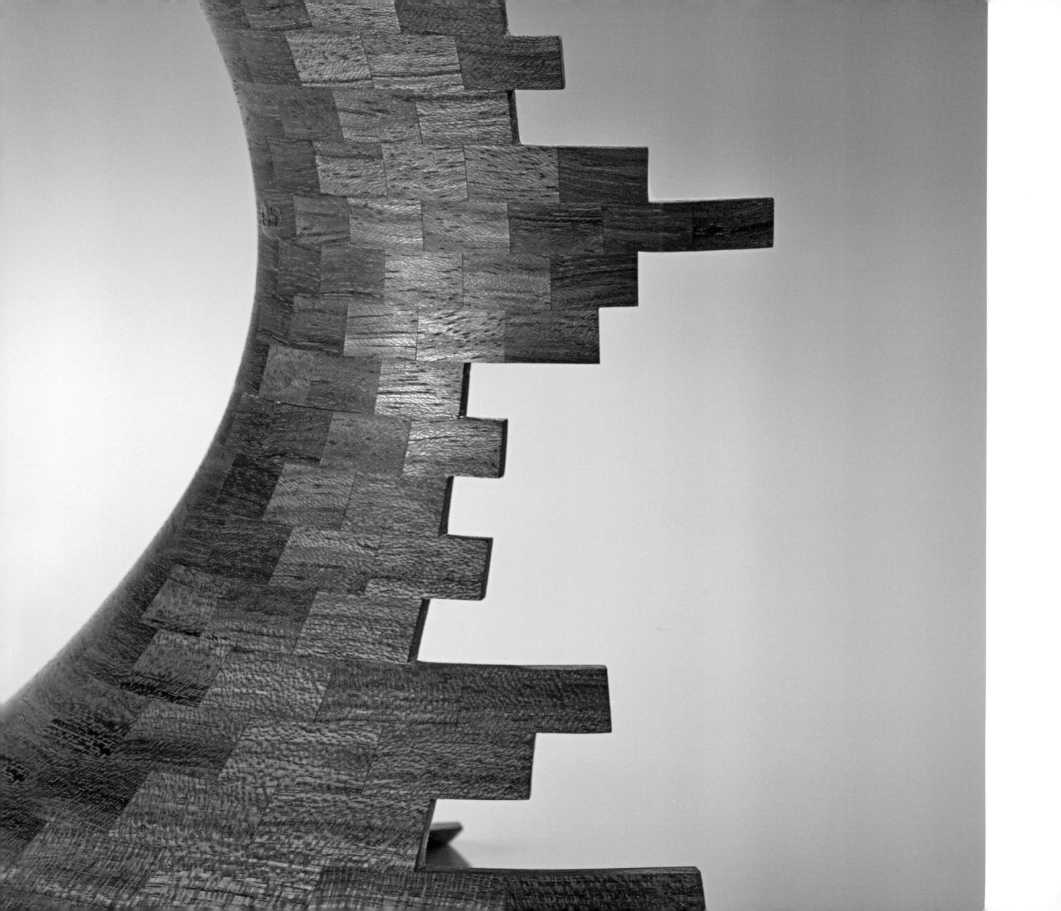

Bob "Bud" Latven

American, born in 1949

Falling into the field of wood turning by chance, Bob (or Bud) Latven's work reinvents the old technique of segmented turning. Traditionally, turners have used segmented turning—a process of laminating different-colored wood segments prior to turning—to produce patterned bowls with geometric designs. In an effort to break free from the constraints of the vessel form, Latven began opening the bottom and removing individual segmented sections of his sculptural forms. At first, the removal of sections began as the initial step in an interspersal of contrasting woods. "Over time, these contrasting sections became more and more pervasive in the forms," Latven explains, "until I realized that the darker contrasting sections were really an attempt to create visual voids. It was at this time that I started carving out sections creating contrasting voids or negative spaces in my forms."[84] *Hyperboloid Fragment* is representative of Latven's use of hyperboloid and parabolic forms to create a sense of motion. Latven skillfully manipulates the extension and voids to integrate the form into itself.

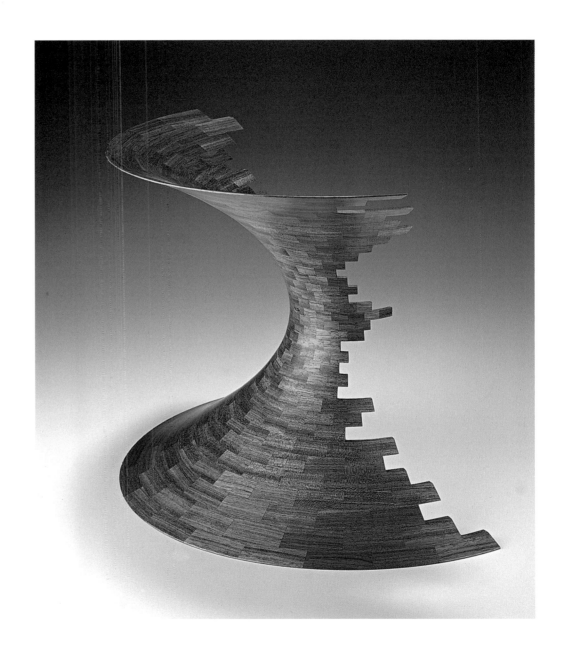

Hyperboloid Fragment in Bubinga
Tajique, New Mexico, 1997
Laminated and turned African bubinga
H. 40.6 cm, w. 30.5 cm, d. 22.9 cm
(H. 16 in., w. 12 in., d. 9 in.)

Bob "Bud" Latven

American, born in 1949

Falling into the field of wood turning by chance, Bob (or Bud) Latven's work reinvents the old technique of segmented turning. Traditionally, turners have used segmented turning—a process of laminating different-colored wood segments prior to turning—to produce patterned bowls with geometric designs. In an effort to break free from the constraints of the vessel form, Latven began opening the bottom and removing individual segmented sections of his sculptural forms. At first, the removal of sections began as the initial step in an interspersal of contrasting woods. "Over time, these contrasting sections became more and more pervasive in the forms," Latven explains, "until I realized that the darker contrasting sections were really an attempt to create visual voids. It was at this time that I started carving out sections creating contrasting voids or negative spaces in my forms."[84] *Hyperboloid Fragment* is representative of Latven's use of hyperboloid and parabolic forms to create a sense of motion. Latven skillfully manipulates the extension and voids to integrate the form into itself.

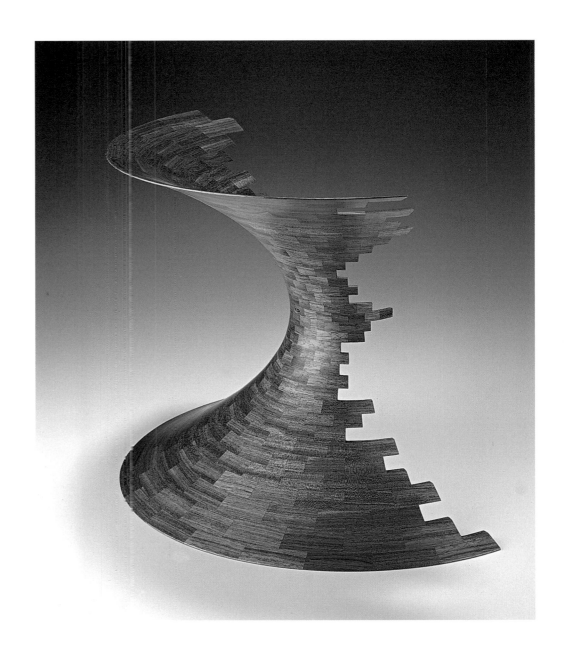

Hyperboloid Fragment in Bubinga
Tajique, New Mexico, 1997
Laminated and turned African bubinga
H. 40.6 cm, w. 30.5 cm, d. 22.9 cm
(H. 16 in., w. 12 in., d. 9 in.)

Malcolm Martin
Gaynor Dowling

English, born in 1959 and 1965

Pushing the boundaries between two and three dimensions, the artistic team of Malcolm Martin and Gaynor Dowling creates sculptural wooden forms that allude to vessels but are strongly frontal and flat. The partnership works primarily in oak or lime wood, hand carved with traditional tools before the surface is altered by scorching, liming, or coloring. In this piece, the complex shallow relief of the carving articulates the way light falls over the surface, enhancing its frontal quality. While staunchly insisting that their work is nonfunctional, Martin and Dowling admit they take inspiration from "real world" forms, "'re-seeing' the tradition of the figure in sculpture, whether it be ancient, medieval or modernist, revisioned through our own formal language."[85]

Untitled
Stroud, England, 2001
Carved and charred oak
H. 137.2 cm, w. 41.9 cm, d. 7 cm
(H. 54 in., w. 16½ in., d. 2¾ in.)

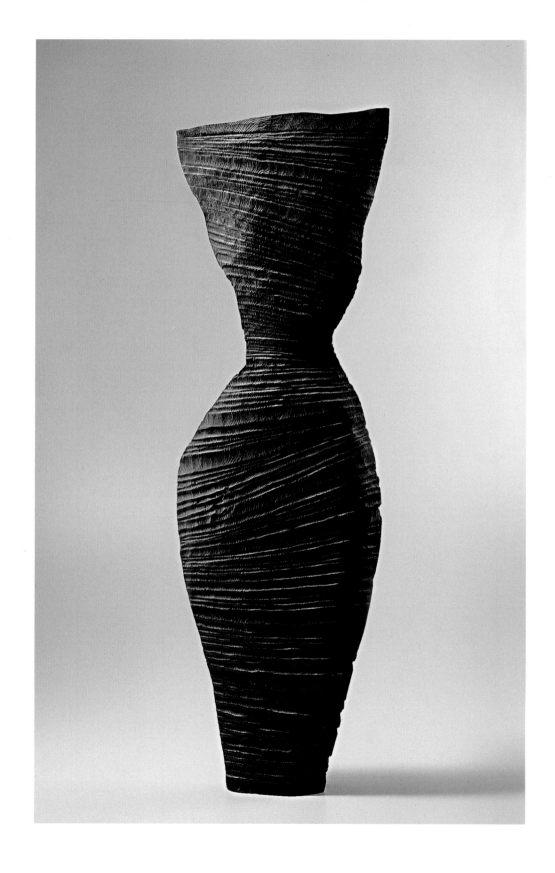

Robyn Horn

American, born in 1951

Surrounded
Little Rock, Arkansas, 2006
Redwood burl
H. 62.2 cm, w. 50.8 cm, d. 25.4 cm
(H. 24½ in., w. 20 in., d. 10 in.)

During the past twenty-five years, Robyn Horn of Arkansas has become one of the nation's leading artists in wood. Influenced by sculptors such as Isamu Noguchi and Barbara Hepworth, she has created a body of work characterized, in its various manifestations over time, by her ability to transmute wood into stone shapes.

Surrounded, an example of her Slipping Stones series, is fashioned from a single large redwood burl, which she cut, sanded, textured, and otherwise manipulated to form the impression that the object is assembled from a number of small pieces.[86] The resulting work expresses an enormous sense of movement, as the assemblage of faux blocks swirls around jagged, irregular voids. The faceted, chiseled exterior surfaces enhance the object's aerodynamic appearance, contributing to the suggestion of stone blocks caught in the vortex of a massive, hurricane-like whirlwind.

Horn, a significant collector and donor in her own right, was also the founder and first president of the Collectors of Wood Art in 1997.[87]

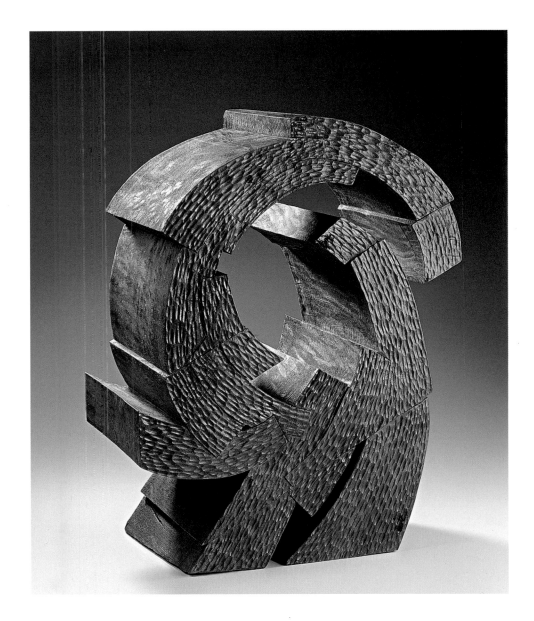

79

Michael Bauermeister

American, born in 1957

Michael Bauermeister attended the Minneapolis College of Art and Design, and then studied sculpture at the Kansas City Art Institute. Since 1986 he has operated Nona Woodworks in Augusta, Missouri. Known for his wooden vessels, he explains that he chose this medium "for my sculptural ideas because I find it to be a comfortable place for both the viewer and myself to start. From here I can explore the issues of form, texture, scale and color, all in the natural beauty of wood."[88]

The Wornick Collection example is a tall, vase-like vessel with a pronounced faceted surface enriched with scored swirling lines that encircle the base and trail upward. Majestic in its own right, *Calm after the Storm* is imbued with deep emotional meaning for the artist:

> This piece is my reflection on the flood of 1993. . . .
> The flood filled my studio with over 3 feet of water which stayed around for almost a month. My wood storage shed was under 8 feet of water. Most of my tools and materials were submerged. When the water went down everything was covered with mud and debris was strewn in chaotic patterns everywhere I looked. When the mud dried it formed a beautiful cracked pattern. I started to see beauty in the patterns of debris too. These are the textures you see on the piece. How is it possible that with all the pain and increasing suffering and chaos in the world that there can still be such beauty?[89]

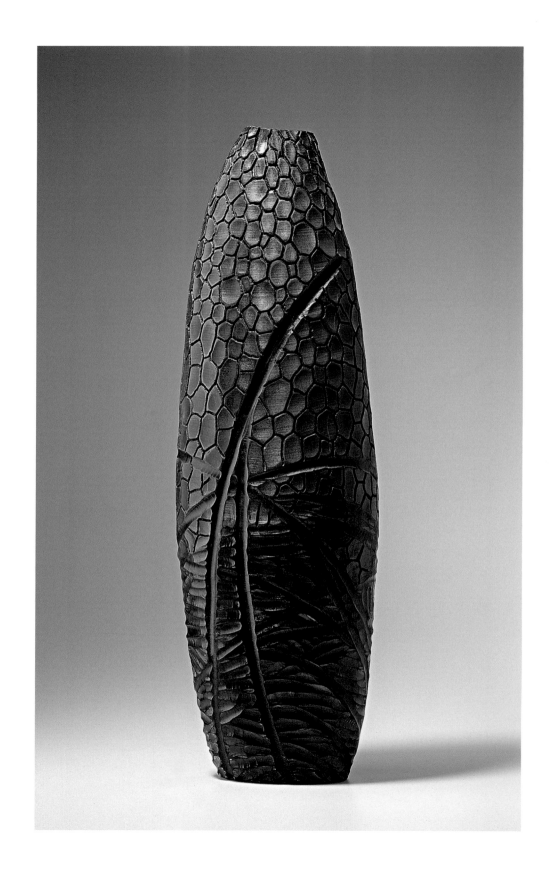

Calm after the Storm
Augusta, Missouri, 2005
Stained linden
H. 77.5 cm, w. 24.1 cm, d. 15.2 cm
(H. 30½ in., w. 9½ in., d. 6 in.)

Thierry Martenon

French, born in 1967

20072005
Grenoble, France, 2005
Maple, slate
H. 69.9 cm, w. 43.2 cm, d. 11.4 cm
(H. 27½ in., w. 17 in., d. 4½ in.)

Trained as a cabinetmaker, Thierry Martenon started to work in wood turning in his early thirties. Part of his decision to work in this medium came from the experience of seeing the work of Jean-François Escoulen (see p. 156). To develop his skills, he studied with Betty Scarpino, Mark Sfirri, Michael Hosaluk (see p. 167), Terry Martin, Alain Mailland, Philippe Bourgeat, and others. Today he is recognized as one of France's leading wood artists, working out of his shop in his small home town of Le Desert.

Thierry works in a wide variety of forms and shapes, generally elemental in nature, like the crescent shape seen in this work. He often uses texturing, scorching, and other surface treatments to enliven the object. As in the Wornick Collection example, fashioned of maple and slate, Martenon often mixes unexpected materials in his work. Here the dark center section of slate, with its "grain" running horizontally, stands in contrast to the whitish maple whose ridged surface moves in a circular fashion around the core.[90]

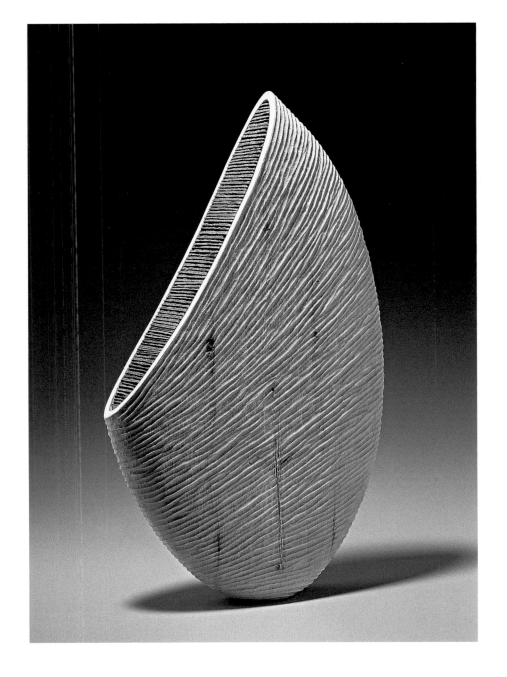

Donald Fortescue

Australian, born in 1957

PIP
San Francisco, California, 2002
Finnish birch plywood
H. 106.7 cm, w. 121.9 cm, d. 15.2 cm
(H. 42 in., w. 48 in., d. 6 in.)

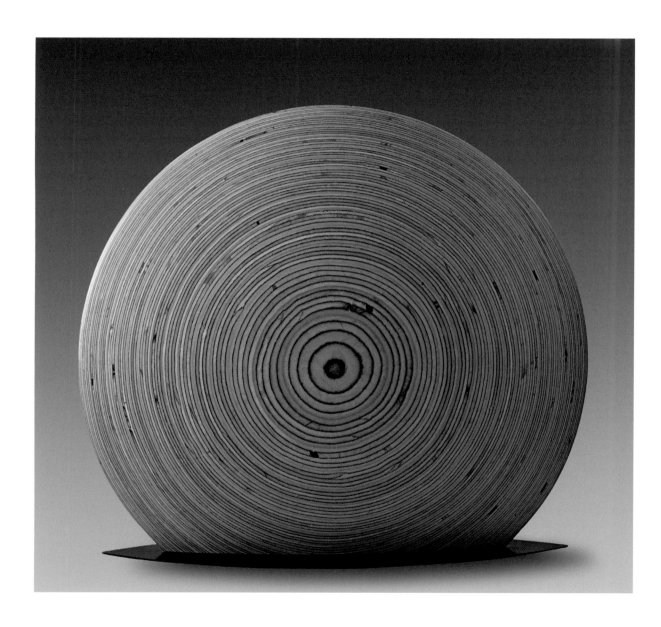

Donald Fortescue began his career as a furniture designer in his native Australia before turning to sculpture. The former head of furniture design at Adelaide's Jam Factory, Fortescue claims his work became increasingly more sculptural and he began to abandon traditional furniture forms as he worked toward a master's degree in sculpture at the University of Wollongong.

In his sculptural work, Fortescue interweaves his technical mastery of wood with his design sensibilities to create powerful forms that bridge the so-called divide between fine art and craft. For *PIP*, Fortescue stacked and laminated sheets of plywood before hand-shaping and smoothing them into a large round disk that stands on end. The surface slopes toward the outer edge, revealing each layer of plywood as irregular, concentric rings. The overall effect recalls the annual growth rings of the timber, thus reminding the viewer of the materiality of wood and the passage of time.

David Nash

British, born in 1945

British artist David Nash goes beyond being inspired by nature—he collaborates with it. Nash is probably best known for his living sculpture, planting and manipulating live trees into an artistic and ever-changing choreography. Attempting to create a discourse between art and nature, Nash also uses naturally fallen wood to extend and refer to nature and the environment. Using a chain saw and blowtorch, Nash violently slashes and chars the wood, creating elegantly minimalist sculptures that respond to the time, space, and circumstance of the tree's existence. Once completed, Nash allows the unfinished wood to take over in the artistic process, cracking and warping as it dries. In *Downpour*, Nash slits the log's surface to suggest the blurry torrent of Mother Nature.

Downpour
Blaenau Ffestiniog, North Wales, 2004
Cut and charred limewood
H. 223.5 cm, w. 63 5 cm, d. 33 cm
(H. 88 in., w. 25 in., d. 13 in.)

Arlie Regier
American, born in 1931

A sculptor for more than thirty years, Arlie Regier takes inspiration from the unknown. His work revolves around themes of space exploration, technology, miniaturization, and passage. Working in every size and shape of stainless steel he can find, Regier composes arrangements contrasting heavy and delicate elements: "Long pieces of standard stainless steel flat bar, square, round, angle, rectangular tubing, round tubing, square tubing, hex, sheet, plate, and pipe are purchased and stored for use in designs."[91] His process is additive, welding pieces together, rather than the subtractive method of carving. His sculptures range from the small, table-top size to large installations up to fifteen feet high. In *Hemisphere,* Regier has fashioned one thousand pieces of steel into one of his favorite shapes to evoke the modern mystery of technology.

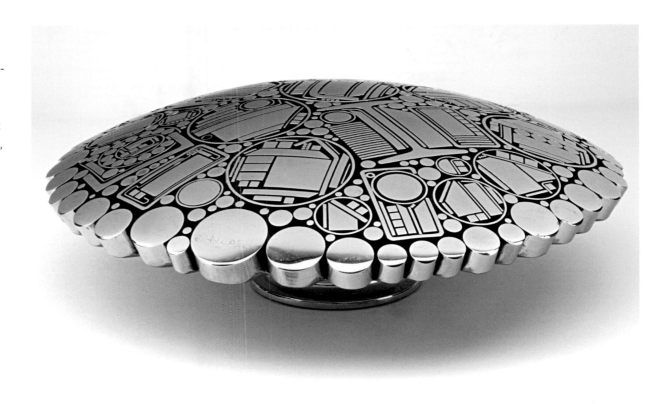

Hemisphere
Overland Park, Kansas, about 1996
Stainless steel
H. 14 cm, w. 41.9 cm, d. 41.9 cm
(H. 5½ in, w. 16½ in., d. 16½ in.)

Brad Silberberg

American, born in 1953

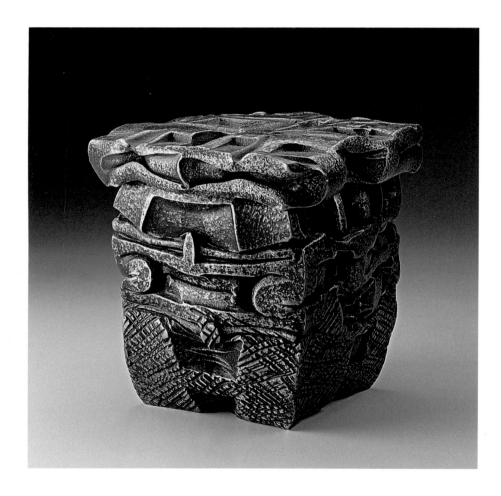

Inspired by ceramic pinch pots, Brad Silberberg wanted to create a similar technique for metalwork. Starting with a cube of heated steel, he began pushing shaped tools into the blocks to create "squashed containers" reminiscent of ancient relics. "The surface markings are a visual vocabulary I have developed," explains the artist. "They not only decorate but also directly shape the metal."[92] Lids are made by first decorating the surface with stamping tools, then reheating and pressing into an unheated container to create a snug fit. In *Container for Odd Methods,* the dichotomy between the rounded patterns and the hard surface reflects Silberberg's fascination with the material, which is malleable when hot but unyielding when cold.

Container for Odd Methods
Burgettstown, Pennsylvania, 1995
Forged and pressed steel with sanded black oxide finish
H. 15.2 cm, w. 14 cm, d. 14 cm
(H. 6 in., w. 5½ in., d. 5½ in.)

Tom Joyce

American, born in 1956

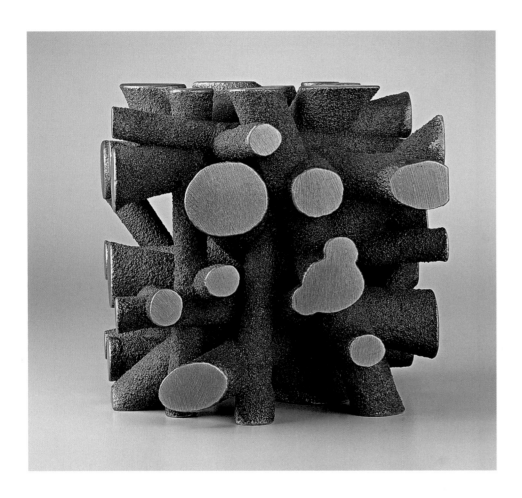

Tom Joyce, essentially self-trained as a blacksmith, has operated a studio in Santa Fe, New Mexico, since 1978.[93] The creativity and quality of his work were recognized in 2003 by his receipt of a five-year fellowship from the John D. and Catherine T. MacArthur Foundation.

Joyce's work varies dramatically in size, from small objects such as *Inside Out* to large-scale architectural commissions. Each, however, demonstrates his facility with working and utilizing the inherent characteristics of iron, his chosen material. *Inside Out* is a small, dense mass of interconnected and interpenetrating shafts of metal, resembling tree branches or twigs, sharply cut and smoothed on the ends and textured like bark on their sides.

Inside Out
Santa Fe, New Mexico, 2003
Cast iron
H. 15.2 cm, w. 15.2 cm, d. 15.2 cm
(H. 6 in., w. 6 in., d. 6 in.)

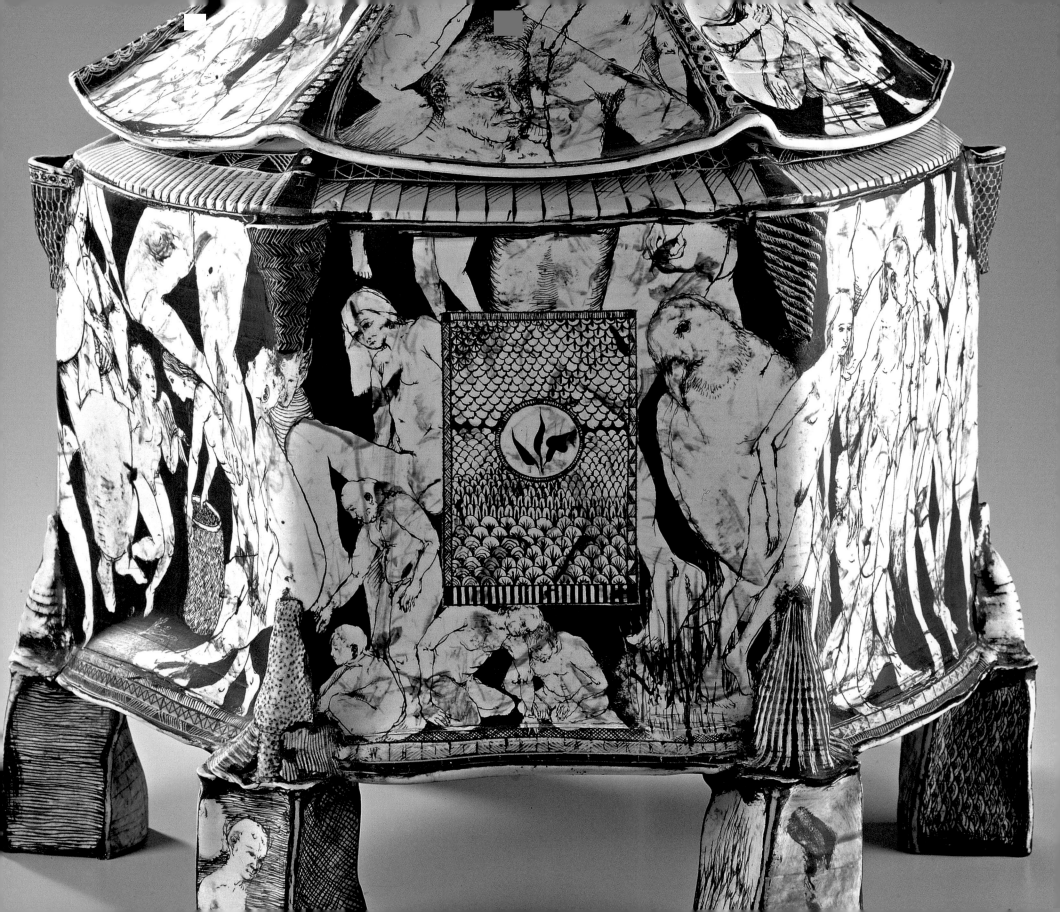

CEREMONY ▪ NARRATIVE

Sergei Isupov

Russian, born in 1963

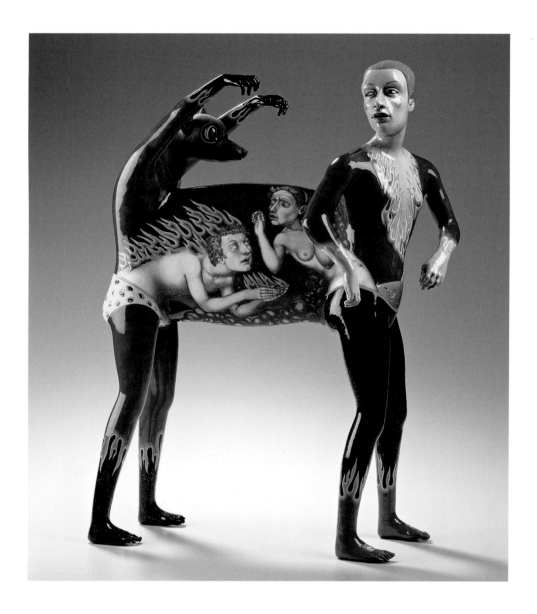

Russian-born ceramist Sergei Isupov's work seems to writhe with meaning just as the figures themselves writhe, twist, and at times explode from the surface. Crammed with imagery, the pieces seem to speak a personal narrative. In fact, they do not. Rather, Isupov purposely crowds his surreal figures so as to allow for multiple readings. Trained as a painter, Isupov masterfully employs a painterly sensibility to his work. His images often violate the surface, breaking free from their planar facade into three-dimensionality, as in *Passions Rise.* The often sexually charged and disturbing images both repel and seduce the viewer. As if seeing a gruesome car accident, we are horrified but still cannot look away. Understanding this humanistic duality, Isupov masterfully manipulates the viewer as he does his clay.

In *Passions Rise,* Isupov creates a two-headed creature—half human, half beast—on which he paints a couple in the midst of a heated fight. The aggressive arm gestures of the beast (which emerges from the man's legs) parallel the arm positions of the painted female as she rises above the male, who is cowering and in flames. In *Fault* (p. 92), Isupov depicts two heads in a touching exchange. The opposite side illustrates a female on roller skates, holding a tray. The juxtaposition of such disparate images exemplifies Isupov's suggested narratives that are open to interpretation.

Passions Rise
Richmond, Virginia, 2004
Hand-built porcelain
H. 55.9 cm, w. 40.6 cm, d. 16.5 cm
(H. 22 in., w. 16 in., d. 6½ in.)

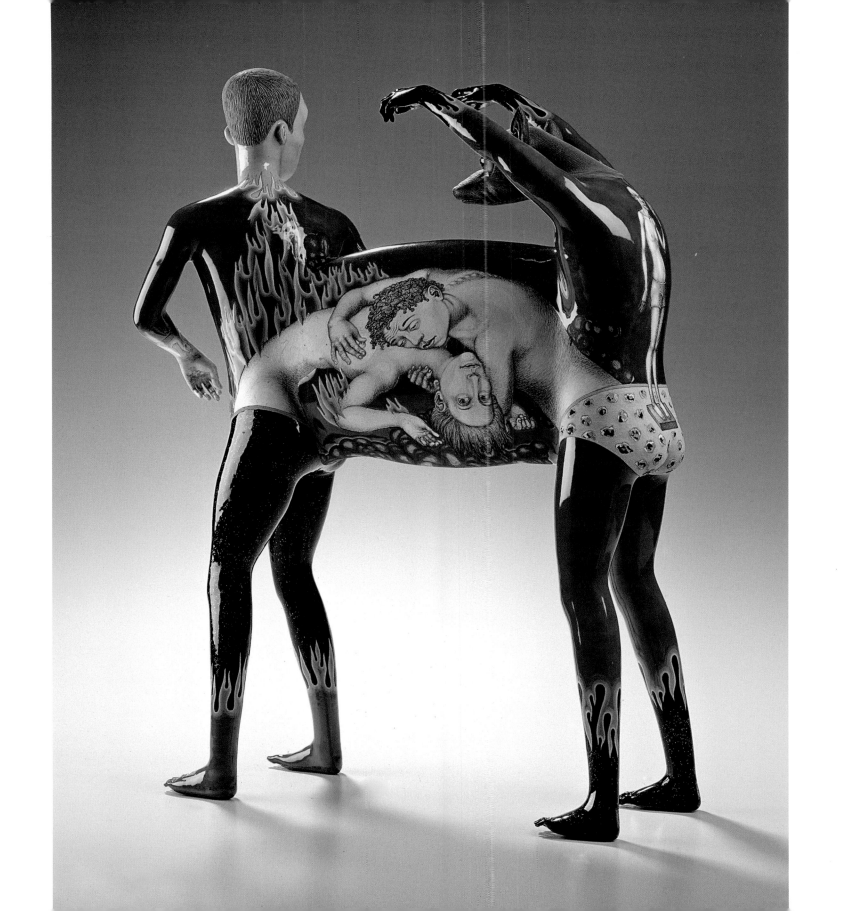

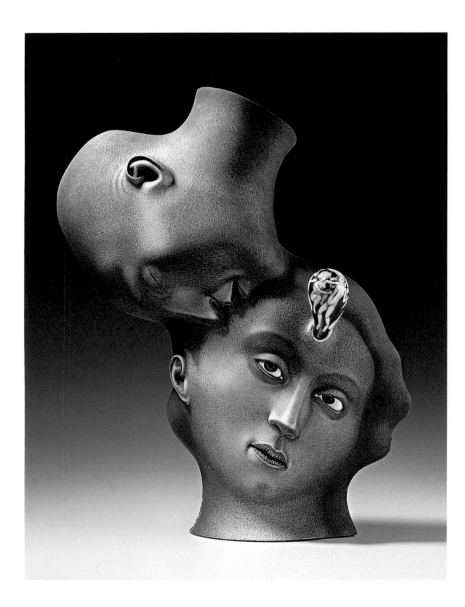

Sergei Isupov
Fault
Richmond, Virginia, 2005
Hand-built porcelain
H. 43.2 cm, w. 35.6 cm, d. 14 cm
(H. 17 in., w. 14 in., d. 5½ in.)

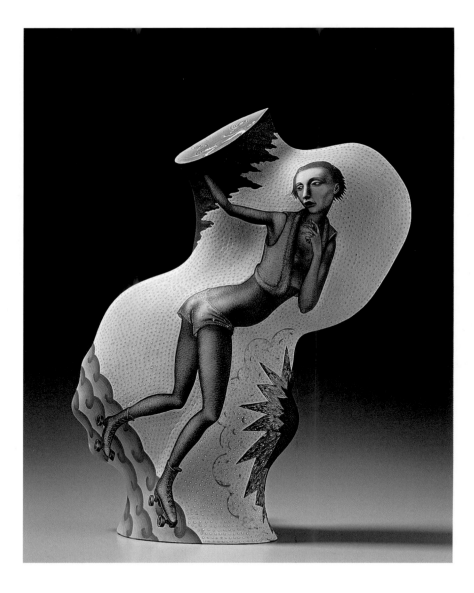

Stanislaw Borowski

Polish, born in France in 1944

Chaise Lounge II
Boleslawiec, Poland, 2001
Blown, hot-worked, assembled, and engraved glass
H. 20.3 cm, w. 29.2 cm, d. 17.1 cm
(H. 8 in., w. 11½ in., d. 6¾ in.)

Born in Moutiers, France, Stanislaw Borowski grew up in Poland. He started work in 1965 for the Krosno Glass Factory, and for ten years developed his skills in all aspects of glassmaking, design, and engraving. After becoming an independent glass artist in 1975, he moved to Germany in 1982 and opened a new studio in Poland in 1992. In 1990 Borowski and his sons, Pawel and Wiktor, formed a new enterprise entitled Glass Studio Borowski, creating a production collection of fanciful and colorful objects. In the mid-1990s, they expanded their line of products to include various lighting forms.

As the senior member of the firm, Stanislaw continues to create studio glass. This example of his work features a blue-and-gold-striped fanciful seating feature, with scrolled legs and vertical posts, which resemble a classical term with the bearded heads atop. An enigmatic, bawdy genre scene is engraved between the posts, which comes to life when lit from behind.

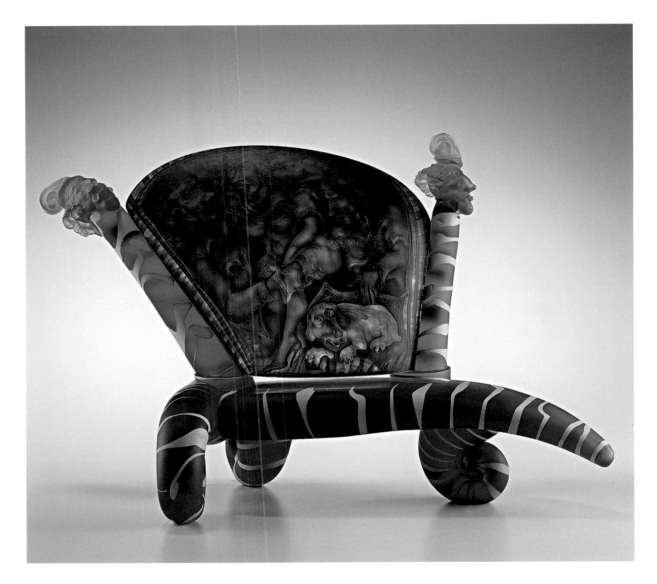

Michael Gross

American, born in 1953

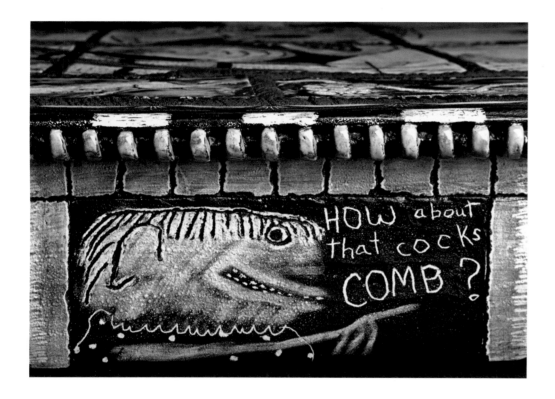

Michael Gross creates vessels and tables using both flat and relief ceramic tiles. His childlike and horrific imagery depicts a view of the world worthy of Hieronymus Bosch. "Images are vocabulary to me," explains Gross, who draws from the experiences of his life and surroundings. "I'm just reacting to the society around me."[94]

In this large, low table, commissioned by the Wornicks in 1997, Gross reacts to the life of Ron Wornick and his love of wood and collecting. Taking artistic liberties, Gross humorously depicts "Mr. Whipple" as he immigrates to America (Ron Wornick's father was a Russian-speaking immigrant in 1918), raises a family, turns wood, and looks for his "cock's comb," a reference to the David Groth piece (p. 114) that began the Wornicks' collection of wood art.

Table
Mont Horeb, Wisconsin, 1997
Ceramic on wood
H. 40.6 cm, w. 142.2 cm, d. 142.2 cm
(H. 16 in., w. 56 in., d. 56 in.)

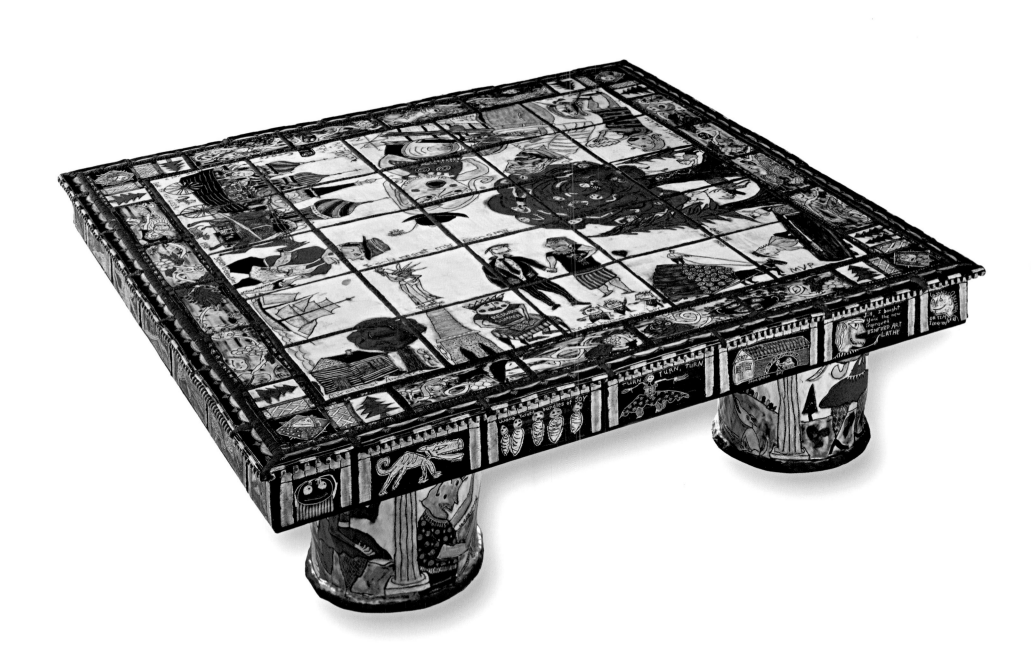

John Garrett

American, born in 1950

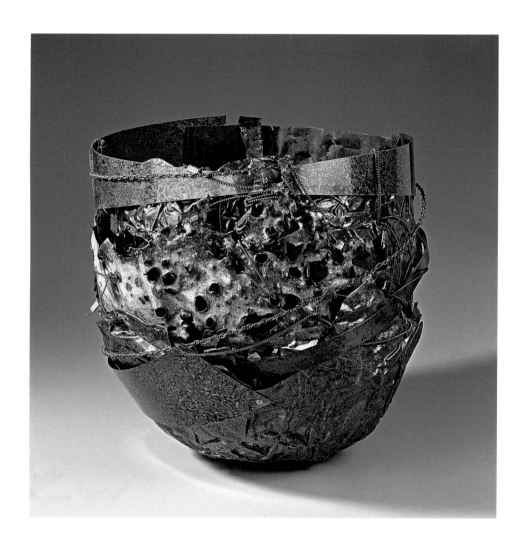

Working in both two and three dimensions, contemporary weaver John Garrett often uses found and recycled materials to create unique wall hangings and vessels. Considered a pioneer in the development of "new basketry," Garrett sees his vessels as "an intimate object for both maker and viewer."[95]

In 2005 the Contemporary Jewish Museum in San Francisco commissioned Garrett and some eighty other artists to reinterpret the traditional spice box *(besamim)* passed among worshipers at the end of the Sabbath. Marking the end of the holy day, the ritual allows the delicate scent's memory to linger. In *Between and Among,* the softness of the vessel's rounded form balances the hard, jagged surface and durability of the metal. The rough armor both literally and metaphorically protects the delicate items within. Though the spices can fit neatly in a gilt oval reserve in the center of the vessel, Garrett's container is much larger than traditional spice boxes. It is instead a sculptural monument to the Jewish ritual.

Between and Among (Spice Box)
Albuquerque, New Mexico, 2005
Various metals, concrete, organic materials
H. 38.1 cm, w. 40.6 cm, d. 40.6 cm
(H. 15 in., w. 16 in., d. 16 in.)

Mike "Chai" Scott

British, born in 1943

Considered a pioneer in the method of freestyle turning, woodworker Mike "Chai" Scott takes an intuitive approach to his art. Never working from a preconceived design, Scott instead spontaneously responds to existing moods and feelings within himself, as well as the unique external qualities of each cut of wood. As each piece evolves, Scott looks for emerging themes. In *Chai*, Scott blackens and mars the outer rim of the large vessel to offset the highly polished figure of the burl. This framing effect contributes to the ceremonial quality of the piece, transforming the wood into a precious artifact. The title parallels the name given to Scott by an Indian guru, the name he uses to sign his work: "Chai," a shortened Sanskrit word meaning "awareness" or "consciousness." By giving the piece such a name, Scott both draws awareness to the wood and aligns himself with it. In a Zen-like way, the man and his material are one.

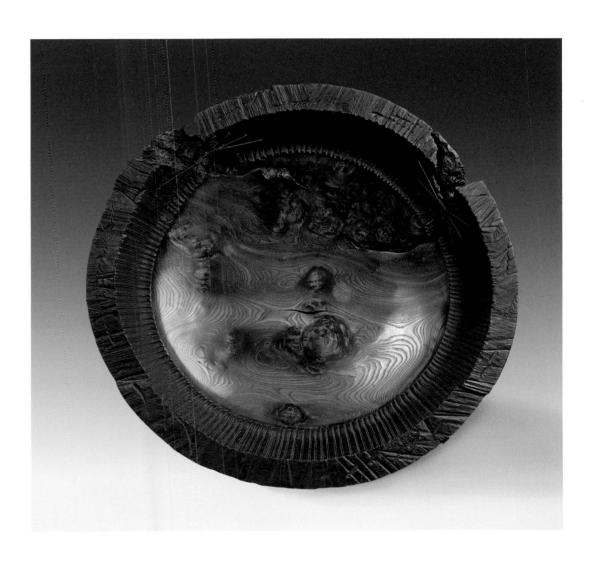

Chai
Llandeusant, Holyhead, Anglesey, Wales, 1990
Turned and carved elm burl, leather
H. 88.3 cm, w. 94.3 cm, d. 20.3 cm
(H. 34¾ in., w. 37⅛ in., d. 8 in.)

Todd Hoyer
American, born in 1952

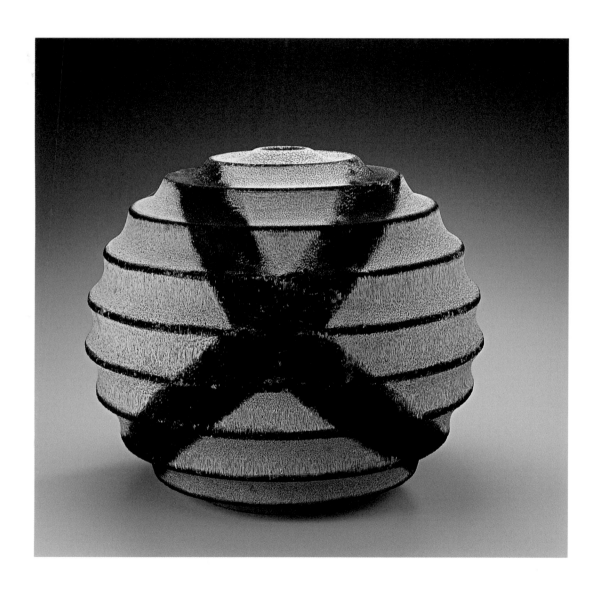

The art of Todd Hoyer reaches beyond mere technical ability, of which the artist is indeed a master, and into the realm of deep emotional meaning. The theme of Hoyer's work is change and growth; each piece is a reflection of the artist's life and personal experience. "After I learned the techniques of turning, I started to trust my intuition and explore the emotional responses of form and texture which related directly to my life situations at the time," explains the artist.[96] Using specific imagery to evoke meaning—weathered surfaces to represent aging, for example—Hoyer therapeutically works through life's trauma and pain. In Hoyer's X series, of which *Untitled* is a part, the artist struggles to overcome "anger, frustration and the sense of helplessness when caught in struggles beyond one's control."[97]

Untitled
Bisbee, Arizona, 1990
Turned and burned palm
H. 34.6 cm, w. 41 cm, d. 41 cm
(H. 13⅝ in., w. 16⅛ in., d. 16⅛ in.)

Peeling Orb
Bisbee, Arizona, 1987
Turned mesquite
H. 37.5 cm, w. 33.7 cm, d. 20.3 cm
(H. 14¾ in., w. 13¼ in., d. 8 in.)

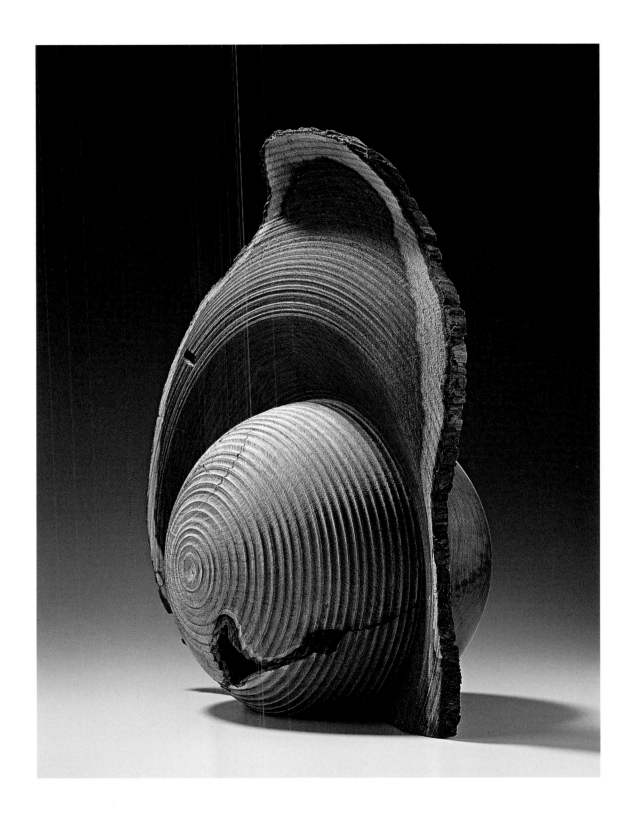

William Moore

American, born in 1945

Persepolis
Hillsboro, Oregon, 1997
Turned myrtlewood burl, black walnut, koa wood
H. 96.5 cm, w. 119.4 cm, d. 91.4 cm
(H. 38 in., w. 47 in., d. 36 in.)

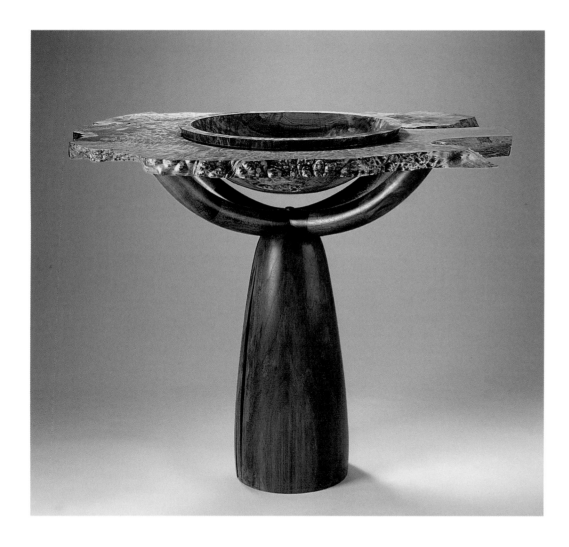

Sculptor William Moore considers himself a modernist, inspired by masters such as Jean Arp and Gaston Lachaise. A third-generation woodworker, Moore learned turning under the watchful eye of his mother, whom he describes as an avid hobbyist. In 1979 Moore began creating shrinelike vessel sculptures, and he has focused on the "silent power" of the vessel form ever since. "I want my vessels to have a ceremonial presence and carry an aura of an undefined but uncommon purpose," explains Moore.[98] In *Persepolis*, named after an ancient Persian ceremonial city, Moore uses Northwest myrtlewood to express the power of ritual. Moore prefers to use native Northwest woods for environmental reasons, but he does occasionally employ exotic woods, like Hawaiian koa.

John McQueen

American, born in 1943

John McQueen entered the craft spotlight as a pioneer in the contemporary basket movement, helping to transform the traditionally utilitarian vessel into a conceptual work of art. Aligning himself with basket makers, McQueen rejected sculpture, finding the preconceptions of the fine arts too constrictive. Instead, the artist sought to redefine the concept of containment: "This room is a container. I am a container. The earth is being contained by its atmosphere," he explained.[99] In the last decade of the twentieth century, however, McQueen's work took on a decidedly sculptural, figural component. Expanding on the theme of the body as container, McQueen constructed human and animal figures from willow twigs held together with plastic bundle ties, thus suggesting a metaphoric link between man and nature. In *Mire*, McQueen's figure stands forlornly in a pile of loose twigs as if melting into the earth as the title suggests.

Mire
Saratoga Springs, New York, 1999
Willow with bundle ties
H. figure 160 cm, w. 45.7 cm, d. 27.9 cm
(H. figure 63 in., w. 18 in., d. 11 in.)
H. base 17.8 cm, w. 91.4 cm, d. 27.9 cm
(H. base 7 in., w. 36 in., d. 24 in. [approximate])

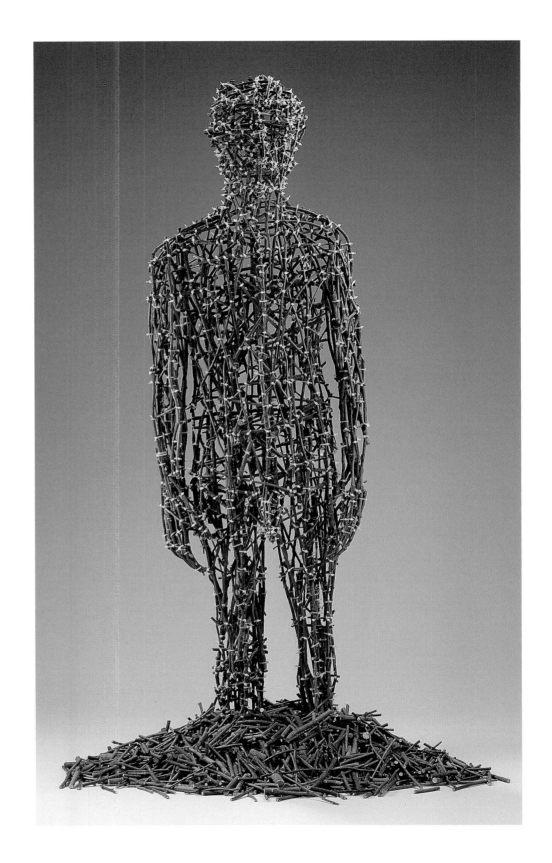

Peter Pierobon

Canadian, born in 1957

Since the early 1990s, Peter Pierobon has incorporated obscure writing systems in his furniture, exploiting the narrative and graphic qualities of written symbols. In his earlier works, he inscribed the surfaces of his furniture with cryptic devices, such as Nordic runes, or the nearly forgotten stenographer's code known as Gregg short-hand. As he developed his idea, the written symbols became increasingly integrated into the form of the objects—first as sculptural metal hardware, and then carved in relief on the surface of the wood. In his most recent works, including this example, the form of the table itself is intended to represent abstract calligraphy; the gestural linear elements supporting the tabletop resemble large-scale ink brushstrokes or charcoal marks.[100] To convey this concept and focus attention on the table's form, Pierobon concealed the mahogany from which the table was made with an ink-black ebonized surface. The sculptural elements of the base pierce the plane of the tabletop, yet enough of the flat surface remains to allow the table to serve as a functional object as well as a work of sculpture.

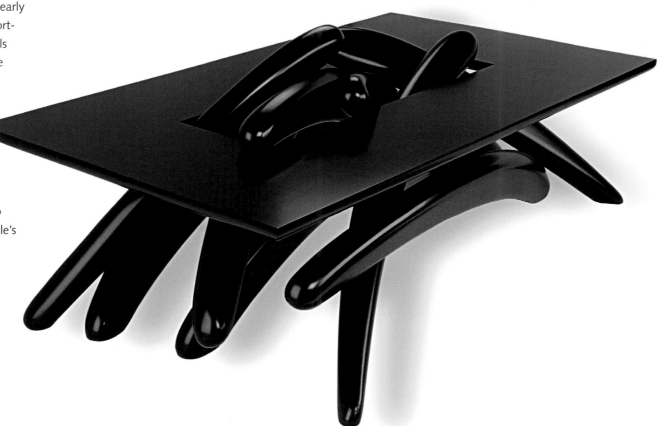

Coffee Table
North Vancouver, British Columbia, 2002
Ebonized mahogany with clear lacquer finish
H. 50.8 cm, w. 152.4 cm, d. 99.1 cm
(H. 20 in., w. 60 in., d. 39 in.)

Tommy Simpson

American, born in 1939

Tommy Simpson's colorful, playful, humorous, and enriching furniture has stood as the epitome of the "freewheeling" spirit of studio furniture makers since the 1960s.[101] Commissioned by the Wornicks for their library in May 1991, this ladder was finished and ready to be shipped by Simpson's Toastietoes Workshop in December of that year.

The Story Ladder tells a rich, humorous, and occasionally enigmatic tale related to the Wornick family, their work in the food business, and their background in woodworking. (It is perhaps a reflection on Simpson's playfulness that even the Wornicks admit they are not entirely sure of the meaning of each and every symbol on the piece.)

The bottom rungs reflect, as Simpson noted, "the Foundation you stand on . . . of the past," with a ruler, hand clasping a nail, hammer (stamped "WORNICK"), and saw. The center rungs reference "the Harvest—the fruits and the bones from the work & construction of the past," with their plate and flatware, and encapsulated "bone." The upper rungs, including a large screw, are "a smile in the sky."[102]

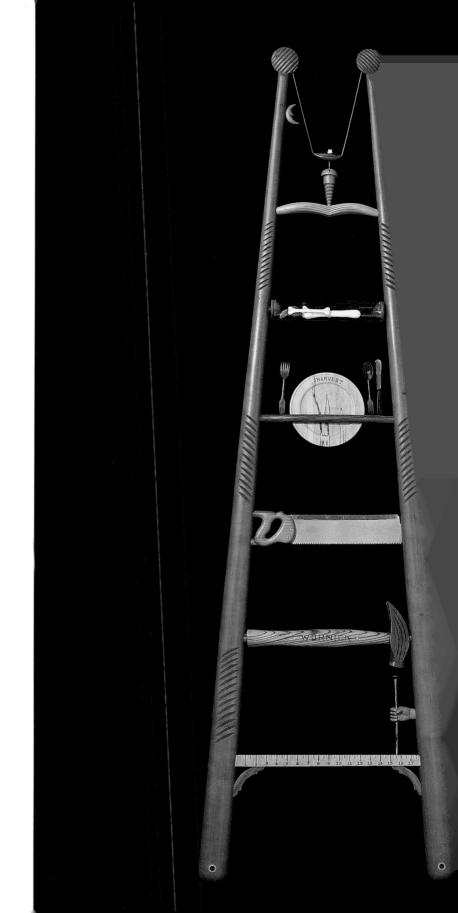

The Story Ladder
Washington, Connecticut, 1991
Wood, mixed media
H. 213.4 cm, w. 63.5 cm, d. 5.1 cm
(H. 84 in., w. 25 in., d. 2 in.)

Judy Kensley McKie

American, born in 1944

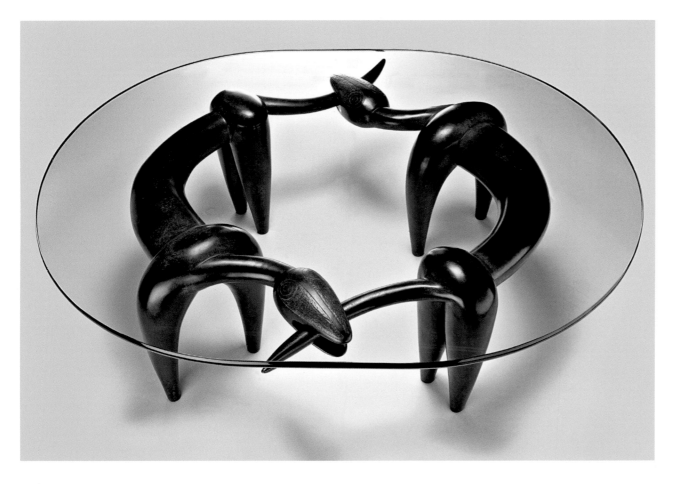

Well known for her carved and painted wood furniture, Judy Kensley McKie began making editions in bronze in the late 1980s when encouraged to do so by a friend, prominent West Coast furniture artist Garry Knox Bennett.[103] McKie trained as a painter at the Rhode Island School of Design, but soon found greater satisfaction in working as a self-taught furniture maker. Inspired by Native American, pre-Columbian, African, Greek, and Egyptian art, she began to incorporate stylized plants and animals in carved low-relief designs. As her carving skills developed, she progressed to sculpting structural members in the form of snakes, dogs, leopards, and some intentionally ambiguous animal forms, like those in the base of this table.[104] By casting these forms in bronze, McKie makes a stronger connection between her furniture and traditional sculpture, at the same time preserving the lively, energetic, and "animated" quality of her designs.

Chase Table
Cambridge, Massachusetts, 1989
Bronze, glass
H. 40.6 cm, w. 121.9 cm, d. 96.5 cm
(H. 16 in., w. 48 in., d. 38 in.)

David Secrest

American, born in 1953

Valley Fault
Somers, Montana, 1999
Bronze, steel
H. 40.6 cm, w. 139.7 cm, d. 43.2 cm
(H. 16 in., w. 55 in., d. 17 in.)
H. 40.6 cm, w. 139.7 cm, d. 43.2 cm
(H. 16 in., w. 55 in., d. 17 in.)

Understanding how textures influence viewer perception, David Secrest strives for new and better methods of manipulating metals to produce different surfaces and structures. Citing material as his mentor, he developed a process named *pâte de fer*, which uses iron filings with other scrap metals fused and acid treated to create an unevenly worn surface texture.[105] In his *Valley Fault*, a clever conceit of the Napa Valley, Secrest first fused plates of steel and bronze before rolling them together and slicing jellyroll-like segments to produce repetitive marquetry patterns across the table's surface. The dynamic interplay of light, texture, and structure tells the story of the fault line destroying the agrarian landscape. Displayed in the Wornicks' living room overlooking the Napa Valley, *Valley Fault* is a whimsical reminder of the fragility of the landscape.

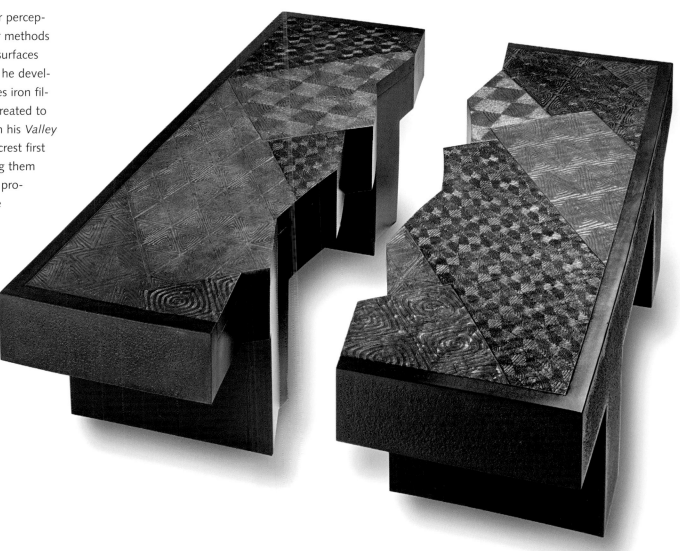

Edward Eberle

American, born in 1944

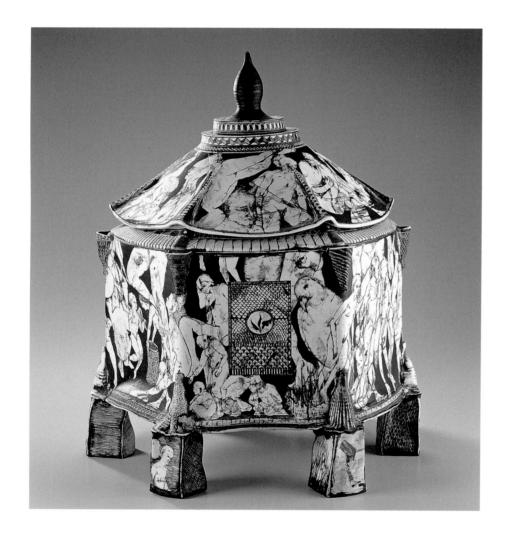

The porcelain vessels of Edward Eberle possess both a timelessness and a modernity that transcend categorization. His forms range from classic pots to lidded architectonic vessels on whose surfaces he paints stream-of-consciousness figures in black *terra sigillata*. The technique of using *terra sigillata* dates from the ancient Greeks, who used this fine, colored slip to decorate their ceramic ware. Unlike the Greeks, however, Eberle limits his palette to black and gray and applies it on white porcelain to create a stark contrast reminiscent of Chinese ink drawings. Eberle's drawings are almost always unplanned, applied in a painterly fashion, filling the surface. While they seem to suggest a narrative, Eberle insists they are not intentionally so but rather are archetypal renderings of the collective unconscious.[106]

White Blackbird #9724
Pittsburgh, Pennsylvania, 1997
Wheel-thrown and hand-altered porcelain
H. 45.7 cm, w. 38.1 cm, d. 38.1 cm
(H. 12 in., w. 21 in., d. 10 in.)

Marcus Tatton

New Zealander, born in 1963

Shard
Neika, Tasmania, Australia, 1995
Carved myrtlewood with gold leaf and pigment
H. 44.5 cm, w. 29.8 cm, d. 19.1 cm
(H. 17½ in., w. 11¾ in., d. 7½ in.)

Mining the barren fields of clear-cut timberland, Marcus Tatton unearths nuggets of limbs and trunks left behind in the wake of forestry devastation. Although considered scrap by the loggers, these pieces of wooden ore are like gold to Tatton. Wielding a chain saw, the artist roughs out a shape on-site before taking the piece back to his studio for further work. Tatton typically chooses classical vessel forms like amphorae and oenochoes, on which he sculpts intricate carvings. In *Shard*, Tatton refers to broken elements of ancient pottery that depict images of daily life. Instead of an ancient culture, however, Tatton's images refer to modern civilization. The headless figures wield rifles, carry briefcases, and push lawn mowers. "It is painted, sandblasted and patinated to give the effect of being bog preserved," explains Tatton, "and to catalyze the viewer's thoughts toward [how] our culture today will be viewed . . . in future millennia."[107]

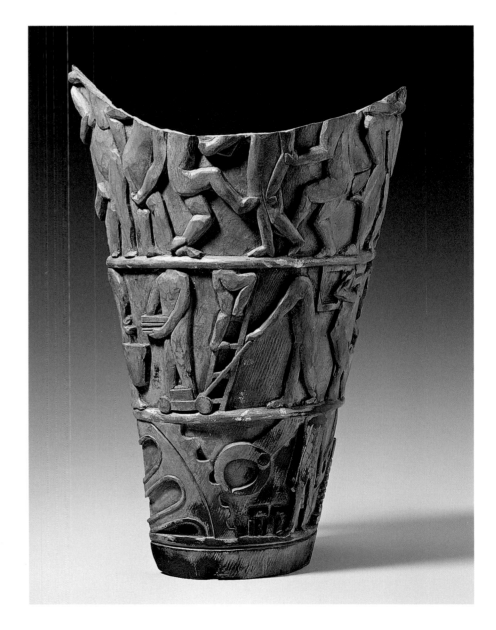

Don Reitz

American, born in 1929

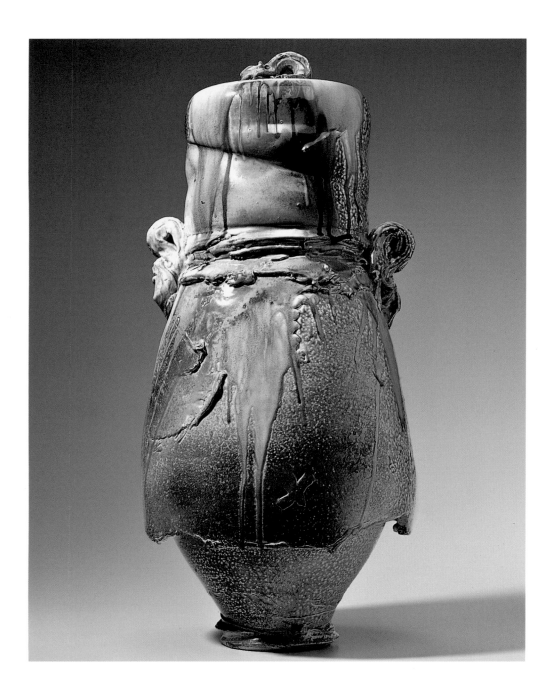

This monumental pot reflects Don Reitz's masterly handling of the relationship between form, surface, and color. Reitz began his career in "the wonderful energy-filled time period of the late '50s when Abstract Expressionism was in full swing." Trained as a painter, he turned to clay because "it would do anything I wanted it to. It recorded every force imposed on it."[108] His wheel-thrown pots—sometimes also stacked and hand built—are vigorously incised, patched, pinched, and folded to create powerful forms with varying planes and textures. Seeking a glaze that would reveal the responsiveness of the clay to his handling, Reitz revived the ancient technique of salt glazing, which produces a semitransparent glaze with an irregular, "orange-peel" texture, and explored innovative ways of producing various colors during the firing process. Later, he began to use wood firing, in which the kiln's flames "paint" the vessels with wood ash and of producing varied and unpredictable marks and colorations on the surface.[109] Reitz's work thus marries his free manipulation of clay with spontaneous surface treatments; his pots embody the Japanese concept of *wabi*, the aesthetic and expressive appeal of spontaneity and imperfection.[110]

Vessel
Clarkdale, Arizona, 1997
Salt-glazed stoneware
H. 86.4 cm, w. 40.6 cm, d. 40.6 cm
(H. 34 in., w. 16 in., d. 16 in.)

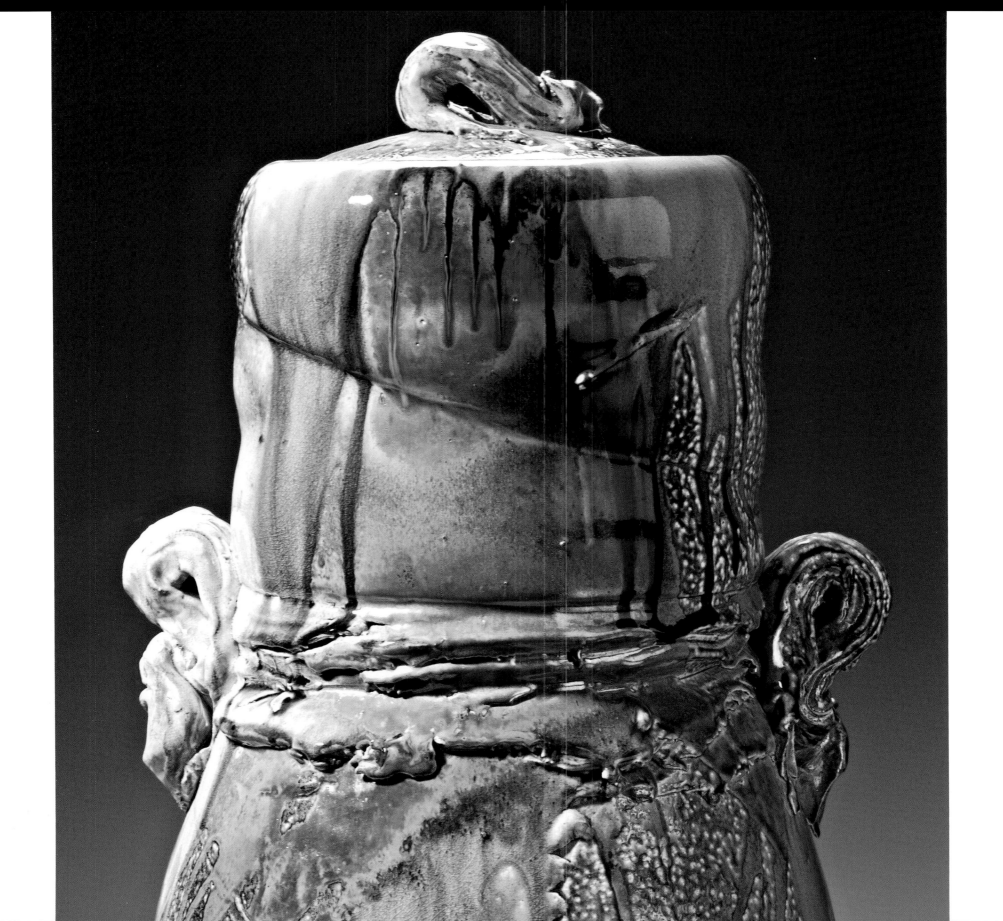

Richard DeVore
American, 1933–2006

Untitled No. 958
Fort Collins, Colorado, 2000
Stoneware
H. 40 cm, w. 31.1 cm, d. 27.9 cm
(H. 15¾ in., w. 12¼ in., d. 11 in.)

The Wornick Collection's dark cylindrical vase is an outstanding example of Richard DeVore's quiet, nuanced pieces, which are distinguished by soft folds, fissures, dimples, orifices, and subtle shaping, all of which have led many commentators to remark upon the relationship of his work to human anatomy or the landscape.[111] The pot also reflects some of DeVore's thoughts concerning beauty published at about the time of its creation. "I want a pot," he wrote, "that seduces one into beauty, sensuality, sexuality and incorporates the equality of tensions. Beauty needs at least a modicum of contrast to be as intense as life—an absence of perfection or ideal rectitude—the awkward attracts nearly as much as the beautiful, but for different reasons. . . . A pot . . . is a common, familiar and fundamental image, but open to metaphoric treatment. I want pots that relate an engagement with life more than an encounter with art."[112]

One of the acknowledged masters of modern studio ceramic art, Richard DeVore taught at Colorado State University in Fort Collins for nearly the last thirty years. Born in Toledo, he graduated from the University of Toledo in 1955 and took his master's degree at the Cranbrook Academy of Art in Bloomfield Hills, Michigan, where he studied with Maija Grotell two years later. His work, widely published and exhibited, is represented in many public and private collections.

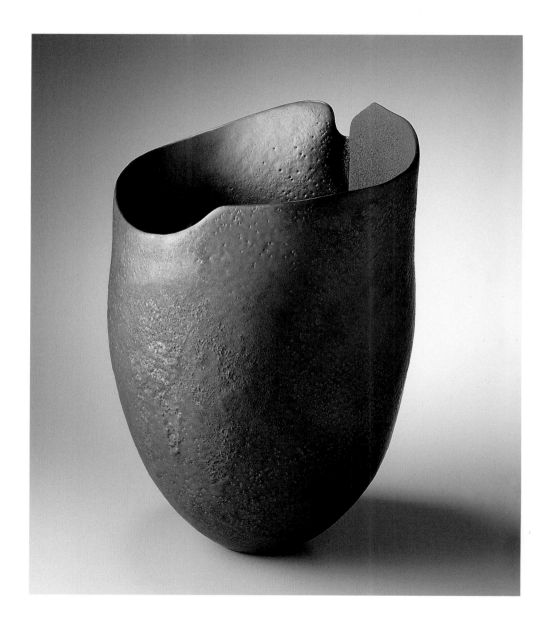

Sebastian Blackie

English, born in 1949

Known for his constant experimentation with process, Sebastian Blackie firmly believes that the way an object is made affects its meaning. Inspired by a four-year visit to Japan, Blackie created *Occidental Teabowl*. The piece expresses Blackie's empathy for the citizens of Hiroshima, as well as his aversion to the moralistic teachings of potter Bernard Leach, whose followers produced functional, Asian-inspired pots.[113] "I felt the world did not need any more Occidentals making Oriental-style teabowls," Blackie recalled.[114] Instead, he struggled to come to terms with "the artistic problem of representing experiences, with which one has empathy or attraction, but are not directly one's own." In this piece, Blackie threw several small tea bowls, and then discarded them into a cardboard mold while still soft. The bowls fused together into a single mass, melting under the pressure of their own weight.

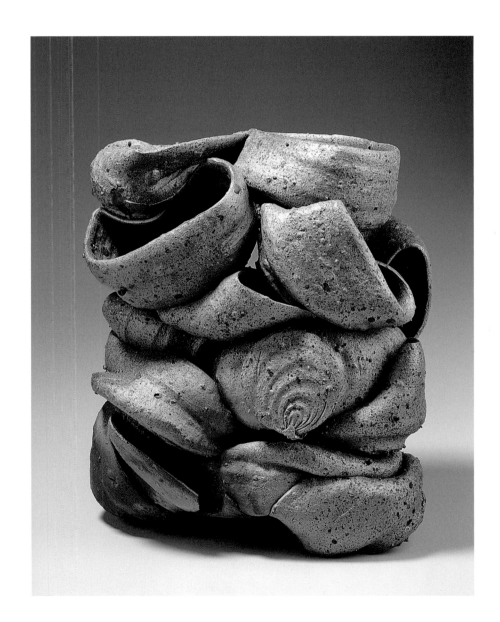

Occidental Teabowl
Hinckley, Leicestershire, United Kingdom, 2004
Thrown and pressed stoneware
H. 26 cm, w. 23 cm, d. 15 cm
(H. 10¼ in., w. 9⅟₁₆ in., d. 5⅞ in.)

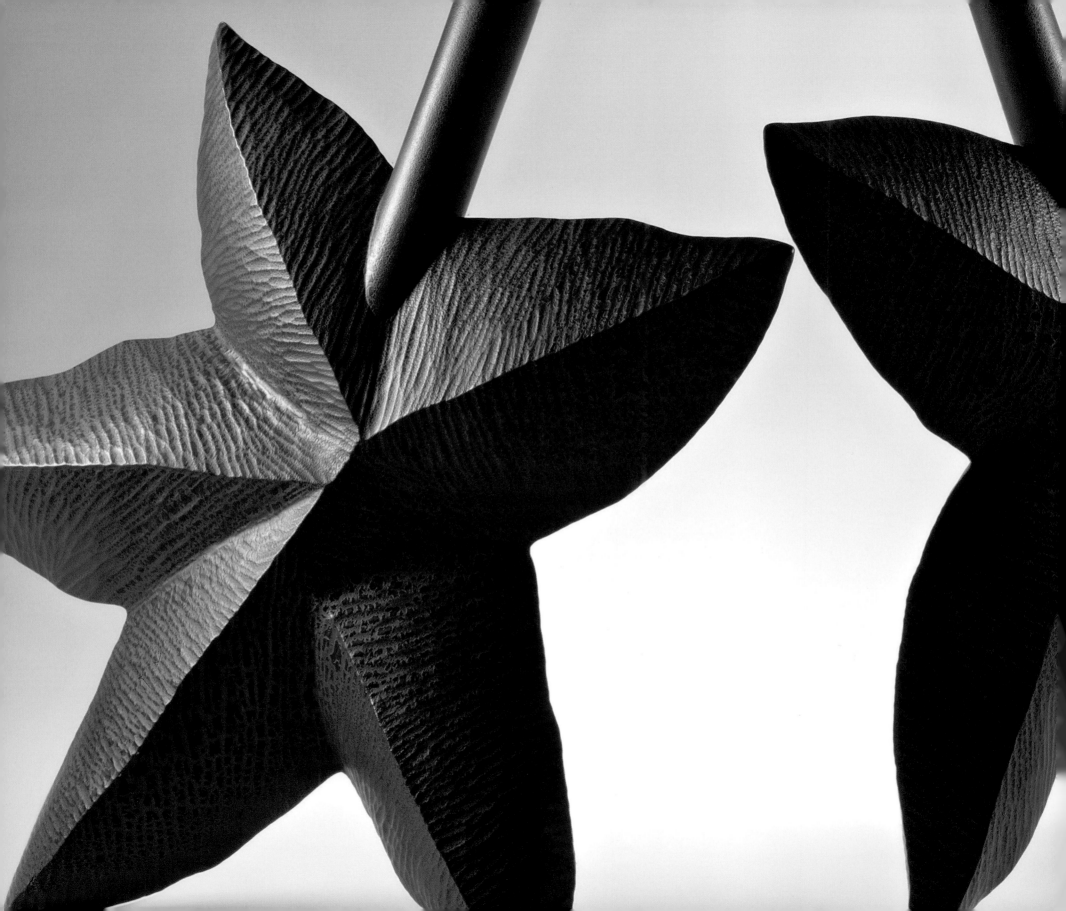

ORGANIC ▪ ABSTRACTION

David Groth

American, born in 1950

Mobilis
Trinidad, California, 2001
Carved myrtlewood
H. 72.4 cm, w.118.1 cm, d. 61.6 cm
(H.28 ½ in., w. 46½ in., d. 24¼ in.)

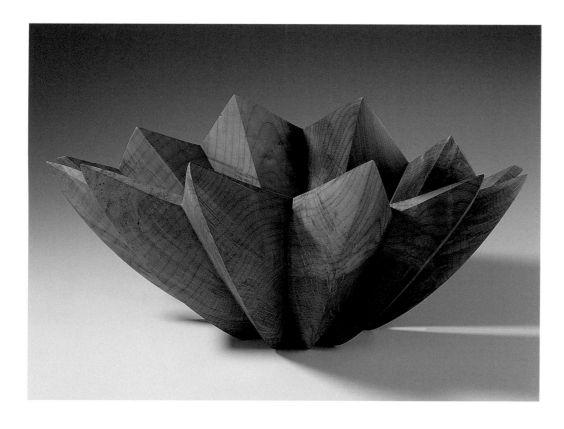

Cock's Comb Oyster Series No. 2
Trinidad, California, 1984
Carved myrtlewood
H. 30.5 cm, w. 25.4 cm, d. 50.8 cm
(H. 12 in., w. 10 in., d. 20 in.)

These two objects in the Wornick Collection represent the work of the California artist David Groth and provide a contrast in size and form. The earlier *Cock's Comb Oyster Series No. 2* was the Wornicks' first acquisition for the collection, purchased in 1987.[115] A rendering in hardwood of the spiky oyster *Lopha cristagalli*, it is a small-scale, monumental form. As Matthew Kangas has observed, it is notable for the "tension" created by the contrast of the "elaborately curving wood grain and figuring on the outer surface" and the "threatening, jagged points of the segmented bowl wall."[116] It also represented a dramatic break from the more customary rounded forms created by most workers who use the lathe. Groth's more recent work, *Mobilis*, differs dramatically in its large scale and deceptively natural appearance. The artist has explained his process for fashioning these organic, dynamic masterpieces, which often begins with the use of a chain saw:

> Sculpting from myrtlewood collected after washing up along the Pacific Northwest beaches is a journey that begins by reclaiming these timbers between storms and after rivers have flooded. Next, working intuitively I allow the form to evolve as I carve, and finally chisel lines, curves, and planes to their finished angular dynamic composition. Over the years I've grown to especially respect and appreciate the encompassing transformation from the reclaimed tree to finished carving that is woven into the character and nature of each individual sculpture.[117]

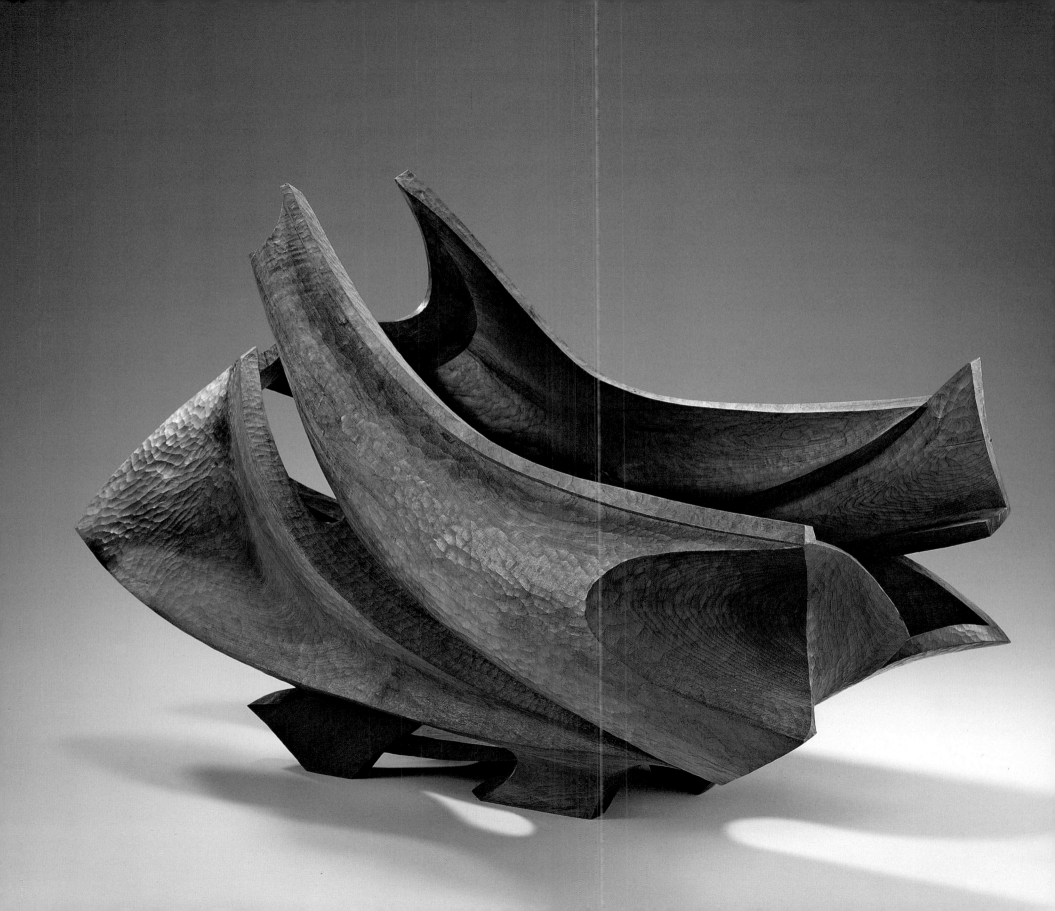

Liv Blåvarp

Norwegian, born in 1956

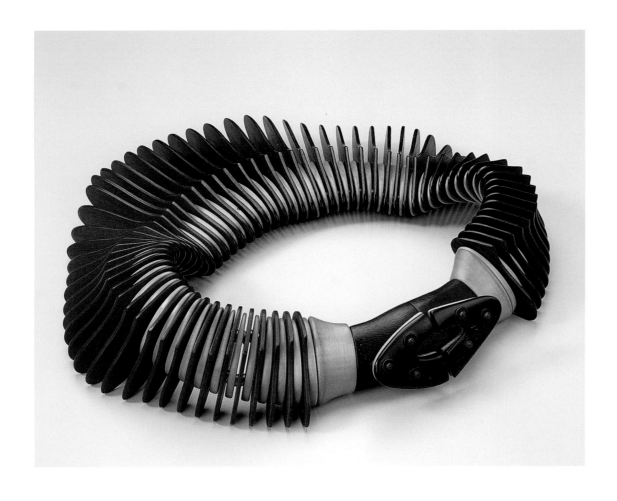

Norwegian woodworkers have long used their country's plentiful supply of native timber to make beautiful and functional objects. Liv Blåvarp, a contemporary artist making jewelry exclusively in wood, sees herself as connected to that highly regarded tradition. Since the early 1980s, she has explored variations on a single form: the flexible, segmented wooden collar. Using both indigenous and imported woods, which she laminates and carves in segments, she dyes the wood with a limited palette of vegetable dyes. These natural materials harmonize with the forms of the collars, in which nature themes predominate: the necklaces may suggest vertebrae, ribs, and other skeletal structures; the spirals of seashells or coiling vines; or a bird's unfurling wing feathers. The flexibility of the interlocking segments allows them to bend and move with the wearer's body, suggesting the variation and movement of the natural world.[118]

Shadows Falling
Lena, Norway, 2006
Dyed maple, palisander, satine
H. 25.4 cm, w. 26.7 cm, d. 8.9 cm
(H. 10 in., w. 10½ in., d. 3½ in.)

Matthew Harding

Australian, born 1964

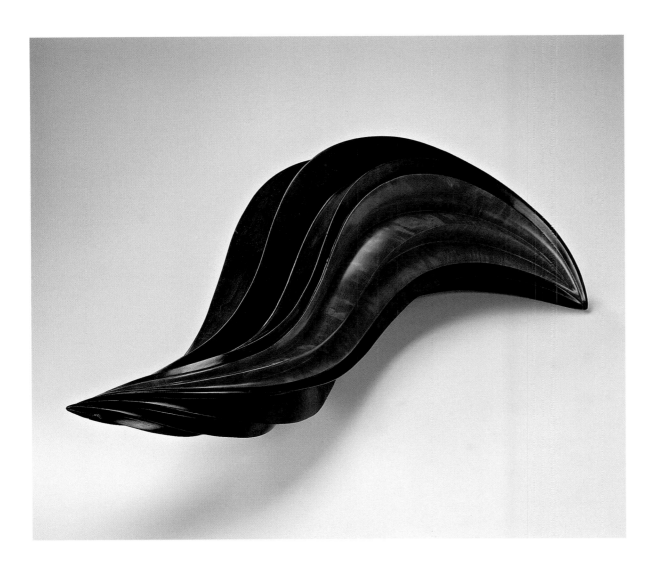

Australian sculptor Matthew Harding was initially trained in carpentry and joinery. In 1984 he studied painting and printmaking at the Hunter Street School of Art and Design in Newcastle, Australia, and then pursued additional training in the visual arts at the Canberra School of Art in the mid-1990s. Noted for his public commissions as well as smaller objects, he works today in a variety of materials, including stone, bronze, stainless steel, aluminum, mosaics, fiberglass, textiles, and plastics, in addition to wood.

Fireseed is a recent example of his work in wood, notable for its strong curvilinear presence. It takes full advantage of the richness of New South Wales rosewood (*Trichilia glandulosa*), a tree related to the margosa. Harding initially formed the piece with a chain saw and angle grinder, and then carved, sanded, and finished it by hand. It symbolizes, in title and form, the regeneration of nature and "the cyclic life of the humble seedpod—time capsules that possess all the potentiality and magic of life."[119]

Fireseed
Canberra, Australian Capital Territory, 2003
New South Wales rosewood
H. 25.4 cm, w. 90.2 cm, d. 40.6 cm
(H. 10 in., w. 35½ in., d. 16 in.)

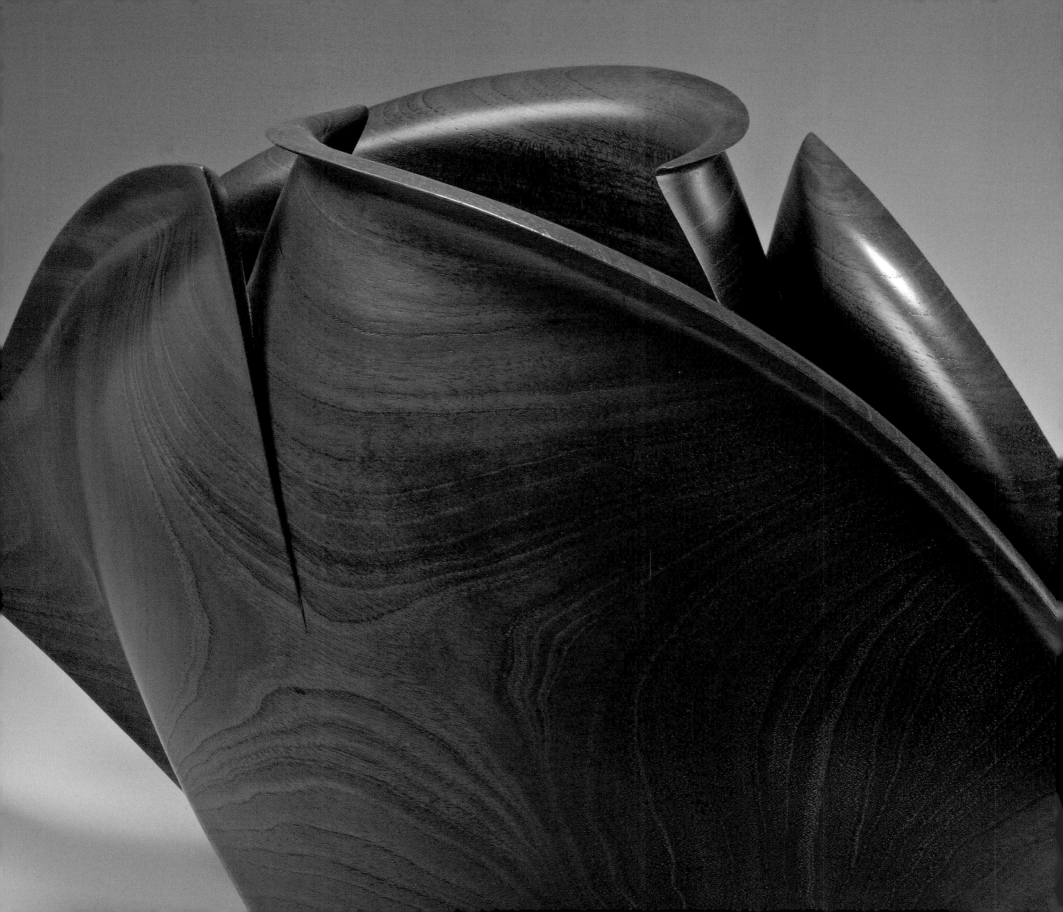

Grant Vaughan

Australian, born in 1954

Never eschewing his artistic vision for the sheer complexity of creation, Grant Vaughan is a master of form and line. The simplistic grace of his work belies its technical difficulty. In *Split Form,* Vaughan skillfully carves the vessel from a single piece of prized Australian red cedar, undulating its split lip in unto itself like an opening rose blossom. The delicate grain inherent in the material enhances the vessel's organic shape. Soft folds, sinuous curves, and flowing lines are recurring elements in Vaughan's work, which takes the vessel form beyond its traditional aesthetic without abandoning it completely.

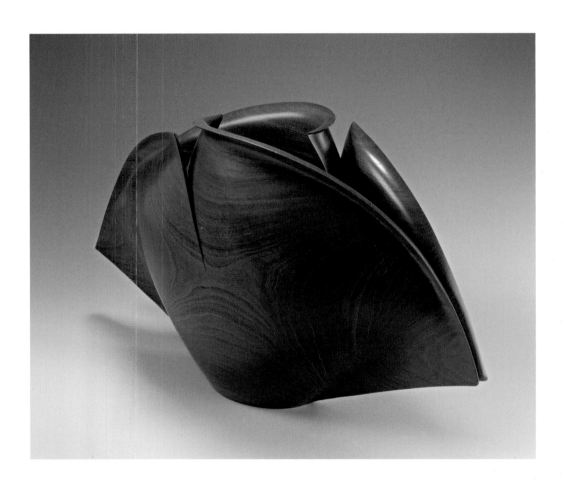

Split Form
Rock Valley, New South Wales, Australia, 2005
Australian red cedar
H. 34.3 cm, w. 68.6 cm, d. 20.3 cm
(H. 13½ in., w. 27 in., d. 8 in.)

Grant Vaughan

Australian, born in 1954

Never eschewing his artistic vision for the sheer complexity of creation, Grant Vaughan is a master of form and line. The simplistic grace of his work belies its technical difficulty. In *Split Form,* Vaughan skillfully carves the vessel from a single piece of prized Australian red cedar, undulating its split lip in unto itself like an opening rose blossom. The delicate grain inherent in the material enhances the vessel's organic shape. Soft folds, sinuous curves, and flowing lines are recurring elements in Vaughan's work, which takes the vessel form beyond its traditional aesthetic without abandoning it completely.

Split Form
Rock Valley, New South Wales, Australia, 2005
Australian red cedar
H. 34.3 cm, w. 68.6 cm, d. 20.3 cm
(H. 13½ in., w. 27 in., d. 8 in.)

Stephen Hughes
Australian, born in 1958

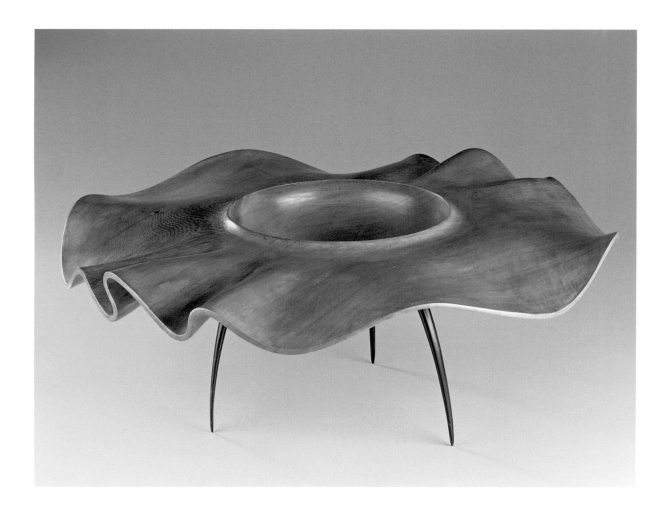

Born, educated, and trained in Australia, Stephen Hughes emphasizes in his sculpture the nature of wood as an organic material; thus the resulting works can frequently be associated with the land and the sea.[120] His *Manta* vessel, a technical tour de force, consists of a turned central bowl surrounded by a large wavy border, alluding both to the ceaseless motion of the ocean and the ominous form of the manta ray. The work is perched delicately on slightly arched dark Indian ebony legs that contrast with the Huon pine used for the vessel. Evidence of turning tool marks has been eradicated, heightening the sense of illusion that this floating form creates.[121]

Huon pine (*Lagarostrobus franklinii*, formerly *Dacrydium franklinii*, the only member of the genus *Lagarostrobus*) is an extraordinary, ancient tree that dates back some 135 million years. Specimens have been known to live for more than three thousand years. It is found only in various parts of western and southwestern Tasmania, where it has become a completely protected species. Modern woodworkers, however, are allowed to salvage fallen timbers. Its durability is due to the presence of the oil methyl eugenol, which also gives the wood a sweet aroma. Creamy yellow in color, Huon pine is highly prized by woodworkers for its many excellent qualities.[122]

Manta
Aspendale Gardens, Victoria, Australia, 1991
Turned and carved Huon pine, Indian ebony
H. 17.8 cm, diam. 47. 3 cm
(H. 7 in., diam. 18 ⅝ in.)

Robert Howard

Australian, born in 1949

Born in Queensland, Australia, Robert Howard studied economics at the University of New South Wales. He worked in business in his native country, the United States, and Germany for many years. In 1988 he switched careers to become a full-time furniture maker and wood carver.

Since 1998 Howard has focused on carving, and he is noted for the extraordinary forms he carves from single pieces of wood, as is the case with the example in the Wornick Collection.[123] This round form, with its exquisite, delicately furled passage, reflects a minimalist trend in this type of woodwork, in which the evidence of the object's fabrication is eradicated and the surface is rendered pristine. Bonita Fike, for example, has likened Howard's work to the hard-edged paintings of Ellsworth Kelly (born in 1923) in which the hand of the artist is rendered invisible.[124]

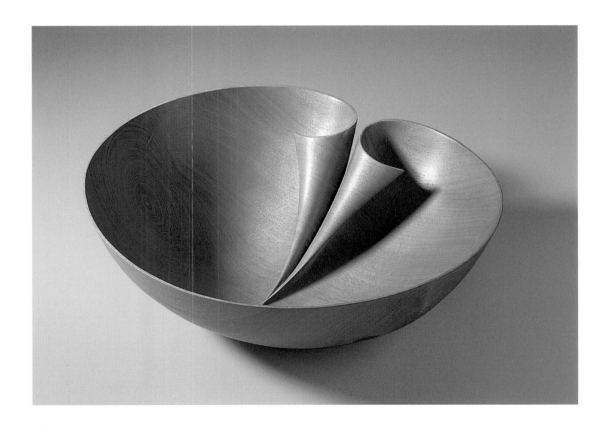

Untitled
Brisbane, Queensland, Australia, 1999
White beech
H. 33 cm, w. 27.9 cm, d. 8.9 cm
(H. 13 in., w. 11 in., d. 3½ in.)

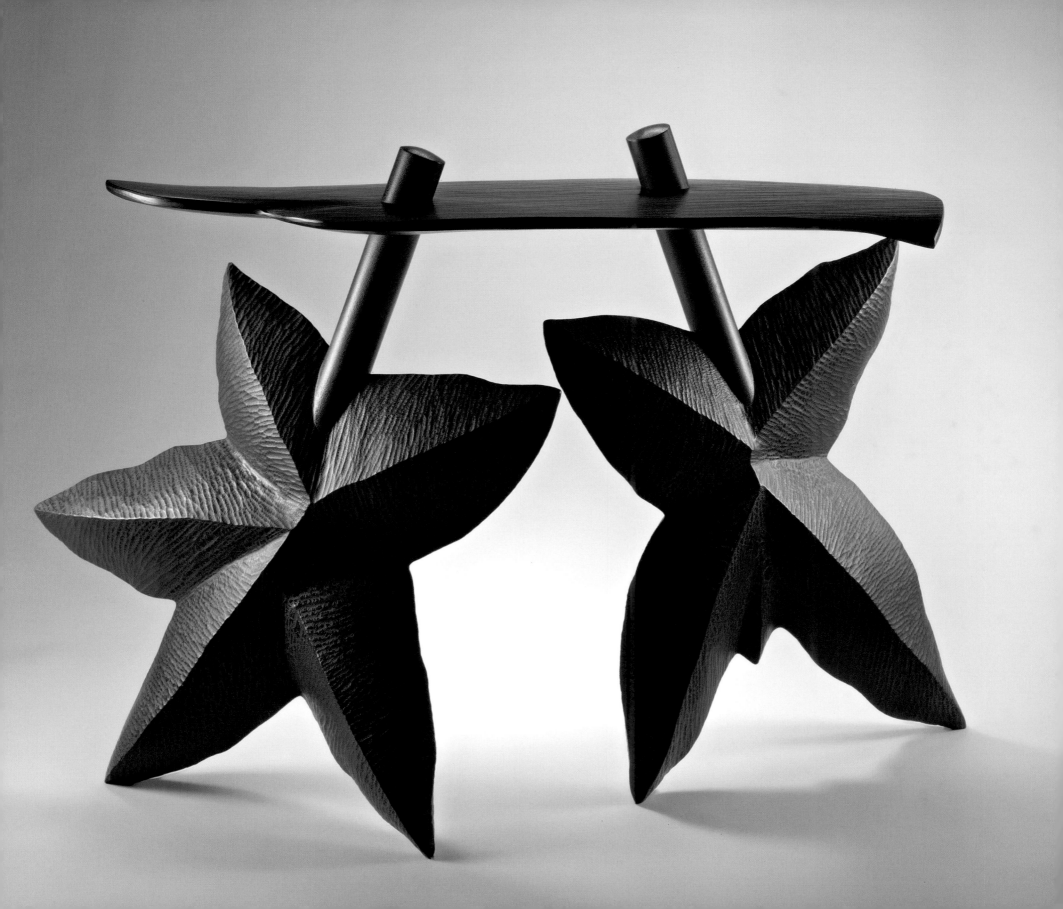

Wendell Castle
American, born in 1932

Stealth
Rochester, New York, 1997
Laminated bubinga
H. 40.6 cm, w. 148.6 cm, d. 73.7 cm
(H. 16 in., w. 58½ in., d. 29 in.

Pisces
Rochester, New York, 1995
Jelutong, mahogany
H. 106.7 cm, w. 152.4 cm, d. 62.2 cm
(H. 42 in., w. 60 in., d. 24½ in.)

Among all studio furniture makers, Wendell Castle has perhaps most fully explored the possibilities for sculptural expression and artistic innovation. In this, he follows in the footsteps of Wharton Esherick of Pennsylvania, who is widely acclaimed as the founder of the American studio furniture movement. Castle, in his youth, visited Esherick, and while he received a gruff reception, he nevertheless acknowledges readily the impact of the older artist's philosophy upon his work.[125]

The two pieces here, which function as a hall or pier table and as a large coffee table, respectively, represent Castle's style of the mid-1990s. *Pisces* is from the Seeing Stars series, which reflects Castle's ongoing exploration of organic themes and is notable for its multilayered, textured finish.[126] The large *Stealth* table, distinguished by its chiseled sides and smooth top, was commissioned by the Wornicks for use in their then-new home in 1997. Although they planned to have it made of Macassar ebony, light-colored bubinga was ultimately chosen to blend more harmoniously with its architectural surroundings.[127]

Ron Fleming
American, born in 1937

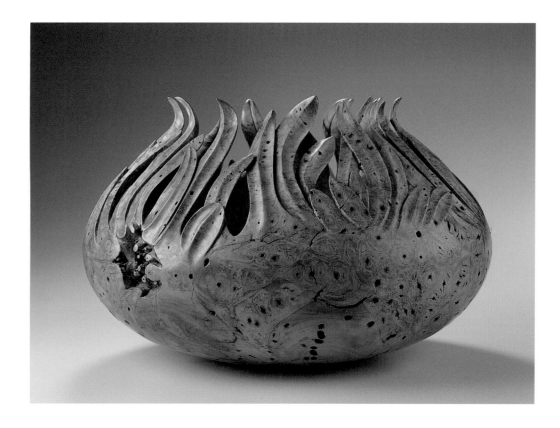

Reeds in the Wind
Tulsa, Oklahoma, 1988
Turned and carved box-elder burl
H. 21.6 cm, w. 33 cm, d. 33 cm
(H. 8½ in., w. 13 in., d. 13 in.)

Nature is the predominant point of entry in Ron Fleming's wood sculpture. In his words: "Woodturning is a natural way for me to combine my capabilities as an artist and a craftsman. Whether it is the remains of a burned or charred forest transformed into a statement of new beginnings or a single flower bud unfolding in spring, each piece gives me an opportunity to make a delicate expression about the never-ending rituals of nature's evolution."[128]

In *Reeds in the Wind,* Fleming has transformed box-elder burl into a rounded form with waving reeds entangling and overlapping each other at the top. The central spine of each reed is clearly articulated, while the character of the burl provides dark speckled highlights contrasting with the overall lighter-colored wood.

From a woodworking family, Fleming is largely self-taught and has gained valuable informal training at many workshops and symposia during his career. In his love and reverence for wood as a material, Fleming is aligned with many woodworkers and furniture makers in the early years of the studio craft movement, such as Sam Maloof and George Nakashima, although he came to pursue his calling somewhat later than those first-generation masters. After working for a few years as a draftsman in the Oklahoma State Bridge Department in the 1950s, Fleming was an independent graphic illustrator from 1960 to 1985. Since 1985, he has pursued both illustration and sculpture.

William Hunter

American, born in 1947

From the Heart
El Portal, California, 2002
Turned and carved vera wood
H. 43.2 cm, w. 19.1 cm, d. 19.1 cm
(H. 17 in., w. 7½ in., d. 7½ in.)

A member of the first generation of modern artists to use turned and shaped wood as their principal medium, William Hunter has been practicing his craft for nearly four decades.[129] His work, although varied in form, is instantly recognizable, always possessing extraordinary movement, refinement, and expressive qualities. Its degree of finish and seeming perfection evokes the high-quality twist- or spiral-turned work in the early baroque mode produced by turners in the late seventeenth and early eighteenth centuries.

From the Heart is fashioned of vera wood (*Bulnesia arborea*), an evergreen native to Colombia and Venezuela. It demonstrates Hunter's care, bordering on obsession, in creating a carved and polished open-work, flamelike vessel.

Hunter has been working independently as an artist since 1970, when he participated in his first craft show. Extremely focused, he puts his heart and soul into every work.[130] In his thoughtful, poetical, even spiritual approach to his art, Hunter is akin to other California furniture makers and woodworkers from the 1960s forward, for whom work is as much a way of life as an aesthetic expression.

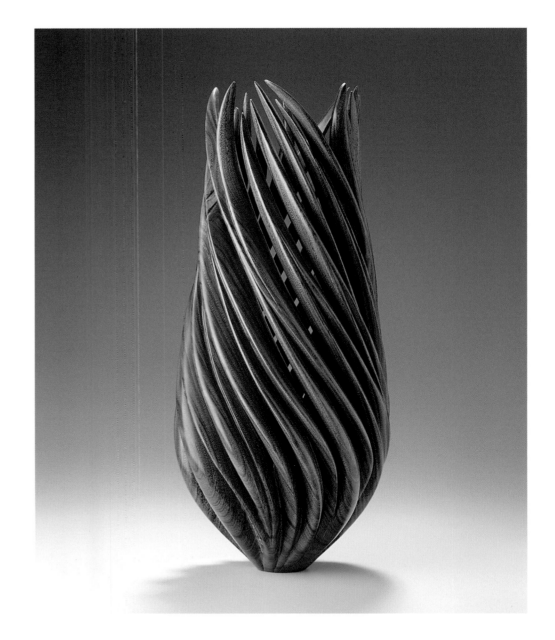

Ben Trupperbäumer

German, born in 1948

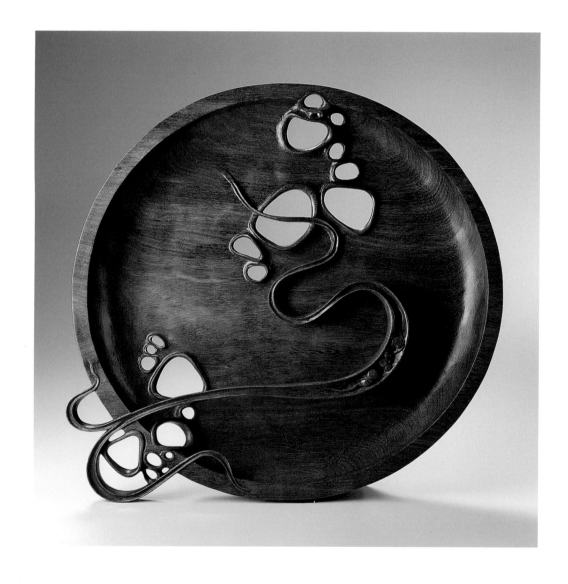

Ben Trupperbäumer's carved platter, clearly modern in its execution, represents a fresh revision of the art nouveau emphasis on serpentine, whiplash lines, specifically in the curvilinear tendril-like form that flows from the edge of the object toward its center. Three-dimensional, this tendril houses several small tadpolelike elements as it meanders over and around some of the openings that pierce the surface of the platter in a variety of sizes. The result elevates a standard, round platter form with a slightly raised edge into an asymmetrical, vibrant work that belies the nature of its hardwood composition.

Born and trained in Germany as a sculptor, Trupperbäumer established his studio in North Queensland, Australia, in the 1980s.[131] Widely traveled in Europe, Nepal, and West Africa, he chose a variety of *Albizia spp.*, a subtropical and tropical hardwood, for this work.

Carved Platter
Mission Beach, North Queensland, Australia, 1992
Albizia spp.
H. 5.4 cm, w. 45.7 cm, d. 45.7 cm
(H. 2⅛ in., w. 18 in., d. 18 in.)

Christian Burchard

American, born in West Germany, 1955

Jovian Moonrise
Ashland, Oregon, 1997
English walnut, maple, mahogany, rosewood, linen thread
H. 61 cm, w. 170.2 cm, d. 8.9 cm
(H. 24 in., w. 67 in., d. 3½ in.)

Born in Germany, Christian Burchard studied furniture making there with Halvor Gutchow. Upon completion of his apprenticeship, he studied at the School of the Museum of Fine Arts, Boston (1977–78), and the Emily Carr College of Art and Design in Vancouver, British Columbia (1978–79). He has been an independent sculptor since 1982, operating Cold Mountain Studio in Ashland, Oregon.[132]

At the time *Jovian Moonrise* was made, it represented the large-scale side of Burchard's creative work, which also featured small vessels of one shape on which he could ring the changes subtly and endlessly. The large works, on the other hand, gave him "all the freedom" he could handle.[133] Combining four woods, the piece features a central disk above a great horizontal curving swath or arc of shaped wedges evoking the rings of the Jovian planets (traditionally Jupiter, Saturn, Uranus, and Neptune). Designed as one of a series of shield and landscape wall-mounted pieces, *Jovian Moonrise* has occupied a prominent location in the Wornicks' Napa Valley home. In keeping with much of Burchard's work, tool marks remain readily visible.

Peter M. Adams

American, born in 1946

Forest Bench
Tasmania, Australia, 1998
Myrtle and Huon pine
H. 49.5 cm, w. 190.5 cm, d. 36.8 cm
(H. 19½ in., w. 75 in., d. 14½ in.)

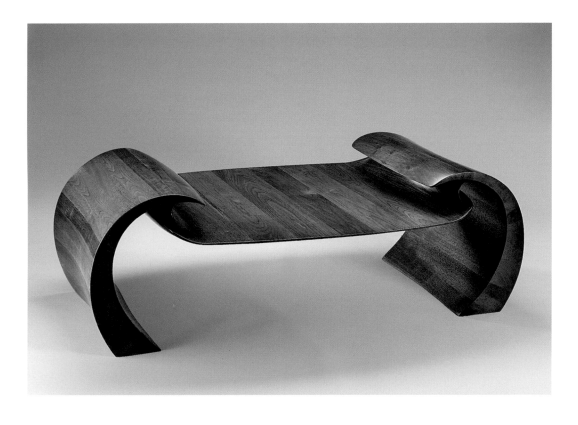

Dotoh
Penland, North Carolina, 1984
Laminated and carved walnut
H. 48.3 cm, w. 147.3 cm, d. 73.7 cm
(H. 19 in., w. 58 in., d. 29 in.)

As Peter Adams explained in 1982, his work was inspired by "wind, waves, flow, and flight."[134] While this is conveyed in both this table and bench, they represent distinct stages in the artist's career. The *Dotoh* coffee table represents Adams's early work using laminated and hand-shaped American hardwoods to make dramatically curved forms. *Dotoh* is Japanese for "large wave." Having studied massage to make his hands more sensitive in sculpting, Adams wrote that his work had "an aura of sensuousness, inviting touch."[135]

After moving to Tasmania in 1985, however, Adams's involvement in political and environmental issues forced him to reconsider the role of the artist in society. He founded a spiritual and environmental retreat center called Windgrove and began to produce works such as *Forest Bench,* intended "to promote a sustainable and peaceful world."[136] Made of Tasmanian Huon pine and myrtlewood, dense with annular rings, the bench invites the user to touch the wood and experience reverence for ancient trees; at the same time, sharing the bench invites two people into a dialogue and a sense of community.

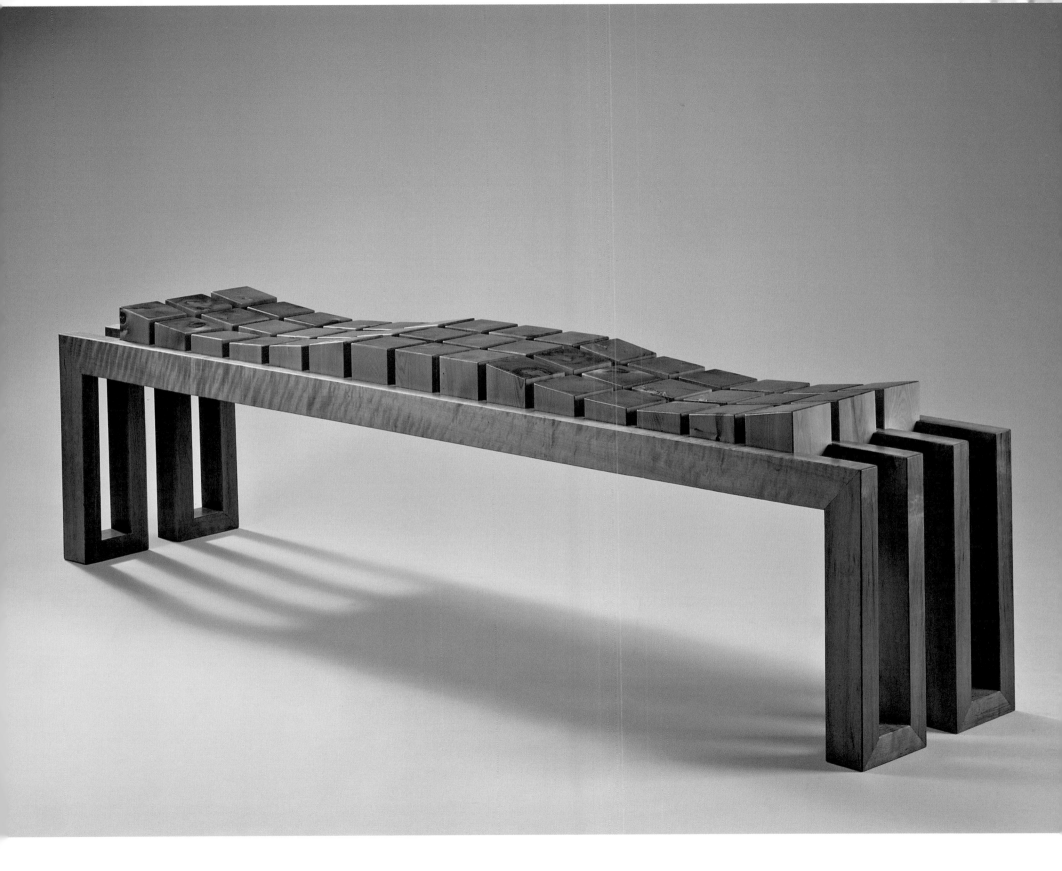

Honda Syoryu

Japanese, born in 1951

Dance
Beppu, Japan, 2003
Madake bamboo and rattan,
nawame (twining) technique
H. 35.6 cm, w. 29.2 cm, d. 29.2 cm
(H. 14 in., w. 11½ in., d. 11½ in.)

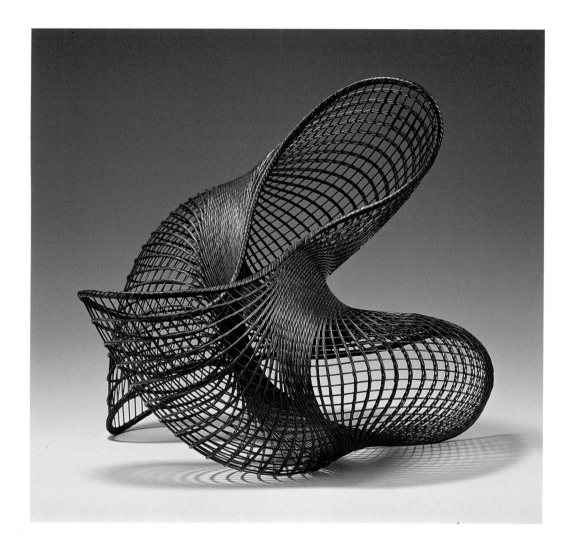

Honda Syoryu uses one of Japan's most abundant natural materials, *madake*, or timber bamboo, to create elegant and dynamic sculptural forms that break free from historical and functional traditions. For thousands of years, Japanese artisans made bamboo baskets and containers used in flower arranging and the tea ceremony, often imitating Chinese forms. Not until the 1870s, during the modernization of Japan in the Edo period, did individual basket makers begin to sign their works. In the twentieth century, basket makers began to adopt Western notions of "fine art" and originality, developing individual and expressive styles. Honda is among a handful of contemporary basket makers whose works are nonfunctional; his works "contain light, space, and volume, rather than objects."[137] Honda's technical virtuosity conceals the years of training and time-consuming labor required to produce such elegant work; instead, the sinuous curves in his basket *Dance* suggest graceful, airy movement.

Marvin Lipofsky

American, born in 1938

A master of abstract expressionism in glass, Marvin Lipofsky has had a long career as a leader in the American studio glass movement. His roots can be traced to his study in 1964 at the University of Wisconsin with Harvey Littleton, who, along with Dominick Labino, is widely credited with initiating the studio glass movement. Lipofsky completed his education at Wisconsin, receiving his degrees in sculpture. Although widely traveled, Lipofsky has been based in California for more than forty years.

The artist made this recent example of his work while he was a visiting fellow at California State University in Chico, collaborating with Robert Herhusky (a former student and now professor at Chico) and his students to make a series of five sculptures. It amply demonstrates Lipofsky's continuing mastery of his medium and craft. Colorful in many hues like a painting and strong in sculptural form, it also takes advantage of the luminosity, malleability, and other unique attributes of glass as a material. Like most of his work, it also provides a Rorschach test for viewers who search for parallels and relationships with organic forms. As noted by Jonathan L. Fairbanks, "Lipofsky's sculpture creates the impression of semi-transparent tissues, bladders, organs, flesh and mammiform shapes, flowers, shells, and other shapes with female associations."[138]

Chico Group II 2004–2005 No. 2
Chico, California, 2004–5
Blown glass
H. 33 cm, w. 33 cm, d. 40.6 cm
(H. 13 in., w. 13 in., d. 16 in.)

Dale Chihuly

American, born in 1941

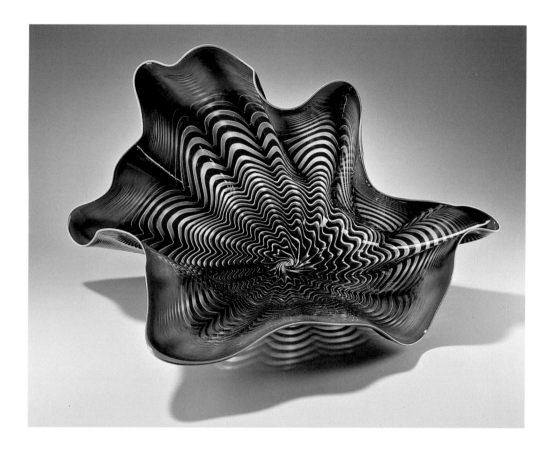

Rembrandt Blue and Oxblood Persian
Seattle, Washington, 1990
Blown glass
H. 88.9 cm, w. 67.3 cm, d. 69.9 cm
(H. 35 in., w. 26½ in., d. 27½ in.)

Largely recognized as a leader in the American studio glass movement, Dale Chihuly studied glassblowing at the University of Washington before receiving a Master of Science in Glassblowing from the University of Wisconsin (1967) and a Master of Fine Arts from the Rhode Island School of Design (1968), where he helped establish the glass program. Later that same year, Chihuly received a Fulbright grant and became the first American to work and study with Venetian glass artists on the island of Murano. Returning to his home state of Washington, Chihuly established the Pilchuck Glass School in Stanwood in 1971. Pilchuck has since become the premier glass school in America, training some of the most talented and important glass artists working today.

Chihuly began making his Persian series in 1986. Initially without a name, the series was born from a desire to experiment with form and color.

> I had hired Martin Blank [see p. 46] in 1985 right out of R.I.S.D., and I saw right away that he was very talented and creative. He wasn't concerned as much with craftsmanship as he was with experimenting, so I immediately set him and Robbie Miller up in a corner of the hot shop. . . . I would make large pencil drawings for Martin and Robbie with a couple dozen small forms and then I would put an X under the one I wanted them to go for. Over the next year, we made more than 1,000 miniature experimental forms.[139]

The name *Persian*, along with the vibrant colors of the series, recalls the exoticism of the Near East and the ancient history of Islamic glass. Indeed, Chihuly described the earliest Persians as possessing an "archaeological" feel.[140] Typically grouped and/or installed, the Persians push the concepts of vessel, form, and color to extreme ends. Individually, the elements are breathtaking manifestations of rhythm and life. Combined, the pieces can create monumental and lavish environments of color that recall the Islamic interiors from which they draw their name.

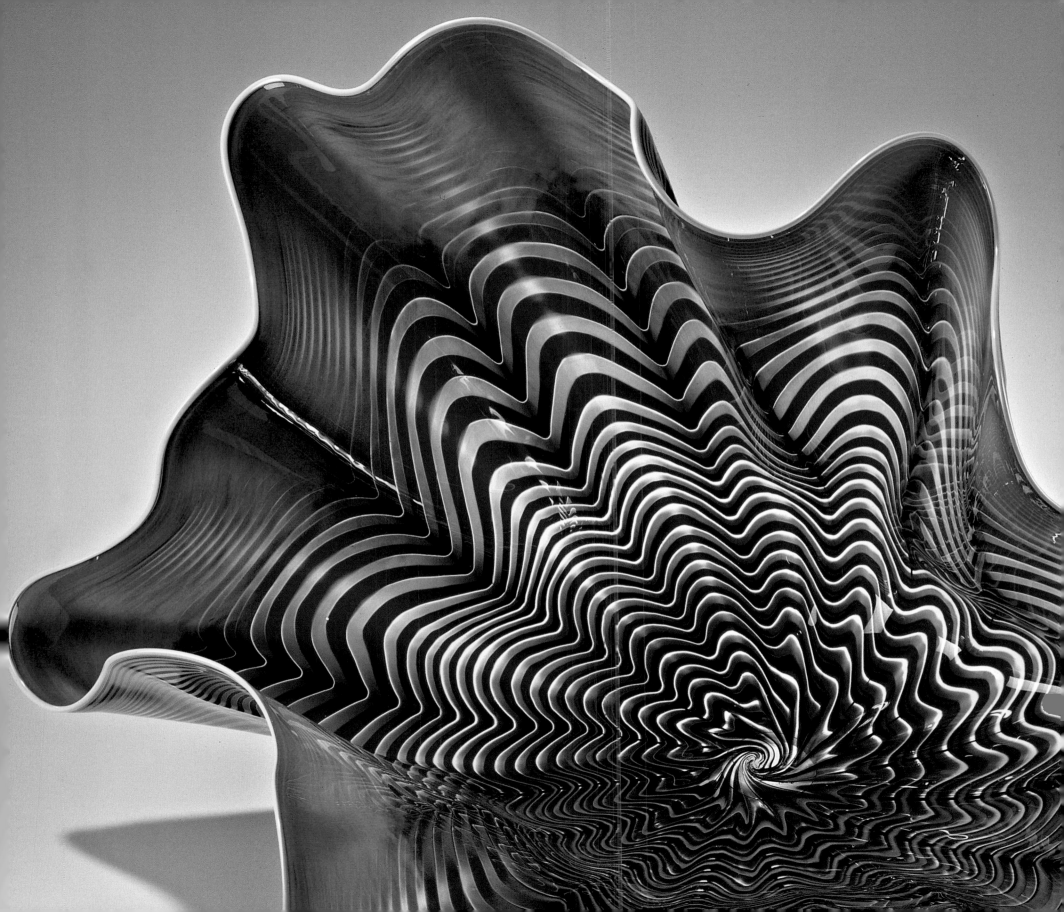

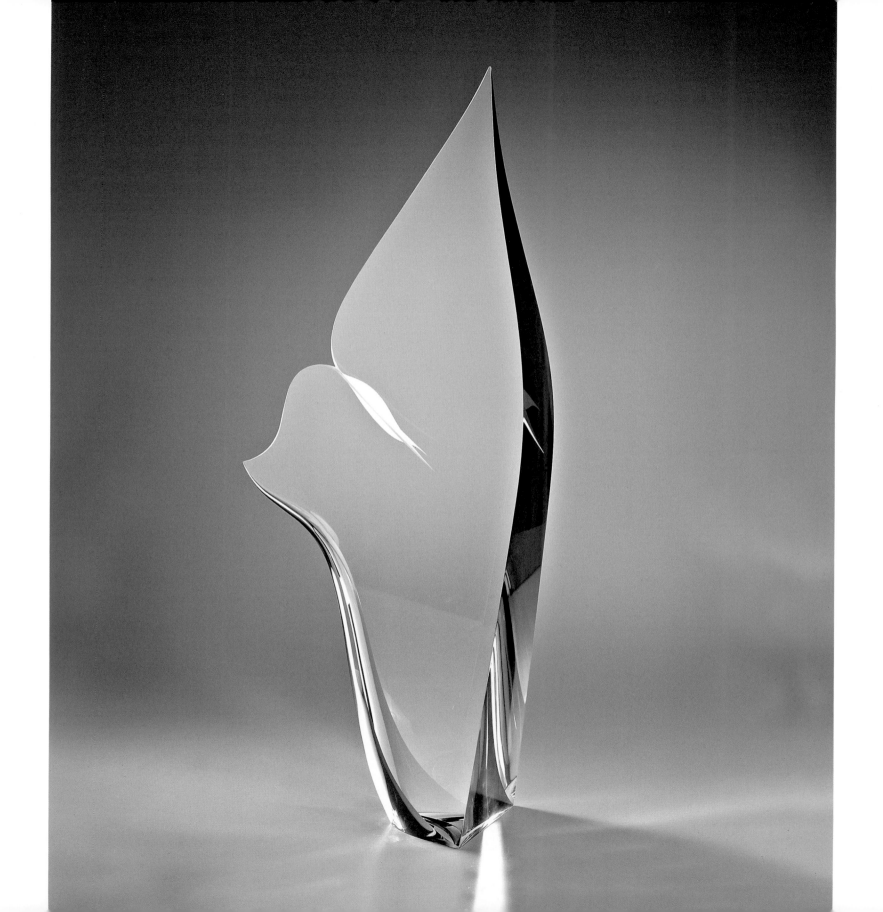

Christopher Ries

American, born in 1952

Desert Flower
Duryea, Pennsylvania, 2004
Cut optical glass
H. 80 cm, w. 34.9 cm, d. 16.8 cm
(H. 31½ in., w. 13¾ in., d. 6⅝ in.)

When growing up on a rural farm in Ohio, Christopher Ries was fascinated by the optical qualities of water. As an artist, Ries strives to emulate these qualities. Working with ultraclear lead crystal, Ries cuts, sand-blasts, and polishes each piece to maximize its internal optical characteristics. Skillfully sculpting light, Ries creates shifting, complex illusions within his clear, simple forms. In *Desert Flower*, Ries cuts a singular petal into the glass at a 45-degree angle. As light hits the surface, it refracts to create an eight-leafed flower within the crystal. The hypnotic image compels the viewer to look deeper within the piece and within himself as his image is reflected back as a fractured, Cubist-like portrait. The resulting intimacy creates a powerful bond between the viewer and art.

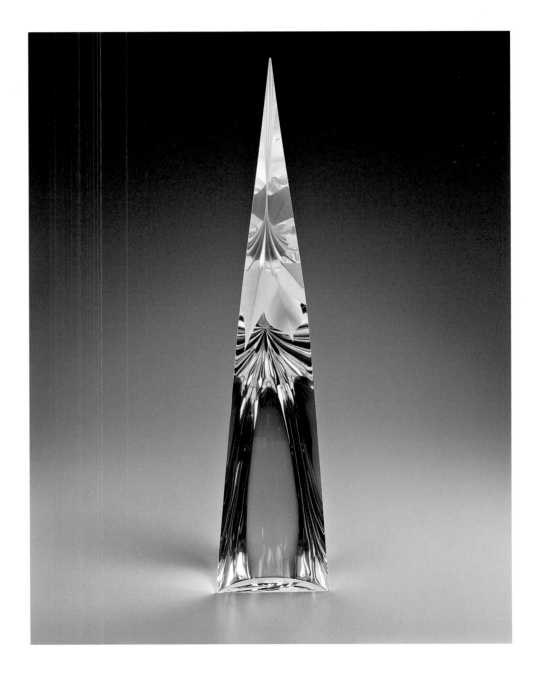

Daniel Clayman

American, born in 1957

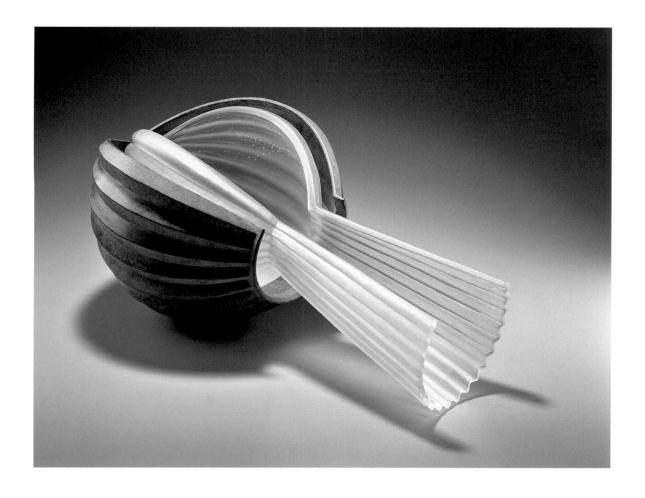

Daniel Clayman is part of a Rhode Island school of contemporary studio glassmaking. He studied theater and music at Connecticut College in New London before doing graduate work the Rhode Island School of Design in Providence. After graduating from RISD in 1986, he spent two years as an assistant to Michael Glancy, a Rhode Island artist known for combining glass and metal in his work.

That training, as Matthew Kangas has observed, is well revealed in works by Clayman that similarly combine materials in an effective manner, such as his deceptively simple sculpture entitled *Emerge*.[141] Here, the hollow, bulbous upper section of a striated white *pâte de verre* form, evoking something from the organic, botanical world such as an onion, is housed with a delicately patinated, reeded bronze shell or husk, while the stem protrudes. *Emerge* thus raises issues of penetration, containment, concealment, revelation, and ultimately, as its title suggests, metamorphosis.

Emerge
Rumford, Rhode Island, 2002
Cast glass, bronze
H. 25.4 cm, w. 61 cm, d. 35.6 cm
(H. 10 in., w. 24 in., d. 14 in.)

Pavel Hlava

Czech, 1924–2003

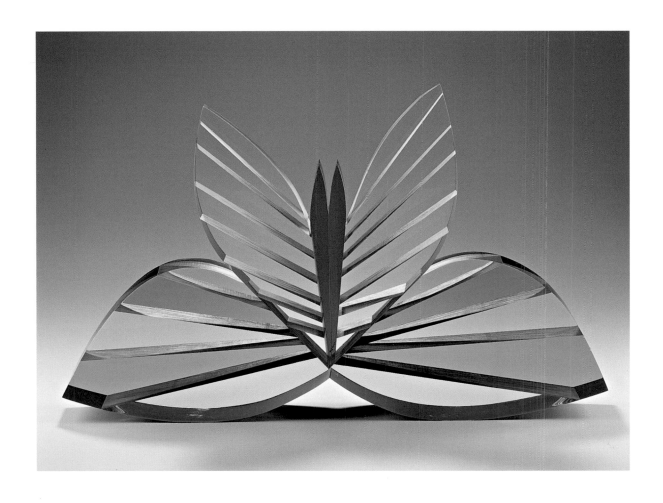

Considered an innovator in the technical developments of Czech glass, Pavel Hlava designed factory-produced glassware before turning his talents to sculpture in the 1970s. In the 1980s, Hlava began training his son-in-law, Tomáš Hlavicka, whose work is also represented in the Wornick Collection (see p. 72).

Inspired by the nature and vegetation that surrounded his home in Prague, Hlava's glass sculptures feature abstracted, geometric shapes that play with the opposition of surface and interior. *Flower Kiss* is typical of Hlava's mastery of technique to produce an emotional response. Cutting and polishing cast glass, Hlava assembled his pieces by cleverly using the interior edges to create pattern and illusion. The repetitive almond shape of the leaves and petals produces a rhythmic harmony in which stripes of color fill the interior with light and texture.

Flower Kiss
Prague, Czech Republic, 1999
Cast, polished, and laminated glass
H. 40 cm, w. 60.3 cm, d. 8.1 cm
(H. 15¾ in., w. 23¾ in., d. 3³⁄₁₆ in.)

Maria Lugossy

Hungarian, born in 1950

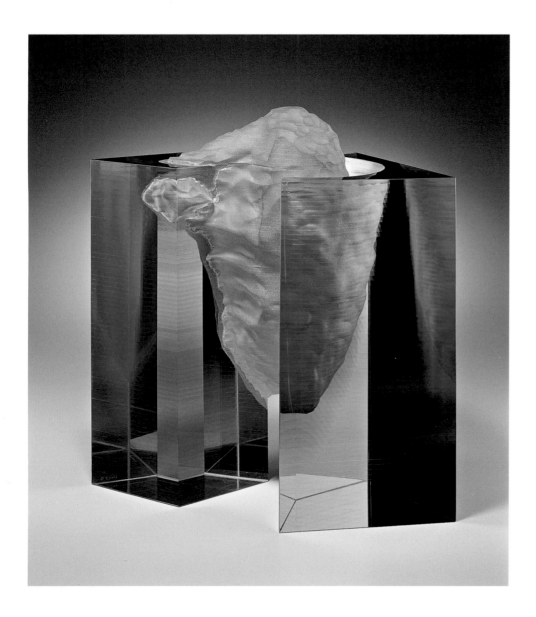

Born in Budapest, Hungary, in 1950, Maria Lugossy has achieved international acclaim as an artist since she finished her undergraduate and graduate work at the Hungarian Academy of Fine Arts in 1975. She works in a constructivist mode, producing works of art in granite, limestone, and metal, as well as glass. She is an active member of the international glass community, and her work has been widely exhibited.[142]

New Dripstone consists of two blocklike sections of crystal-clear green glacial glass (one fashioned in 1996 and the other five years later), with a sandblasted occlusion forming part of the larger section. This iceberglike mass rises above the "surface" of the blocks, but it also descends or "drips" into the crevasse beneath them to an even greater extent. The arrangement of the two segments creates striking reflections, varying based on the perspective of the viewer and the available light.

New Dripstone
Budapest, Hungary, 1996–2001
Laminated, polished, and sandblasted glass
H. 24.8 cm, w. 43.2 cm, d. 23.5 cm
(H. 19¾ in., w. 17 in., d. 9¼ in.)

Albert Paley

American, born in 1944

Following in the footsteps of Samuel Yellin of
Philadelphia and others, Albert Paley is a master metal-
smith known for his ability to fashion fluid forms in
steel. Best known for his gates at the Renwick Gallery
in Washington, DC, Paley's jewelry, furniture, and other
objects have earned him national and international
acclaim. While evocative of historic styles such as art
nouveau, Paley's personal interpretations—ranging
from exquisite jewelry to monumental outdoor sculp-
tures and architectural commissions—are instantly rec-
ognizable as modern expressions that represent a blend
of the best from the past and present. Significantly,
Paley's work stands as a rejection of hard-edged, mini-
malist modernism.[143]

His tall *Millennium Floor Lamp*, entwined with
ribbonlike bands of steel from the base to the top, is
a major example of Paley's work at the end of the last
century.[144] Like all his pieces, it relies for its visual suc-
cess on an incredible fluidity of line, made even bolder
here by the large scale of the lamp.

Millennium Floor Lamp (one of a pair)
Rochester, New York, 1999
Formed and fabricated steel, glass, electrical wiring
H. 182.9 cm, diam. 74.9 cm
(H. 72 in., diam. 29½ in.)

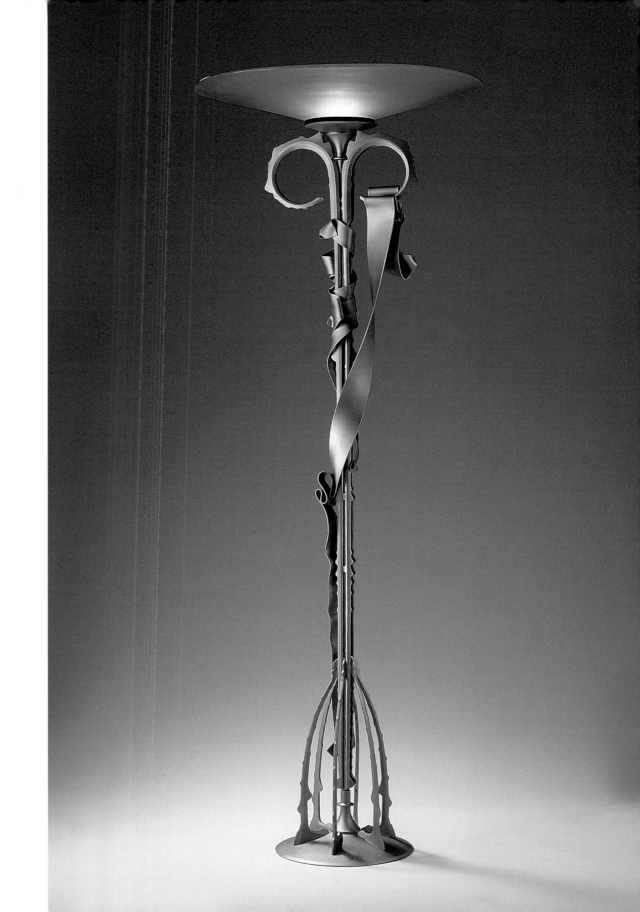

Martin Rosol

Czech, born in 1956

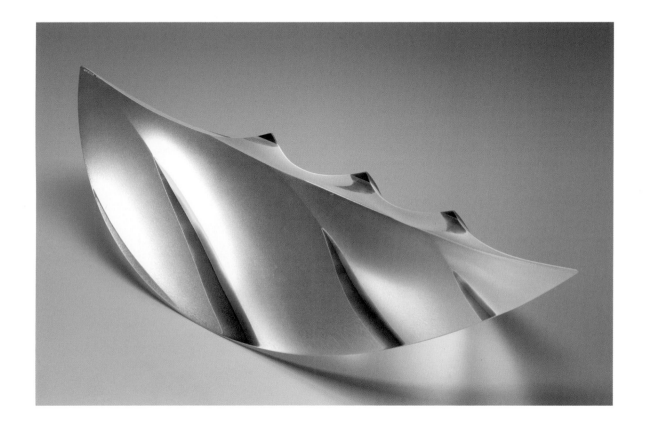

Glass artist Martin Rosol, who immigrated to the United States in 1988, creates his sculptures by laminating cut blocks of crystal into abstracted geometric forms. In his Psychorealm series, Rosol departs from his usual architectonic repertoire to explore the inter- and extraplanetary worlds of the ocean and the cosmos. Both realms have deep psychological and mythical associations. In addition, both realms reflect light, either via the water's surface or through the stars in the sky. *Psyquatica* also reflects and captures light while paying homage to the aquatic world in its clamlike shape and coloring. The work is a multidimensional monument to light, but also a psychological connection to our subconscious.

Psyquatica
Charlemont, Massachusetts, 2005
Laminated and polished glass
H. 14 cm, w. 58.4 cm, d. 22.9 cm
(H. 5½ in., w. 23 in., d. 9 in.)

Helen Shirk
William C. Leete

Americans, born in 1942 and 1950

This sculpture represents the combined talents of two artists who met at a workshop entitled "Breaking Barriers '98," a seminar devoted to fostering artistic collaboration. Sponsored by the Saskatchewan Craft Council, the event attracted more than one hundred artists to Emma Lake in Saskatchewan, Canada.

Helen Shirk, an internationally recognized metalsmith who has been a professor and head of the jewelry and metalsmithing department at San Diego State University since 1975, contributed the polychromed metal section, shaped into a plant-like form and then colored with patina and Prismacolor pencils.[145] The sculptural maple base, designed to house the metal element, was turned and carved by William C. Leete, a professor of woodworking, furniture design, and product design at Northern Michigan University in Marquette since 1974. As Professor Leete observes, "The whole work had a resemblance to a large snail."[146] Both Leete and Shirk attended the conference again in 2000 and collaborated on another untitled work of art.

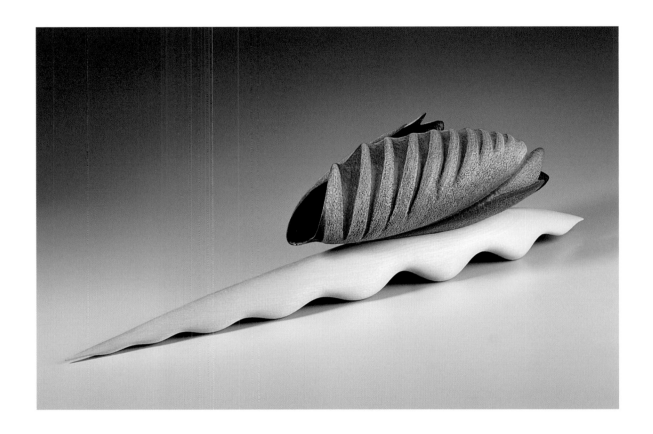

Untitled
Emma Lake, Saskatchewan, Canada, 1998
Copper, patina, Prismacolor; maple base
H. 12.7 cm, w. 61 cm, d. 15.2 cm
(H. 5 in., w. 24 in., d. 6 in.)

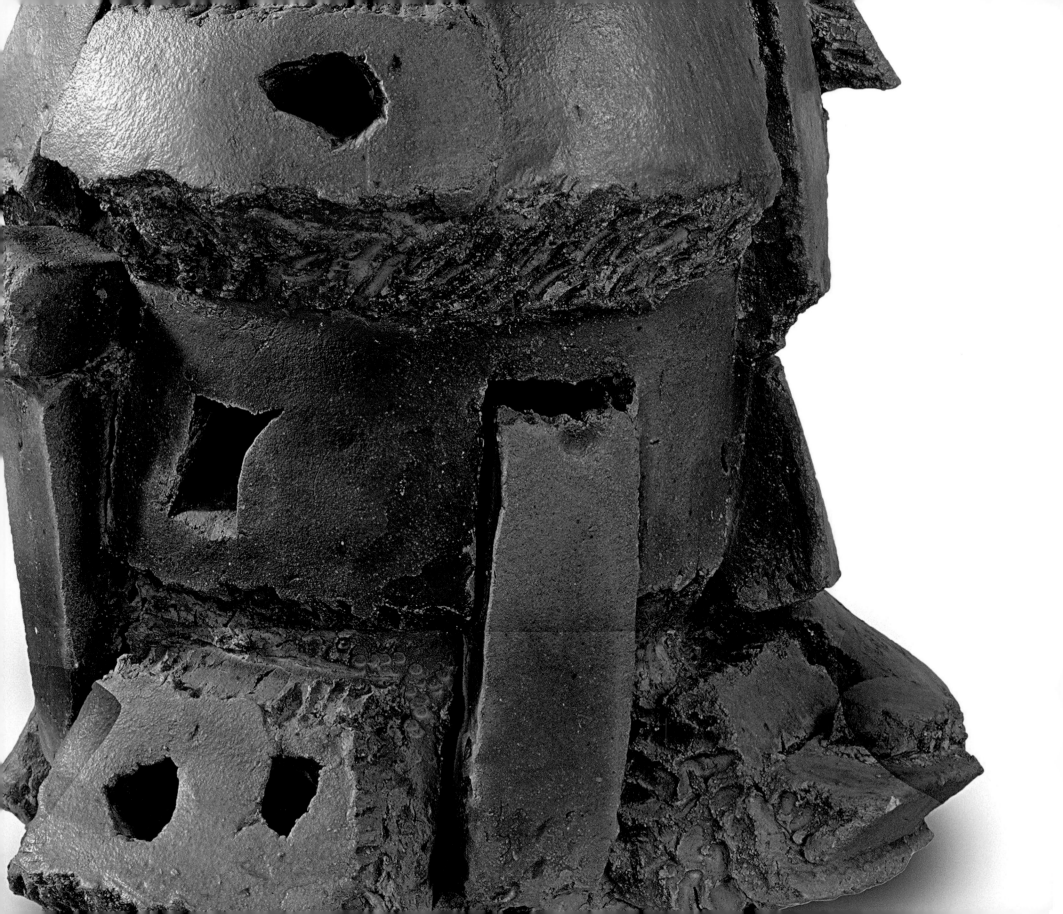

Peter Voulkos
American, 1924–2002

As one of the seminal figures in American studio ceramics, Peter Voulkos revolutionized the field in the 1950s and 1960s by moving away from function and toward greater personal expression and abstraction.[147] Rather than rejecting ceramics in favor of sculpture, however, Voulkos used clay in a fresh and spontaneous way while celebrating the vessel form and the inherent earthiness of ceramics. Working quickly with wet clay, Voulkos stacked wheel-thrown pots, which he paddled, gouged, and sliced to reveal the hollow spaces of the vessels. His assembled forms create dynamic oppositions between the smooth outer surfaces and the jagged, ripped edges where the pots are torn open. Voulkos remained active in ceramics for nearly five decades; this work, made one year before his death, reflects the monumental "bottle-shaped" forms he explored in his later years. Recalling the architectonic forms of sixteenth-century Japanese *haniwa* terracotta figures, this vessel embodies the forceful and imposing qualities of Voulkos's mature work.[148]

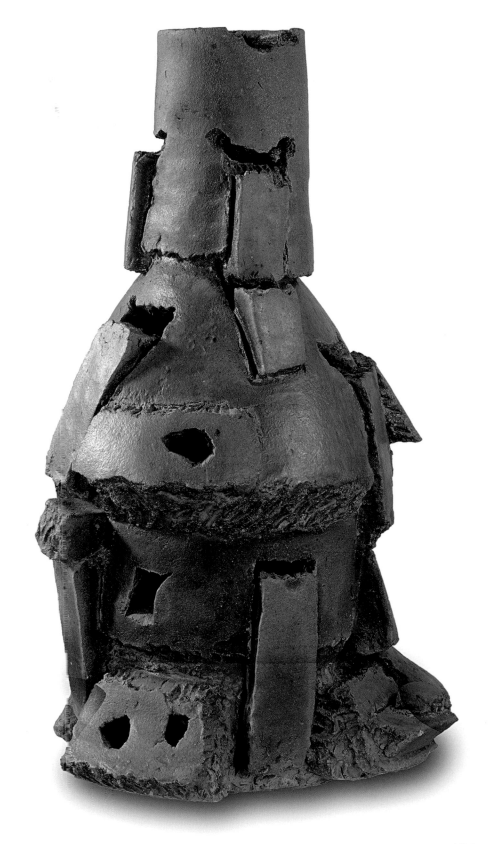

Isis
Bowling Green, Ohio, 2001
Woodfired stoneware
H. 128.3 cm, w. 66 cm, d. 66 cm
(H. 50½ in., w. 26 in., d. 26 in.)

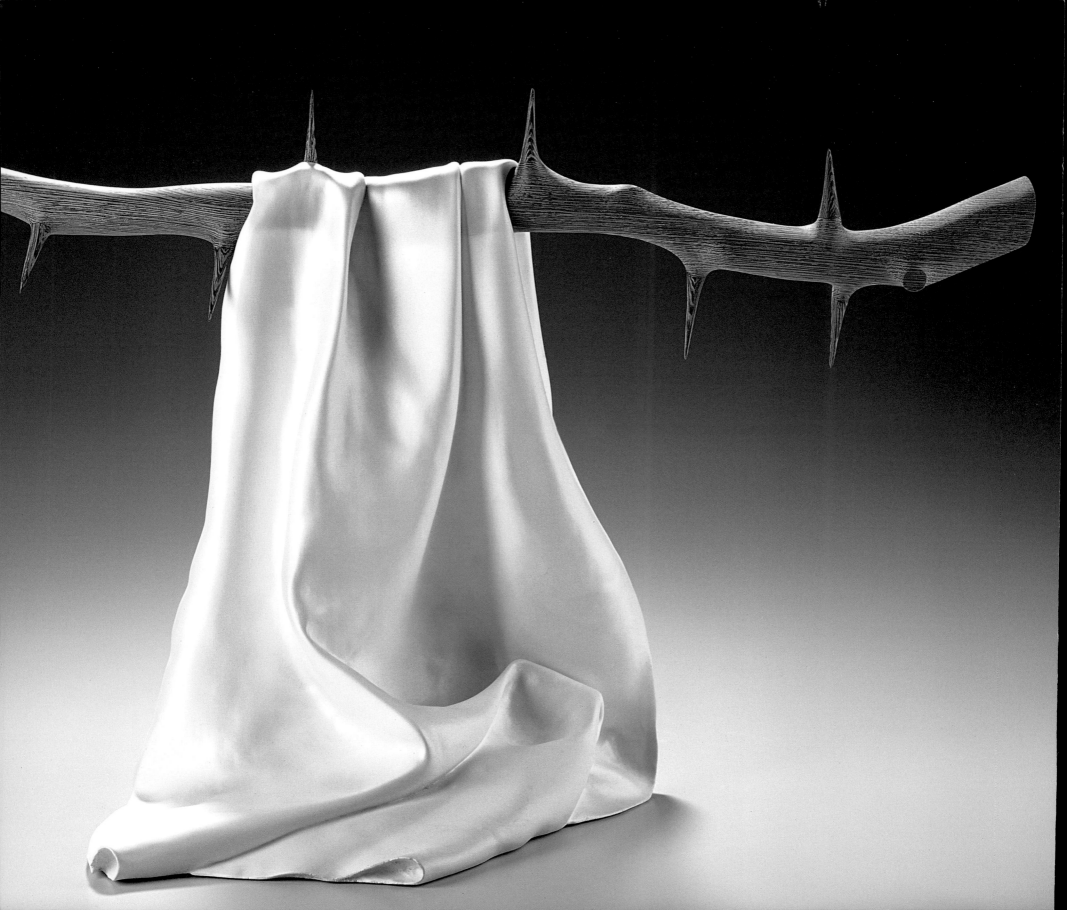

MATERIALS · ILLUSIONISM

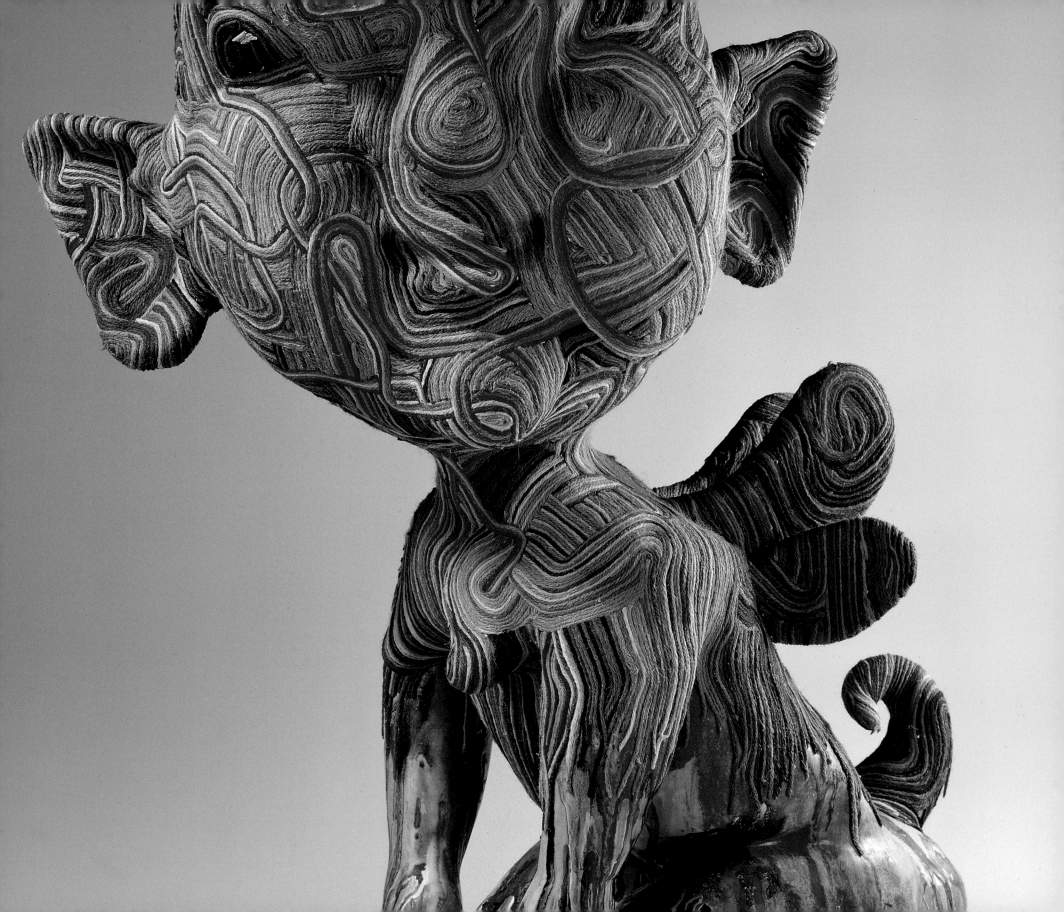

Michael Lucero

American, born in 1953

She Devil
Upper Nyack, New York, 2005
Ceramic with glazes and wool yarn
H. 76.2 cm, w. 58.4 cm, d. 35.6 cm
(H. 30 in., w. 23 in., d. 14 in.)

Best known over the years for his work in ceramics, Michael Lucero, in *She Devil*, demonstrates his departure into mixed materials. Here, he wrapped wool yarn around the head of a kneeling figural female form, while the bottom half of the ceramic object is glazed with dripping polychrome colors. The result is a startling image worthy of its name.

Inspiration for *She Devil* and its related works came while Lucero was living and working in Faenza, Italy, where he was captivated by the colorful yarn produced by the local Missoni knitting factory. The surreal figure, with its oversize head and protuberant ears, is part of a series of works that feature what the artist calls "personified, untouchable images," including mermaids, elves, and pixies, in addition to the devilish apparition seen here.[149]

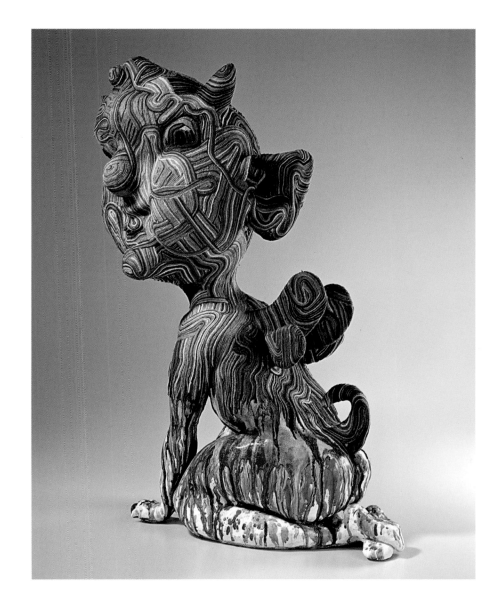

Tom Eckert

American, born in 1942

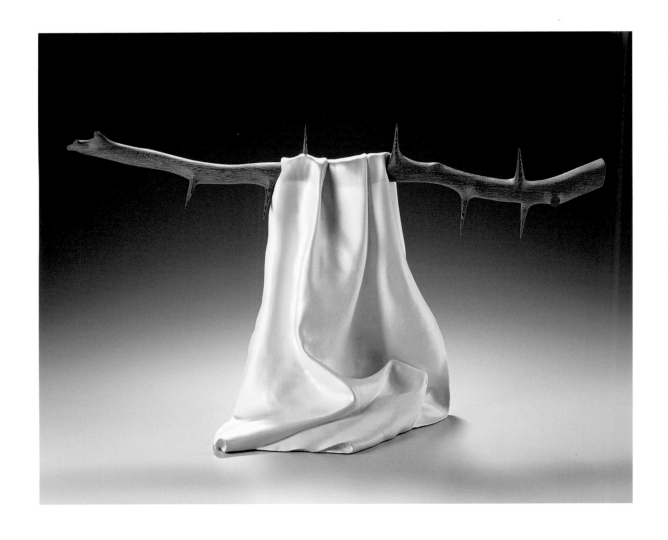

In a manner similar to some of the early furniture of Wendell Castle (see p. 123) and exquisite carved vessels of Michelle Holzapfel (see p. 154), Arizonan sculptor Tom Eckert confronts the viewer's perception of reality. By producing highly realistic trompe l'oeil compositions of seemingly disparate objects, Eckert creates a covert narrative that reflects the human condition. In *Floating Chimera,* Eckert drapes his trademark white "silk" scarf over a thorny branch that appears to hover in midair. Eckert uses water-borne acrylic paint to airbrush the textured surface. The soft drapery of the scarf, seemingly supported by the floating branch, poses an immediate physics problem that draws the viewer in. The answer to the problem lies in the piece's clever title. While a chimera is typically defined as a fabled monster from Greek mythology, it can also mean "a fanciful mental illusion or fabrication."[150]

Floating Chimera
Tempe, Arizona, 1999
Sculpted and lacquered linden and
wenge woods with acrylic paint
H. 30.5 cm, w. 53.3 cm, d. 25.4 cm
(H. 12 in., w. 21 in., d. 10 in.)

Gugger Petter

Danish, born in 1949

Working primarily with newspaper, Danish-born artist Gugger Petter weaves images of daily life. To Petter, her chosen medium provides a means of not only dating her work, but also recording the historical events of the time. Each piece becomes a time capsule documenting its moment of creation. Petter begins by sorting the newspaper according to color, keeping in mind how the overall tone will be read from a distance (photographs, for instance, read gray, and comics and advertising circulars add color). She then rolls the pages into tubes that she attaches end to end to create a thick paper "yarn." Petter then skillfully weaves this "diary of our lives" into oversized close-ups from daily existence—faces, glasses, shoes. Once completed, Petter finishes with varnish and occasional touches of paint to enhance the color.

In *Bolsjer #1*, Petter focuses on the abstract forms of the "hard candy" (*bolsjer* in Danish) that she knew from her childhood in Denmark. While representational, the image can also be seen as an abstraction of form and color. The use of such non-traditional material blurs the line between relic and rubbish, forcing the viewer to reinterpret objects traditionally considered waste.

Bolsjer #1 (Hard Candy #1)
Lagunitas, California, 2006
Woven newspaper, hemp
H. 190.5 cm, w. 157.5 cm
(H. 75 in., w. 62 in.)

Lia Cook

American, born in 1942

Prodigious fiber artist Lia Cook has built a reputation for pushing the boundaries of her medium. Her latest work uses contemporary technology to weave nostalgic images of childhood, aging, and life experience. Cook isolates close-ups of family snapshots, focusing her eye on emotional elements such as the hands and face. Just as Rumpelstiltskin magically wove hay into gold, Cook then weaves the image into cloth using a computerized Jacquard loom. Weaving the grains of the enlarged film into the fiber, Cook creates cloth that is reminiscent of pointillist images by artists such as Georges Seurat, abstracted independent pixels that become a recognizable image as one steps farther away. In *Half Seen*, Cook uses her own image from childhood, recalling the nostalgia of blurry family memories.

Half Seen
Berkeley, California, 2004
Woven cotton
H. 233.7 cm, w. 139.7 cm
(H. 92 in., w. 55 in.)

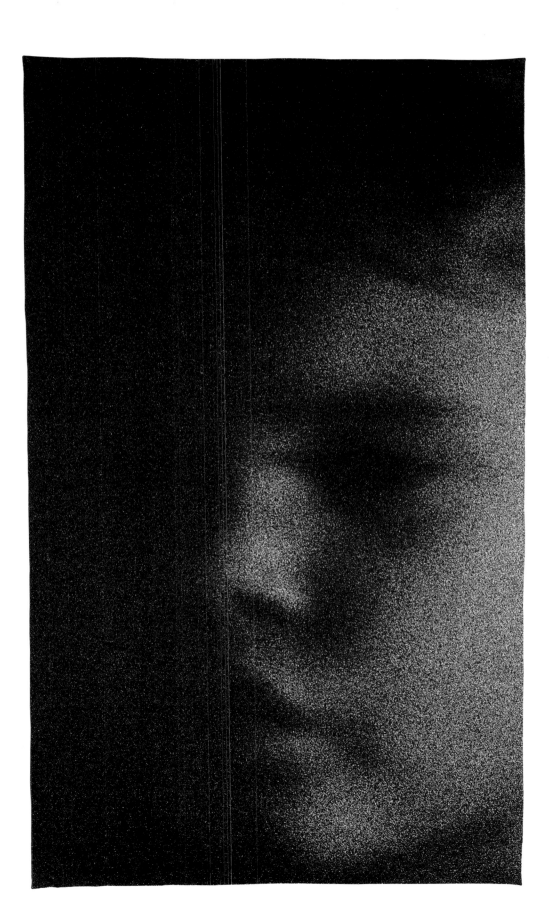

Norma Minkowitz

American, born in 1937

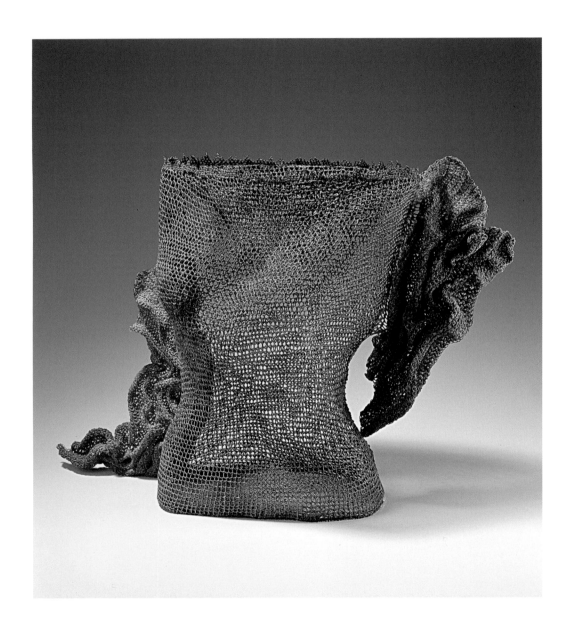

The crocheted work of Norma Minkowitz nimbly straddles the worlds of craft and sculpture. Using the traditionally feminine art of crochet, Minkowitz manipulates the domestic occupation to create ethereal works of art that combine the concept of containment with the figural form. Minkowitz's devotion to crochet, a weaving technique traditionally used to make clothing, is appropriate, for while her finished work stands freely in three dimensions, Minkowitz creates her work through a process of swaddling. Starting with a circular shape, the artist wraps her crochet around a mold—a mannequin, bust, abstract form, or whatever interests her. She then stiffens the soft fiber with shellac and resin. The resulting skeletal mesh plays on the dichotomy between the supple web and rigid structure. Transparent and seemingly fragile, each piece speaks to the vulnerability of the human condition.

Medusa
Westport, Connecticut, 1991
Crocheted fiber with paint
H. 45.7 cm, w. 66 cm, d. 20.3 cm
(H. 18 in., w. 26 in., d. 8 in.)

Michal Zehavi

Israeli, born in 1966

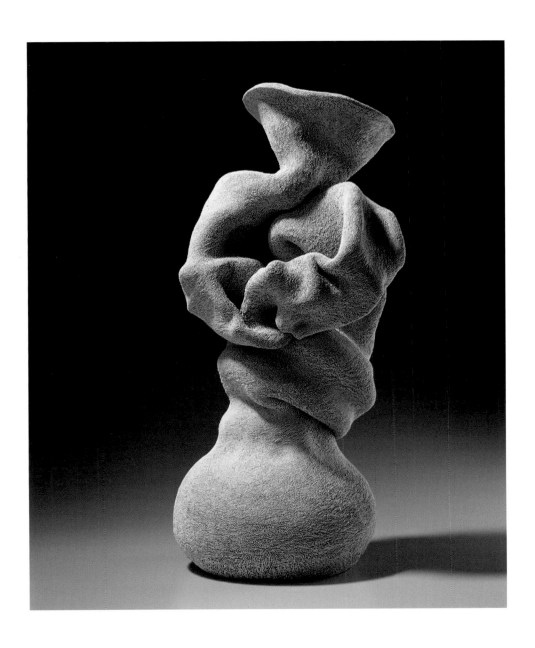

Michal Zehavi is among a group of young Israeli artists who are becoming better known in the United States due to the efforts of AIDA, the Association of Israel's Decorative Arts. In contrast with potters like Peter Voulkos and Don Reitz, whose rough-edged works emphasize the earthiness of clay and the strength and power of great pots, Zehavi deliberately challenges these traits of the medium. Working in white clay, Zehavi creates objects in which brittle ceramic vessels are made to appear soft, spongelike, and organic; the forms seem to be in the process of disintegrating and collapsing inward. The closely spaced perforations dotting the surface suggest an organism's cellular structure or porous skin and—like the crafts of knitting and metal hammering—reveal the artist's time-intensive, repetitive labor.[151] For the artist, this absorbing and detailed handwork takes on a spiritual quality and is a central theme of her work.

Shell #4
Jerusalem, Israel, 2005
White clay
H. 61 cm, w. 30.5 cm, d. 30.5 cm
(H. 24 in., w. 12 in., d. 12 in.)

Michelle Holzapfel

American, born in 1951

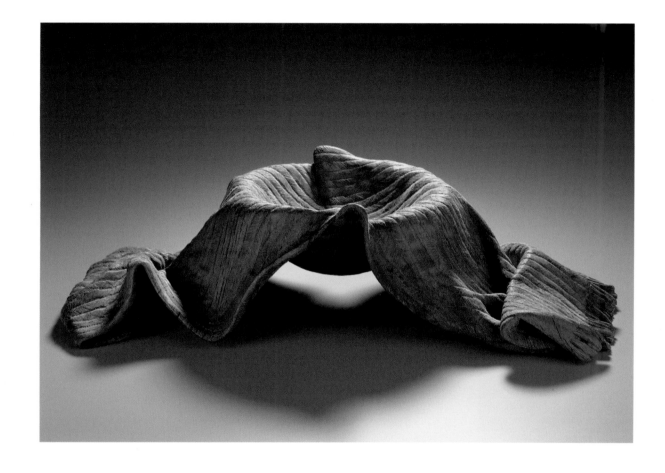

Chiefly self-taught, Michelle Holzapfel has emerged as a world-class wood sculptor in a field largely dominated by men. Her subject matter leans toward common objects found in nature or in the rituals of domesticity—baskets, leaves, scarves, vases, and so on—each done in exacting detail. Her vessels tend toward sculpture rather than functional objects, their ultrareal illusionistic effects beguiling the eye with their decorative nature, much like the work of Tom Eckert (see p. 148). In *Scarf Bowl*, Holzapfel first turned a shallow bowl form before intricately carving the soft drapery of a scarf that appears to lie across it. The power of the piece comes from the contrasting nature of the materials and the subject: the hardness of the wood versus the delicacy of the scarf. The way the scarf lifts the bowl from the ground and supports it rather than the other way around belies the suppleness of the material.

Scarf Bowl
Marlboro, Vermont, 1992
Turned and carved yellow birch burl
H. 10.2 cm, w. 39.4 cm, d. 19.1 cm
(H. 4 in., w. 15½ in., d. 7½ in.)

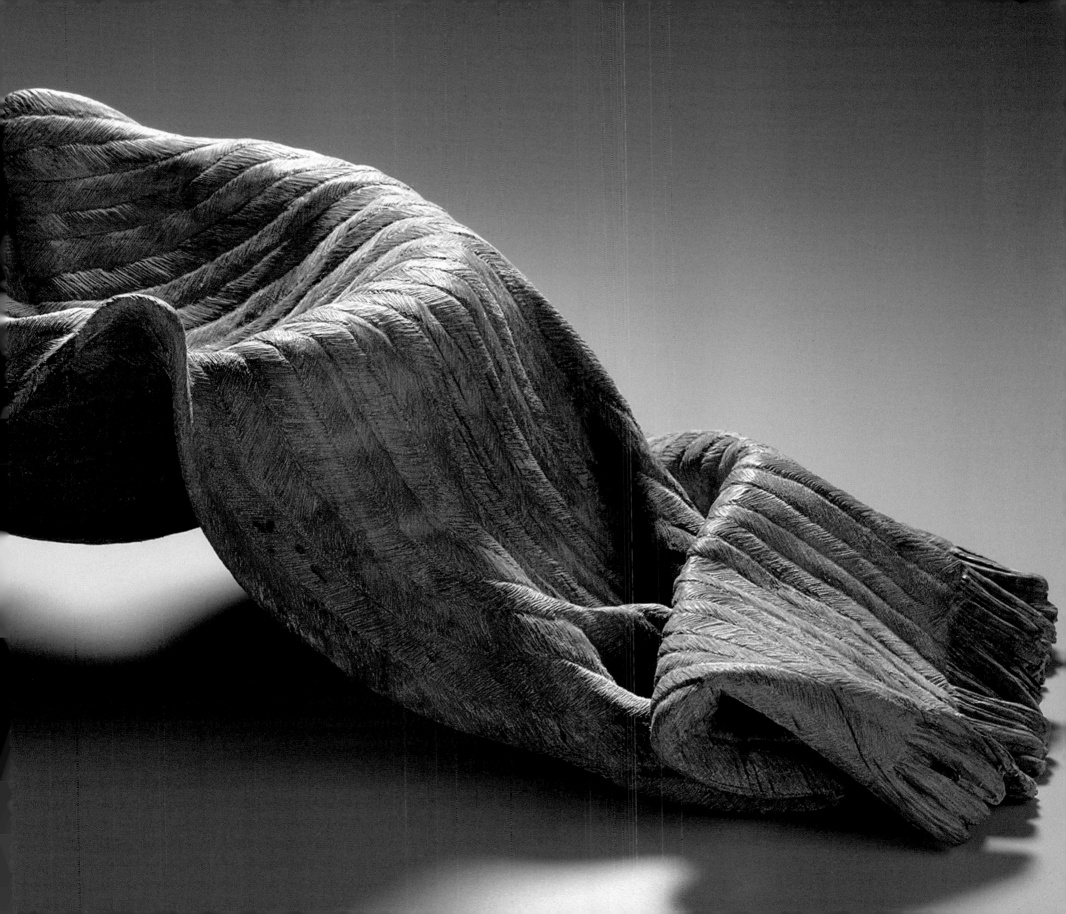

Jean-François Escoulen

French, born about 1956

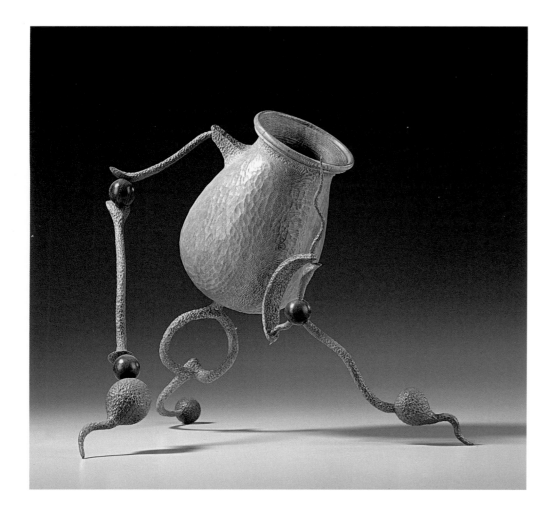

After serving a seven-year apprenticeship under his father, a traditional wood turner, French artist Jean-François Escoulen established his own shop in 1979, working with his wife, a trained cabinetmaker. Initially he produced standard production-line turning, but he quickly grew tired of such routine work. "I was tired of the same thing, day in and day out. I saw the work of some of the old French ornamental turners in a museum and wondered how they produced such extraordinary work." Pursuing his goal of making more "eccentric" shapes, he "devised a chuck consisting of a ball and socket which enabled me to swing the work around its central axis. I called it de-axising and when I took the idea to a local engineer he was able to make what I wanted. . . . [S]oon I was de-axising the whole work."[152]

In 1996 Escoulen received a fellowship at the International Turning Exchange in Philadelphia, which transformed his life. Starting with boxes and moving to other forms, such as *La cruche en folie* (The Crazy Pitcher), he has created asymmetrical, off-balance, crooked, and assembled forms that take advantage of both his traditional and innovative technical skills.[153] In time, he has become the most influential figure in the woodturning movement in France.[154]

La cruche en folie (The Crazy Pitcher)
Puy-Saint-Martin, France, 1997
Turned and carved sycamore,
cocobolo, pernambuco
H. 26.7 cm, w. 33 cm, d. 22.9 cm
(H. 10½ in., w. 13 in., d. 9 in.)

Ron Gerton

American, born in 1946

Out on a Limb No. 2
Richland, Washington, 1997
Spalted curly maple, bronze
H. 58.4 cm, w. 61 cm, d. 40.6 cm
(H. 23 in., w. 24 in., d. 16 in.)

An experienced engineer in the nuclear field, Ron Gerton has made jewelry for many years; in the early 1990s he began to work in bronze and then wood turning. He combined all of these interests and skills in the creation of *Out on a Limb No. 2*, a technical tour de force.

The metal parts of this work are created using what Gerton calls "the lost wood process." He selects sagebrush fragments from the dry desert environment near his home in eastern Washington and "gives them permanence in bronze." To do so, "A ceramic material capable of withstanding high temperatures is placed around the wood. The wood is heated in a kiln until the wood is completely burned out, then molten bronze is poured into the cavity, creating an exact bronze duplicate of the original wooden piece." Several of these are then welded into what Gerton calls a "Bronzai," a reference to his capture in metal of the natural forms of a bonsai tree.

Gerton selected spalted maple to make the hollow vessel section of this piece. He prefers wood that "is often decayed, resulting in spectacular colors and black line patterns." To form the hollow vessel, "wood is rotated on a lathe while holding a sharp cutting tool stationary on a tool rest. Once the outside is cut to the desired shape, a tool is inserted through the small center hole to cut the wood on the inside. This is a fairly slow process since it is necessary to stop frequently to remove the shavings. After the wood is turned to a uniform thinness, it is slowly dried, sanded and finished."[155] In this manner, Gerton has been able to produce hollow forms some four feet in diameter.[156]

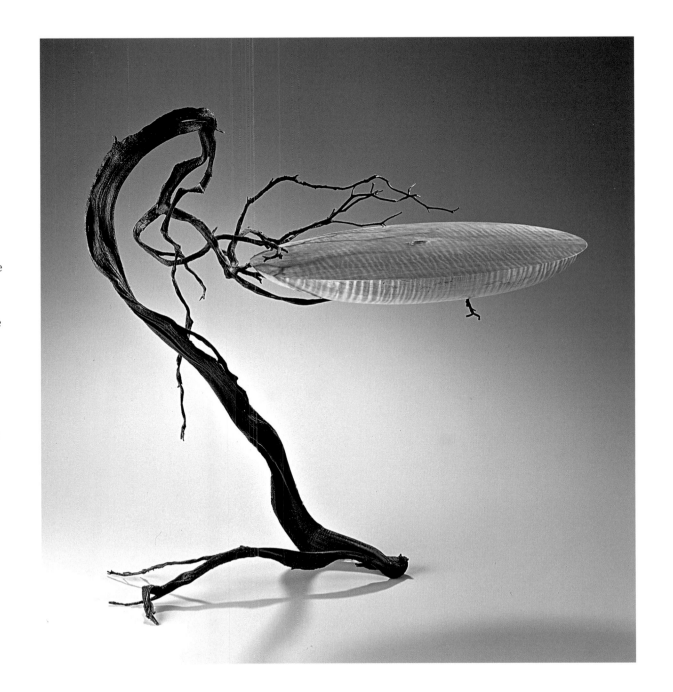

Michael James Peterson

American, born in 1952

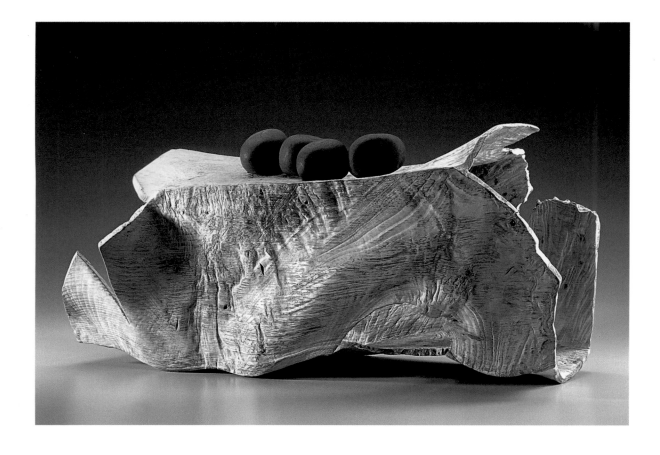

Michael James Peterson, a self-taught artist born in Texas but now living in the Pacific Northwest, derives his inspiration from the raw materials and the rocky coastline near his home in the state of Washington or the landscape of the American Southwest. His technique allows him to echo the "natural sculpting forces of wind, sand, sun, and water to achieve a more stone-like imagery." Many of his earlier works were turned vessels, influenced by the work of David Ellsworth (see p. 161) and Mark Lindquist, but in recent years he has moved away from the lathe and focused on more sculptural forms that are chainsawn, sandblasted, bleached, and textured in a "geological" manner. Although nature has perhaps been the most dominant influence on Peterson's work, the artist also indicates his indebtedness to the sculpture of Henry Moore, Barbara Hepworth, and Jean Arp.[157]

Earth and Stones II is a wall-mounted work, with a hollow and pierced "earth" body of madrone surmounted by four loose "stones" of African blackwood. It is a major example of the artist's recent interest in "arrangements." "Framing the organic object within grouped arrangements or constructions gave me added freedom as a maker to create the individual object and then explore its larger potential. This approach requires an ever-evolving concept of presentation that is aimed at creating greater visual interest and a stronger sculptural statement."[158] Madrone (*Arbutus manziesii*), also called Pacific madrone, is a beautiful hardwood, heavy and strong, known for its burls.

Earth and Stones II
Lopez Island, Washington, 2004
Madrone burl, African blackwood
H. 35.6 cm, w. 73.7 cm, d. 33 cm
(H. 14 in., w. 29 in., d. 13 in.)

George Peterson

American, born in 1966

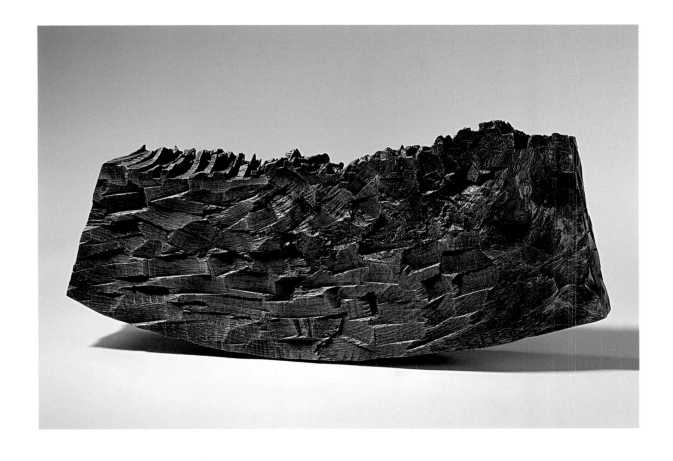

The gently curved form of *Arch* is notable for the jagged and irregular edges that top each vertical segment of the work. This "invasive" technique produces a "distressed" quality that leads curator Mark Richard Leach to liken Peterson's work to slabs of stone roughly extracted from a quarry. Other recent works, in the form of squares, columns, and other bold shapes, similarly demonstrate the rough-hewn, textual qualities of Peterson's technique.[159]

A native of California, Peterson has been working independently since 1992 as a self-taught artist and woodworker. His approach to his work is straightforward and uncomplicated: "I take an intuitive and spontaneous approach to my work. The action of shaping the wood with my hand-held tools is satisfying in a very basic way. As I work the wood, I collaborate with it. The wood has a voice and I have a voice. We interact."[160] He currently produces both "bowls" and "sculptures," such as *Arch*.

Arch
Lake Toxaway, North Carolina, 2005
Carved and painted oak
H. 25.4 cm, w. 62.2 cm, d. 14 cm
(H. 10 in., w. 24½ in., d. 5½ in.)

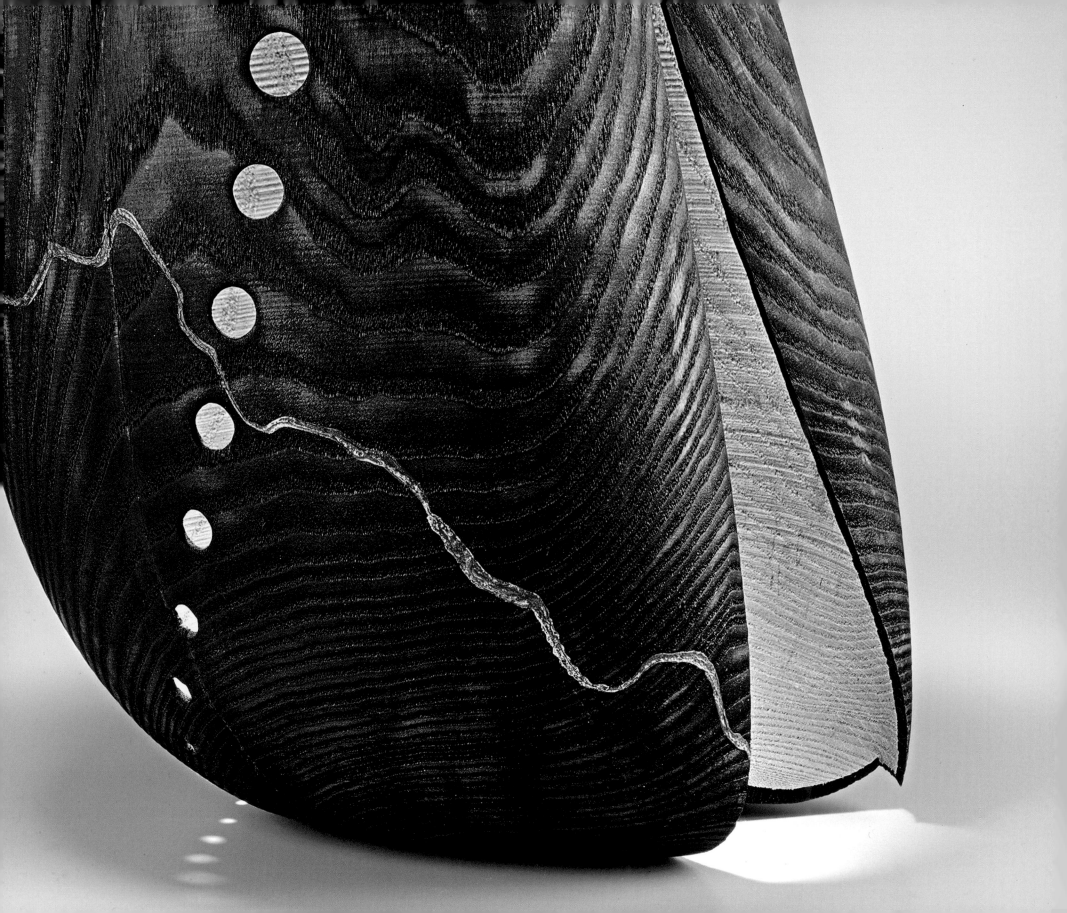

David Ellsworth

American, born in 1944

After studying art at the University of Colorado, David Ellsworth began turning wood in 1975 in a small studio in Colorado. He soon developed a series of bent turning tools that allowed him to produce extraordinarily thin vessels that were also responsive to the inherent characteristics of the wood selected for a given piece—be it root, trunk, or burl.[161] His thin-walled vessels, reminiscent of similar ceramic works like those by Richard DeVore (see p. 110), astounded wood-workers at the time.

A signature piece in the Wornicks' wood collection, Ellsworth's *Machel* is from his "Solstice" series of 1989–91, which included "interspheres" and "monospheres." The artist regards *Machel* as a "breakthrough" work in this series whose painted and burned surfaces "allowed me to introduce a new vocabulary in woodturning that would challenge our preconceptions of what a turned object 'could' be, or 'should' be. These pieces have been both loved and despised: What more could I ask for?"

As he notes, "These opened forms reveal raw edges and dramatic interiors, aglow with vibrant colors which define the inner space as volume. The contrasts between interior and exterior surfaces are intentionally strong. Yet their proximity is so close, and the walls so remarkably thin, they almost seem to be united; separate, but inseparable... as if bonded."[162]

In addition to his artistic work, Ellsworth has been an active advocate for his profession, playing an important role, for example, in the creation of the American Association of Woodturners.

Machel
Quakertown, Pennsylvania, 1991
Turned, cut, burned, and painted ash
H. 45.7 cm, w. 33 cm, d. 37.8 cm
(H. 18 in., w. 13 in., d. 14⅞ in.)

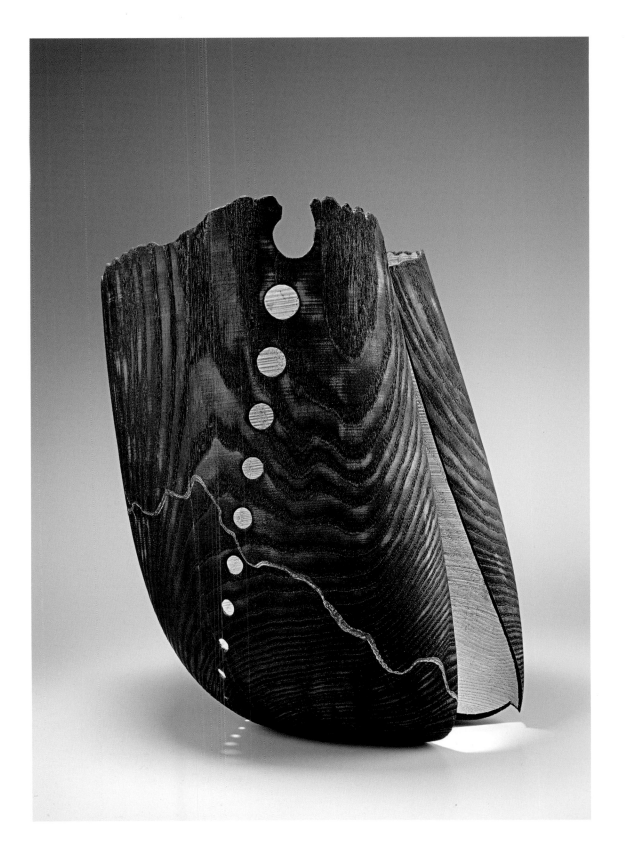

Giles Gilson

American, born in 1942

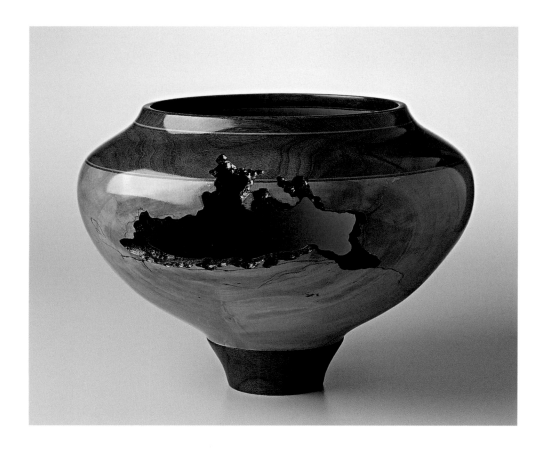

Craftsman Giles Gilson has made a career of breaking the rules. Shocking his fellow wood artists, who worshiped the inherent qualities of the material, Gilson boldly covered his vessels in lacquer and paint, transforming their surfaces into his canvas. In *Point of View*, Gilson draws inspiration from Dada artist René Magritte and illusionist M. C. Escher to play with the viewer's perceptions of reality. What looks to be a natural cavity in the wood is, on closer inspection, an impossibility, its burly hole creeping into the laminated secondary woods. Part of the hole appeared naturally in the burl and Gilson sculpted the rest to match. "I'm playing with the dynamic of the opening in the wall, creating a change in the perceived image when viewed from different angles," explains Gilson.[163] Challenging the viewer to look deeper, Gilson's *Point of View* at the same time pokes fun at the naturalistic trends of the time.

Point of View
Schenectady, New York, 1989
Laminated, turned and painted cocobolo,
holly, ebony, walnut, and elder woods
H. 15.2 cm, w. 21.6 cm, d. 21.6 cm
(H. 6 in., w. 8½ in., d. 8½ in.)

Stephen Johnson

American, born in 1957

Like Gugger Petter (see p. 149), Stephen Johnson uses humble forms of paper to fashion his basket forms. As he wrote recently, "About six years ago I read, for the first time, Ed Rossbach's *The Nature of Basketry*. There is a section in the book where Rossbach talks about 'temporary baskets'; these are made quickly in the 'bush,' with whatever materials were at hand. This notion is the single most influential factor in why I have chosen the materials I use." He was also influenced by the work of John McQueen (see p. 101) and John Garrett (see p. 96), which he saw in an exhibition at Arizona State University, where he teaches.[164]

Johnson uses common things, such as raffle tickets or business cards, secured with basic household staples, to create his own "temporary" baskets. Here, paper and reed are woven together and colored with shoe polish. The name of this example is a reference to the related ceramic vessels produced by the Hopi Indians in northern Arizona.

Hopi
Mesa, Arizona, about 2003
Paper, reed, shoe polish
H. 16.5 cm, w. 29.2 cm, d. 29.2 cm
(H. 6½ in., w. 11½ in., d. 11½ in.)

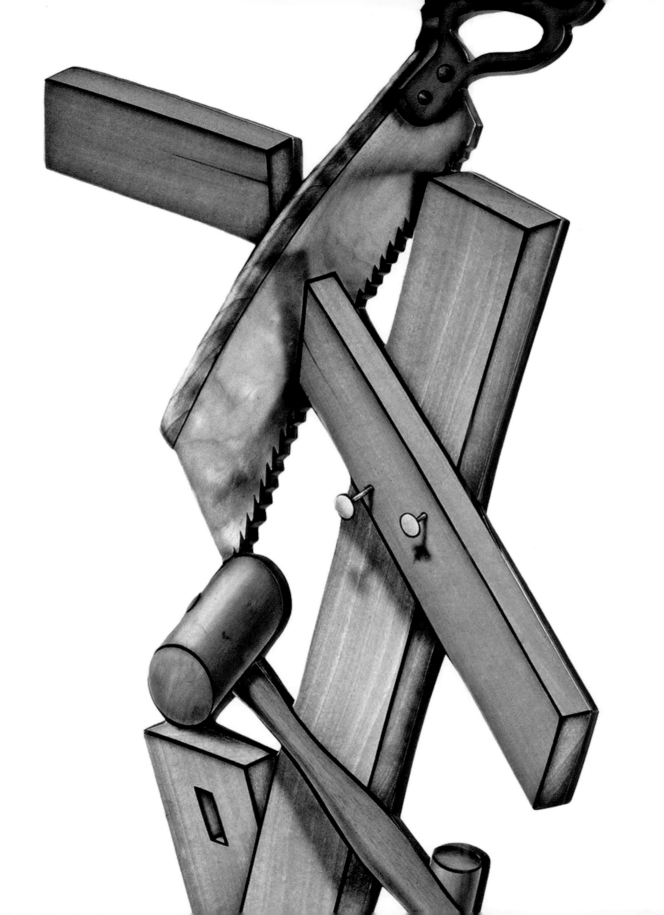

John Cederquist

American, born in 1946

John Cederquist's witty and surrealistic furniture blurs
the line between real objects and images of objects;
The Chair That Built Itself is both a functional chair
and a picture of a chair. In the 1980s, Cederquist be-
came interested in the pictorial and spatial qualities of
Japanese woodblock prints and American cartoons. As
he began to incorporate these pictorial techniques into
furniture, he used veneering, inlaying, airbrushed pig-
ments, and dyes to create illusionistic two-dimensional
imagery on three-dimensional plywood frames. Each
object looks "correct" from a single point of view, but
as the viewer moves around the object, distortions
appear and the illusion is broken.[165]

This chair refers to the Wornick family's history
in woodworking by spoofing the woodworker's art,
using cartoonlike imagery of saws and chisels working
autonomously on a haphazard pile of boards. Like the
bewitched brooms carrying buckets of water in "The
Sorcerer's Apprentice" (in Disney's 1940 film *Fantasia*),
the image suggests that tools can take on a life of their
own.

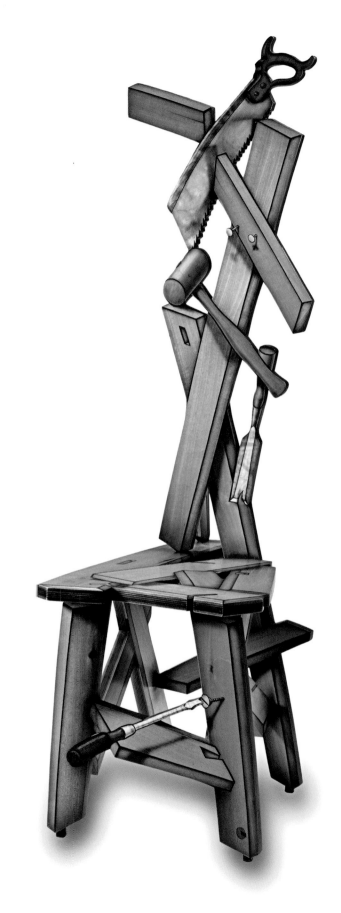

The Chair That Built Itself
Capistrano Beach, California, 2000
Plywood, wood veneers, litho ink
H. 147.3 cm, w. 43.2 cm, d. 61 cm
(H. 58 in., w. 17 in., d. 24 in.)

Gord Peteran

Canadian, born 1956

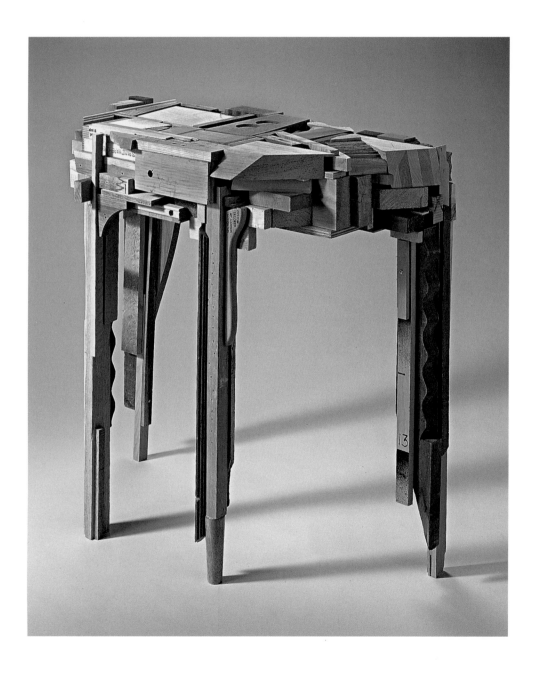

When the Wornicks received a package from Gord Peteran, it was curiously small, not large enough to contain the table that they commissioned from the Toronto-based artist. Inside was a scrap of wood with a pencil inscription: "DEAR ANITA + RON / HANG ONTO THIS / THERE IS MORE ON / ITS WAY / GORD." By sending this seemingly worthless, irregularly shaped piece of wood, Peteran not only teased and amused his clients, but also revealed much about his artistic process.

Aligning himself more with conceptual artists than with furniture makers, Peteran often starts with a found object, such as a pile of scrap wood, and manipulates it to create a work of art without compromising the integrity of the initial found object. For this piece, he arranged pieces of scrap wood into a form that suggests a table, yet the work's uneven top surface and seeming instability make one question its aptitude for that role. Peteran does not seek to make functional furniture, but art that refers explicitly to furniture. The artist has written, "In this piece, I started at one corner and worked right through to the other side, wanting to make something that would be quick and impressionistic—like my paintings."[166] Peteran involved his clients in this conceptual artistic process by having the Wornicks place the final piece of the puzzle, the scrap of wood sent earlier, to complete the work.

A Table Made of Wood
Toronto, Ontario, Canada, 2005
Various woods
H. 94 cm, w. 91.4 cm, d. 43.8 cm
(H. 37 in., w. 36 in., d. 17¼ in.)

Michael Hosaluk

Canadian, born in 1954

Michael Hosaluk approaches his art by starting with a design idea or a story to tell, then selects materials and techniques that express that concept. Like other wood-workers and furniture makers who became active in the 1980s, Hosaluk uses wood as a vehicle for surface design and personal narrative. While he sometimes designs objects to showcase natural materials, such as an interesting piece of salvaged timber or wood with unusual grain, he also makes objects from plain woods like birch that lend themselves to painting and other rich surface treatments.[167]

In this small piece, Hosaluk combines turned elements to create a whimsical, lopsided table that suggests a precariously balanced assemblage of fruits and imaginative organic shapes. The surfaces of the table are slightly three-dimensional, with a ridged exterior on the top and protruding spikes on the fruitlike forms of the base. Hosaluk has enhanced the lushness of the fruit forms with warm, semitransparent colors, brushed and rubbed to create a richly textured paint surface.

Unusual Fruits
Saskatoon, Saskatchewan, Canada, 2000
Wood, acrylic paint, gels, metal
H. 64.8 cm, w. 55.9 cm, d. 33 cm
(H. 25½ in., w. 22 in., d. 13 in.)

Garry Knox Bennett

American, born in 1934

Ice Pail
Oakland, California, 2001
Metal, glass, lighting elements
H. 26.7 cm, w. 29.2 cm, d. 29.2 cm
(H. 10½ in., w. 11½ in., d. 11½ in.)

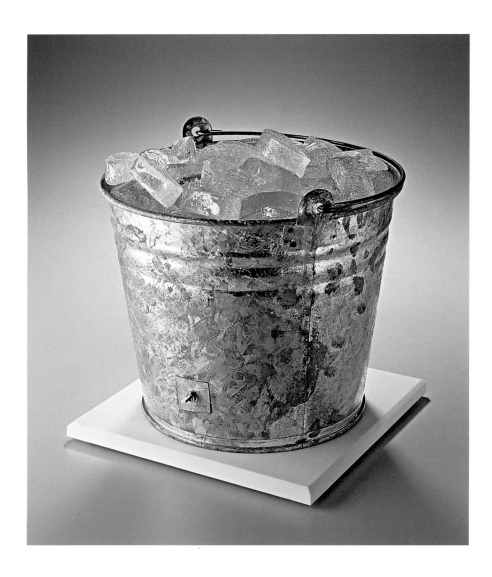

Furniture maker Garry Knox Bennett has attained near-legendary status in the field of studio craft for his free-wheeling, antiestablishment attitude.[168] Displaying his subversive sense of humor, he once used a business card stating that he made "gimcracks for the rich and/or wealthy."[169] For several decades, Bennett has primarily made large-scale furniture, but throughout his career he has also made small, whimsical, mixed-media objects. In the late 1960s, Bennett created counter-culture paraphernalia such as roach clips and peace-symbol jewelry; he soon started a successful metal-plating company and has continued to use metals creatively in his furniture and other works. His gallery shows in the early 1970s showcased metal clocks sprouting clouds, wings, zigzags, and flames, recalling rock posters of the era. The *Ice Pail* lamp—which is only marginally functional as a lighting device but witty and amusing as an object for display—exemplifies Bennett's fondness for unusual materials and visual jokes intended to surprise the viewer.

Hank Murta Adams

American, born in 1956

Yellow Head
Albany, New York, and Milton, West Virginia, 1988
Cast glass with patinated copper
H. 64.8 cm, w. 58.4 cm, d. 58.4 cm
(H. 25½ in., w. 23 in., d. 23 in.)

Originally a landscape and portrait painter, Hank Murta Adams studied at the Rhode Island School of Design before attending the Penland School in North Carolina and eventually the famous Pilchuck Glass School in Washington State. In fact, Adams credits Dale Chihuly, founder of the Pilchuck School, for introducing him to glass and luring him away from painting.[170] Eschewing the beauty of glass, Adams creates a powerful work in a primitive and grotesque style that challenges traditional glass qualities. A master of texture, Adams often sandblasts and mars his surfaces, embedding them with metal and found objects. His opaque works feature garish colors and dull surfaces and his translucent pieces are either colorless or in neutral tones of black and blue.

The cast-glass heads that have become his signature both recall and defy the classical marble bust. Instead of romantic idealizations of heroes and gods, however, they are rough, generalized images of everyday man that examine the extremes of the human condition. In *Yellow Head*, the head contorts upward, eyes bulging yet expressionless, as if the subject had met with a painful death. Indeed, Adams's interest in death and disease is prevalent throughout his work, likely the result of his mother's long struggle with multiple sclerosis and the effects of HIV among his peers. Adams created the mold for *Yellow Head* at his studio in Albany, New York, but cast the piece at the Blenko Glass Company in Milton, West Virginia, where he was lead designer from 1988 to 1994.

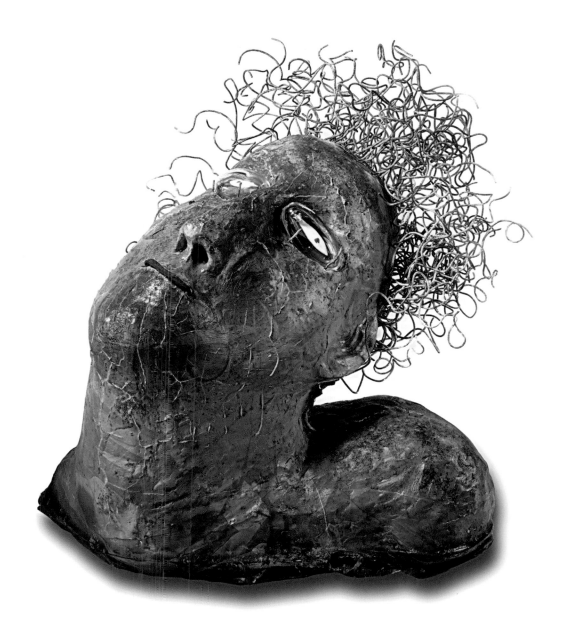

Paul Richard
American, born in 1961

Artist Paul Richard challenges boundaries and precon-
ceived perceptions about art and the context in which
it is viewed. Believing that the venue does not validate
the art, Richard has made a career of "guerrilla show-
ings," displaying his art on chain-link fences, the backs
of jackets, and even in K-Mart. *Olga* first appeared,
along with thirty other similar pieces, when the artist
hung the mixed-media doors on a sound wall along the
Fort Point Channel in Boston in 1997. Richard chose
doors because of their human proportion and because
they are recognizable objects used out of context. For
this and similar doors, Richard uses a process involving
light-sensitive photo emulsion, which he first paints on
the door surface. Once dry, the artist can then project a
negative onto the door and develop it like a black-and-
white print. Richard finishes the process with oil paint
and varnish. The resulting image possesses both photo-
graphic and painterly qualities, as well as a haunting
depth that beckons the viewer in.

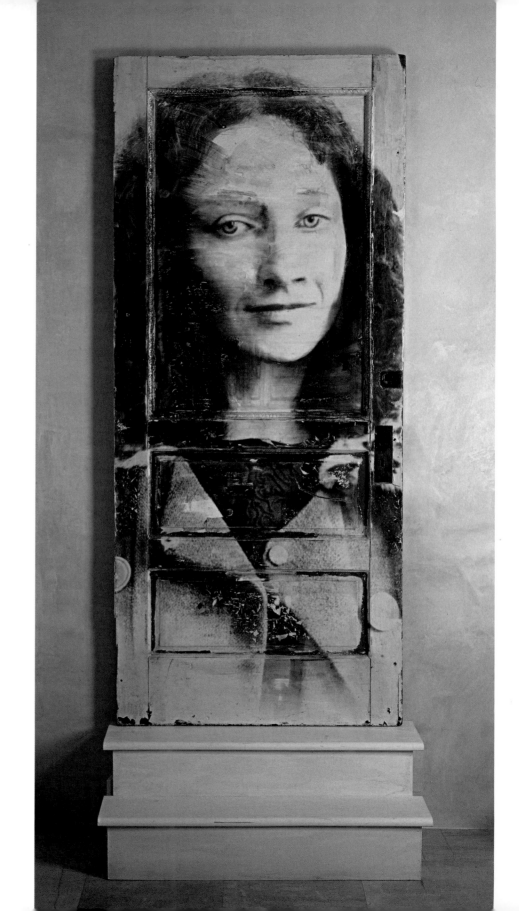

Olga
Boston, Massachusetts, 1997
Photo emulsion and oil paint on wood
H. 213.4 cm, w. 91.4 cm, d. 4.1 cm
(H. 84 in., w. 36 in., d. 1⅝ in.)

Fabiane Garcia

Puerto Rican, born in 1960

This cabinet is a masterpiece of illusionism, incongruity, and, in the eyes of some, even absurdity, all fashioned within an envelope of fine craftsmanship enriched with colorful painting. Tall and thin but apparently functional, even if oddly sized, the piece rests on a small platform supported by four short, scrolled legs. It is surmounted by a vase, seemingly freestanding but in fact an integral part of the object. The door, featuring a small recessed panel with clouds floating in the sky, opens to a faux brick wall.

As is the case with other examples of Garcia's work, the meaning of this brick wall is open to interpretation. A hint of the artist's original intent is provided by the object's title, *Persona*. Garcia initially thought that the cabinet might stand as a metaphor for a person who is cheerful and bright on the outside, but who remains closed and reserved on the inside. Others have seen it differently, and Garcia has stated that her objects "should bring each person their own memories, their own feelings. I'm not going to tell anyone that a piece means only one thing. I like to be vague about it."[171]

Born in Mayagüez, Puerto Rico, Garcia attended the University of Hawaii at Manoa, Honolulu, and the California College of Arts and Crafts in Oakland before establishing a studio in Berkeley in 1988.

Persona
Berkeley, California, 1997
Poplar, basswood, mahogany, oil paint
H. 223.5 cm, w. 43.2 cm, d. 21.3 cm
(H. 88 in., w. 17, d. 8⅜ in.)

Diane Cooper

American, born in 1936

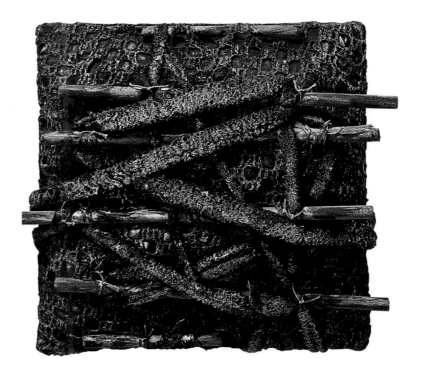

Perhaps the most significant influence on Diane Cooper's life and art came during her time abroad as a resident of Tokyo and later London in the 1970s and early 1980s. In Japan, she studied with Gaston Petit (born in 1930), a multi-talented Canadian artist, teacher, author, and Dominican priest who has resided in Japan for half of each year since 1966. The experience developed her attraction for "the aged and worn surface" so characteristic of Japan's venerable culture.[172]

The five works included here (selected from ten examples in the Wornick Collection) were made in 1999 and are from Cooper's ongoing Genten series. Each approximately twelve-inch square is fashioned from various components such as leather, textured fibers, wood, and a miscellany of other "found" materials; the squares are often displayed in groups, as here.

Genten, the artist notes, "means primal, the very essence of existence."[173] Although the "squares" share a common geometric form, in each instance the varying arrangements and individual transmutation of the materials creates a distinct work of art. Serene and quiet, each offers opportunity for reflection and contemplation.

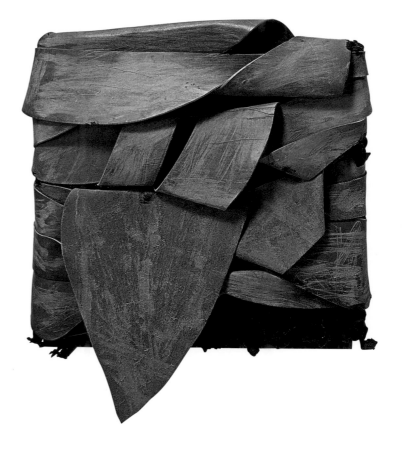

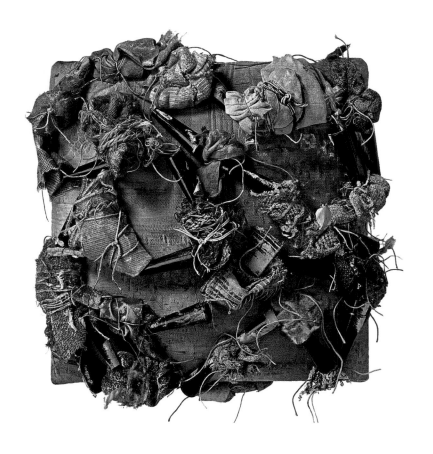

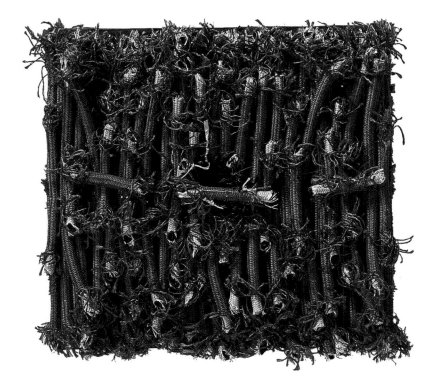

Genten #262, 269, 283, 280, 203
Chicago, Illinois, 1999–2000
Mixed media
H. 30.5 cm, w. 30.5 cm
(H. 12 in., w. 12 in.)

NOTES

COLLECTORS' STATEMENTS

1. Grace Glueck, "Working with the Grain: A Once-Lowly Craft Now Glows with Ambition." *New York Times*, February 6, 1998.

2. Lydia Matthews, "Homespun Ideas: Reinterpreting Craft in Contemporary Culture," in *Practice Makes Perfect: Bay Area Conceptual Craft*, exh. cat. (San Francisco: Southern Exposure, 2005).

3. Malcolm Rogers, "Mutual Passions: A Public Museum and Private Collectors," *Apollo*, June 2005, http://www.apollo-magazine.com/article.php?issue=back&month=6&year=2005&id=02.

TRADITION TRANSFORMED:
Postmodernism in Studio Craft

4. Garth Clark, "Introduction," in *Postmodern Ceramics* by Mark Del Vecchio (New York: Thames and Hudson, 2001), 8.

5. Paul Greenhalgh, ed., *In the Persistence of Craft* (London: A&C Black, 2002), offers repeated references by multiple authors on the link between postmodernism and craft. See also Martha Drexler Lynn, *Clay Today: Contemporary Ceramists and Their Work*, exh. cat. (Los Angeles: Los Angeles County Museum of Art; San Francisco: Chronicle Books, 1990), 28; Edward S. Cooke, Jr., Gerald W. R. Ward, and Kelly H. L'Ecuyer, with the assistance of Pat Warner, *The Maker's Hand: American Studio Furniture, 1940–1990*, exh. cat. (Boston: MFA Publications, 2003), 78, 100–101; Glenn Adamson, "Circular Logic: Wood Turning, 1976 to the Present" in *Wood Turning in North America Since 1930*, exh. cat. (New Haven, CT: Wood Turning Center and Yale University Art Gallery, 2001), 83; and Donald Kuspit, "Craft in Art, Art as Craft," *New Art Examiner* 23, no. 8 (April 1996): 15–16. For a more elaborate discourse on the matter, see Del Vecchio, *Postmodern Ceramics*.

6. Christopher Wilk, "Introduction: What Was Modernism?" in *Modernism: Designing a New World*, exh. cat. (London: V&A Publications, 2006), 14.

7. Paul Greenhalgh, "Introduction," in *Modernism in Design*, edited by Paul Greenhalgh (London: Reaktion Books, 1990),

8–14. The remainder of Greenhalgh's twelve points included the total work of art, technology, abstraction, internationalism/universality, transformation of consciousness, and theology. Greenhalgh later realized that these twelve ideas were simply a checklist, which, taken as a whole, described two central concepts: holism and objectification. See Paul Greenhalgh, "Maelstrom of Modernism," *Crafts* 116 (May/June 1992): 18.

8. Christin J. Mamiya, *Pop Art and Consumer Culture: American Super Market* (Austin: University of Texas Press, 1992), 160. Many authors have commented on the consumerism associated with Pop, and in fact they have even classified Pop art as a part of postmodernism. See also Frederic Jameson, "Postmodernism and Consumer Society," in *The Anti-Aesthetic: Essays on Postmodern Culture*, edited by Hal Foster (New York: New Press, 1983), 127–44.

9. Whereas Greenhalgh points out that much of Leach's philosophy parallels modernist dictums, Clark argues that Leach can in no way be considered a modernist because ceramics had been marginalized from the art world and was therefore not associated with modernism (see Greenhalgh, "Maelstrom of Modernism," 18, and Clark, "Introduction," 9). The labeling of Leach pulls the focus away from the real issue. That Leach took much of his thinking from the Arts and Crafts movement, a foundation for much modernist philosophy, means that Arneson and others were essentially reacting to the same constraints as the early postmodernists in their respective fields.

10. Michell Merback, "Beat Funk, Ceramic Funk, Defunct Funk: A Critical Flashback," *American Ceramics* 10, no. 4 (August 1993): 33. See also Clark, "Introduction," 12.

11. Toni Greenbaum, "The Studio Jewelry Movement, 1940–80: Roots and Results," in *One of a Kind: American Art Jewelry Today* (New York: Harry N. Abrams, 1994), 39–40.

12. Edward S. Cooke, Jr., *New American Furniture*, exh. cat. (Boston: Museum of Fine Arts, 1989), 15.

13. Cooke, Ward, and L'Ecuyer, *Maker's Hand*, 40.

14. Susanne K. Frantz, *Contemporary Glass* (New York: Harry N. Abrams, 1989), 65.

15. Frantz, *Contemporary Glass*, 69.

16. John Docker, *Postmodernism and Popular Culture* (New York: Cambridge University Press, 1994), 83.

17. The article appeared in *Architecture Association Quarterly*, no. 4 (1975).

18. For a full discussion of the term "pastiche," see Frederic Jameson, "Postmodernism and Consumer Society," in *The Anti-Aesthetic: Essays on Postmodern Culture*, edited by Hal Foster (New York: New Press, 2002): 127–45.

19. Janet Wolff, "The Death of the Author" in *The Social Production of Art* (New York: New York University Press, 1993), 117–36.

20. Charles Jencks, *The Language of Post-Modern Architecture* (New York: Rizzoli, 1987), 8.

21. John McQueen, quoted by Ed Rossbach, "Containing and Being Contained," in *John McQueen: The Language of Containment*, exh. cat. (Washington, DC: National Museum of American Art, 1992), 22.

22. Dan Klein, *Glass: A Contemporary Art* (New York: Rizzoli, 1989), 34.

23. Marcus Tatton, *Beyond Imagination*, pamphlet published by Despard Gallery, Hobart, Tasmania, Australia, about 1999.

24. For more on the third space, see Jorunn Veiteberg, "Craft Art—A Third Space," lecture delivered at Craft in Dialogue, Malmö, Sweden, September 15, 2003, transcript translated by Douglas Ferguson available online at http://www.iaspis.com/craft/en2/veitberg.html.

25. For more on postmodern ceramists, see Del Vecchio, *Postmodern Ceramics*.

26. While craftsmen James Prestini and Bob Stocksdale spurred interest in wood turning as early as the 1930s, it was not until artists David Ellsworth and Mark Lindquist pushed to have their work recognized as art in the late 1970s that the field began to blossom. Both men were aware of and encouraged by the strides made by ceramic artists such as Arneson, meaning the field of wood art was definitely influenced by the Pop and Funk movements, even though its artists did not participate in them. For a concise history of the development of studio wood, see *Wood Turning in North America*.

SUBSTANCE AND STRUCTURE:
The Creative Use of Materials and Techniques by Artists in the Wornick Collection

27. The literature on craftsmen of the past is voluminous. Edward Lucie-Smith's, *The Story of Craft: The Craftsman's Role in Society* (Ithaca, NY: Cornell University Press, 1981) remains a useful introduction. A more modern perspective is offered in the essays included in Paul Greenhalgh, ed., *The Persistence of Craft: The Applied Arts Today* (London: A&C Black; New Brunswick, NJ: Rutgers University Press, 2003), and in Matthew Kangas, *Craft and Concept: The Rematerialization of the Art Object* (New York: Midmarch Arts Press, 2006).

28. See William A. Lanford, "'A Mineral of That Excellent Nature': The Qualities of Silver as a Metal," in Barbara McLean Ward and Gerald W. R. Ward, eds., *Silver in American Life: Selections from the Mabel Brady Garvan and Other Collections at Yale University,* exh. cat. (New York: American Federation of Arts; Boston: David R. Godine, 1979), 3–9; see also 49–56.

29. Charles F. Montgomery, *A History of American Pewter,* rev. and enl. ed. (New York: E. P. Dutton, 1978), 20–41.

30. Nancy Goyne Evans, *Windsor-Chair Making in America: From Craft Shop to Consumer* (Hanover, NH, and London: University Press of New England, 2006), part 1.

31. Richard H. Randall Jr., *American Furniture in the Museum of Fine Arts, Boston* (Boston: Museum of Fine Arts, 1965), cat. no. 51. See also Jeffrey Greene, *American Furniture of the Eighteenth Century* (Newtown, CT: Taunton Press, 1996).

32. Edward S. Cooke, Jr., Matthew Kangas, John Perreault, and Fran Turner, *Expressions in Wood: Masterworks from the Wornick Collection,* exh. cat. (Oakland, CA: Oakland Museum of California, 1996).

33. The individual pieces in the Wornick Collection referenced in this essay are discussed at greater length in the relevant catalogue entry included in this book.

34. Edward S. Cooke, Jr., Gerald W. R. Ward, and Kelly H. L'Ecuyer, *The Maker's Hand: American Studio Furniture, 1940–1990,* exh. cat. (Boston: MFA Publications, 2003), chap. 1.

35. More than thirty varieties of wood are represented in the Wornick Collection's objects in this exhibition, testimony to the artists' love for new and different woods.

36. For the relationship of woodworkers to rare and exotic species, see Scott Landis, ed., *Conservation by Design* (Providence: Museum of Art, Rhode Island School of Design, and Woodworkers Alliance for Rainforest Protection, 1993), and John Kelsey, ed., *Furniture Studio 4: Focus on Materials* (Asheville, NC: Furniture Society, 2006).

37. For unusual materials in furniture, see Joellen Secondo, "Poor Materials Imaginatively Applied: New Approaches to Furniture," in Greenhalgh, *Persistence of Craft,* 117–27.

38. Cyril Stanley Smith, "Art, Technology, and Science: Notes on Their Historical Interaction," in *A Search for Structure: Selected Essays on Science, Art, and History* (Cambridge, MA: MIT Press, 1981), 191–241. See also Cyril Stanley Smith, *From Art to Science: Seventy-two Objects Illustrating the Nature of Discovery* (Cambridge, MA: MIT Press, 1980).

HUMAN FIGURE

Viola Frey

39. Quoted by Reena Jana, *Viola Frey*, exh. cat. (San Francisco: Reno Bransten Gallery, 1998), 2.

Xavier Toubes

40. See Polly Ullrich, "Xavier Toubes," *American Craft* 20, no.10 (June–July 2001): 62– 65; quotation 65.

41. For a metaphysical discussion of Toubes's work, see Vincent McGourty, "Xavier Toubes: New Worlds, New Vessels," *Ceramics: Art and Perception,* no. 44 (2001): 14–19. See also Margaret Hawkins, "Enigmatic Sculpture: Food Photos Add Some New Flavor to Art," *Chicago Sun-Times,* April 2, 2004, for perceptive comments on Toubes's recent work (copy in AoA files), as well as Fred Camper, "Xavier Toubes," *American Ceramics* 14, no. 4 (December 2004): 62.

42. Artist's statement http://www.loveedfinearts.com/thb_toubes.html, accessed August 28, 2006; copy in AoA files.

43. Ullrich, in "Xavier Toubes," 62–65, outlines the artist's expertise in the technical advancements of ceramics and ceramic workshops.

Stephen De Staebler

44. Quoted in *Stephen De Staebler: Master Artist Tribute VI; A Thirty-Year Survey,* exh. cat. (Moraga, CA: Hearst Art Gallery, Saint Mary's College of California, 2003), 2.

45. Dore Ashton, "Objects Worked by the Imagination for Their Innerness: The Sculpture of Stephen De Staebler," in *Stephen De Staebler,* 7.

46. For De Staebler's work of the period of the Wornick Collection example, see Donald Kuspit, *Stephen De Staebler: The Figure,* exh. cat. (San Francisco: Chronicle Books for the Laguna Art Museum and Saddleback College, 1987). For a more recent perspective, see the exhibition catalogue cited in note 44. For De Staebler's place in the context of the studio ceramics movement, see Jo Lauria et al., *Color and Fire: Defining Moments in Studio Ceramics,* exh. cat. (Los Angeles: Los Angeles County Museum of Art, in association with Rizzoli, 2000), 68, 144, 151, 162–65.

Clifford Rainey

47. See her foreword in the unpaged catalogue for a one-month exhibition entitled *Clifford Rainey: Boyhood, a Series of Mono Casts and Preparatory Drawings* (Boca Raton, FL: Habatat Galleries, 2005). Each work and its accompanying drawing are illustrated in this publication.

48. See Rainey's description of the process in *Clifford Rainey.* See also an enlightening review of this exhibition by William Warmus in *Glass Quarterly,* no. 102 (Spring 2006): 67.

Bertil Vallien

49. Bertil Vallien, interviewed by Ragnar Klenell, in "Vallien's Dreams: An Interview," *Glass Magazine* 75 (Summer 1999): 29.

David Bennett

50. Quoted in Habatat Galleries brochure for the 2005 exhibition "David Bennett: Glass in Motion," in AoA files.

51. Artist's statement, http://www.bennettglassart.com, accessed August 2, 2006, copy in AoA files.

Ann Wolff

52. Wolff's early career is discussed in *Ann Wolff* (New York: Heller Gallery, 1987). The artist was known as Ann Wärff until 1985, when she changed her name to Ann Wolff in honor of her grandmother (see 3). For more recent work, see a small pamphlet, *Ann Wolff* (Birmingham, MI: Habatat Galleries, 2003), with an appreciation by Ferdinand Hampson (copy in AoA files).

Martin Blank

53. Unpublished artist's statement, AoA files.

Joey Kirpatrick and Flora C. Mace

54. Artist's statement in Foster/White Gallery opening announcement, 1998, AoA files.

Marilyn R. Pappas

55. Marilyn Pappas, in Beth Frankl, "Marilyn Pappas," *American Craft* 61, no. 4 (August/September 2001): 64.

56. Marilyn Pappas, in Susan Hagen, "Goddess Worship," *City Paper*, Philadelphia, May 24, 2001, n.p.

Akio Takamori

57. Akio Takamori to Julie M. Muñiz, e-mail communication, July 9, 2006, copy in AoA files.

Soonran Youn

58. Artist's statement, http://www.fiberscene.com, accessed July 27, 2006; copy in AoA files.

John Morris

59. Terry Martin, "The Art of the Unexpected: The Sculptures of John Morris," *Woodwork,* no. 96 (December 2005): 24–31, and Sean M. Ulmer, ed., *Nature Transformed: Wood Art from the Bohlen Collection*, exh. cat. (Ann Arbor: University of Michigan Museum of Art, in association with Hudson Hills Press, 2004), 94–95, 171.

60. Martin, "Art of the Unexpected," 16.

Christine Federighi

61. The Wornick Collection also includes two Federighi ceramic figures: *House Thoughts* (1992) and *Head* (1999).

Jean-Pierre Larocque

62. Quoted in Jane Walker, *The Human Form in Clay* (Marlborough, England: Cromwood Press, 2001), 107.

Joël Urruty

63. Artist's statement, http://www.joeluuruty.com, accessed on September 29, 2006; copy in AoA files.

Robert Brady

64. For an insightful examination of Brady's work in wood sculpture, see Signe Mayfield, *Robert Brady: Sculpture, 1989–2005*, exh. cat. (Palo Alto, CA: Palo Alto Art Center, 2006). The Wornick Collection piece is illustrated on 31.

PATTERN

Olga de Amaral

65. Edward Lucie-Smith, *Olga de Amaral: El manto de la Memoria* (Bogotá, Colombia: Zona Ediciones, 2000), 13; Kathleen McCloud, "Olga de Amaral's Recent Work Transcends the Grid," *Fiberarts* 26, no. 2 (September/ October 1999): 10.

66. Charles Talley, "Olga de Amaral," *American Craft* 48, no. 2 (April/May 1988): 39–44.

67. Olga de Amaral, as quoted in Jessica Scarborough, "Olga de Amaral: Toward a Language of Freedom," *Fiberarts* 12, no. 4 (July/August 1985): 53.

Bennett Bean

68. Matthew Kangas, "Pattern Reexamined in American Ceramics," in *Craft and Concept: The Rematerialization of the Art Object* (New York: Midmarch Arts Press, 2006), 107–11.

Hervé Wahlen

69. Jeremy Lebensohn, "Hervé Wahlen," *American Craft* 59, no. 4 (August–September 1999): 60–61.

70. Artist's statement, provided by Barry Friedman, Ltd., AoA files.

Betty Woodman

71. For more on the career of Betty Woodman, see Janet Koplos et al., *Betty Woodman*, exh. cat. (New York: Monacelli Press, 2006).

Robert Cooper

72. Artist's statement, http://www.caa.org.uk/cvs/cooper_robert.htm, accessed August 27, 2006; copy in AoA files.

73. Artist's statement, http://www.theceramicartist.com/display1.asp?mainid=1&select=64, accessed August 27, 2006; copy in AoA files.

74. Robert Cooper to Ron Wornick, e-mail communication, April 8, 2005; copy in AoA files.

75. See http://www.robertcooper.net for images of his work and biographical information.

Jun Kaneko

76. For more on Kaneko's work, see Susan Peterson, *Jun Kaneko* (London: Laurence King, 2001).

Hap Sakwa

77. Matthew Kangas, in *Expressions*, 23, compares Hoyer's work in the Wornick Collection (ill. on 93) to sculpture by George Vantongerloo.

78. Kangas, in *Expressions*, 136.

Danny Perkins

79. Artist's statement, http://www.museo.cc/dpe_resume.html, accessed August 26, 2006; copy in AoA files.

José Chardiet

80. James Yood, "Chardiet: Still Life," *American Craft* 58, no. 6 (December 1998/January 1999): 32–35.

Lino Tagliapietra

81. David Whitehouse, "Director's Letter," *The Gather* (Spring/Summer 2006): 1.

Alex Gabriel Bernstein

82. Bernstein's career is summarized in *Tactile Visions: Alex Gabriel Bernstein* (New York: Chappell Gallery, 2004); the quotation is from Charlotte Vignon's essay "Alex Gabriel Bernstein" in the same book, 4.

83. E-mail communication, September 15, 2006; copy in AoA files.

Bob "Bud" Latven

84. Quoted in Kevin Wallace, "Metamorphosis," http://www.budlatven.com, accessed September 22, 2006; copy in AoA files. Originally published in *Woodturning*, no. 26 (August 2003): 7–11.

Malcolm Martin and Gaynor Dowling

85. Malcom Martin and Gaynor Dowling, "About Us," http://www.martinanddowling.co.uk, accessed July 25, 2006; copy in AoA files.

Robyn Horn

86. Doug Stowe, "A Union of Souls: The Work of Robyn Horn," *Woodwork,* no. 98 (April 2006): 22–28; the procedure for creating works such as *Surrounded* is illustrated and discussed step by step on p. 27. For Horn's earlier career, see *Robyn Horn: Union of Souls,* exh. cat. (Little Rock: Arkansas Arts Center, 2003), with an introduction by Glenn Adamson.

87. Michael Monroe, *Living with Form: The Horn Collection of Contemporary Crafts,* exh. cat. (Little Rock: Arkansas Arts Center, 1999).

Michael Bauermeister

88. Dona Z. Meilach, *Wood Art Today: Furniture, Vessels, Sculpture* (Atglen, PA: Schiffer Publishing, 2004), 163; see also 138.

89. E-mail communication to Gerald W. R. Ward, August 28, 2006; copy in AoA files.

Thierry Martenon

90. Terry Martin, "Thierry Martenon," *Turning Points* 18, no. 2 (Winter 2006): 15–18.

Arlie Regier

91. Unpublished artist's statement, AoA files.

Brad Silberberg

92. "Brad Silberberg," *American Craft* 55, no. 5 (October/November 1996): 93.

Tom Joyce

93. Ellen Berkovitch, "Studio Visit: Tom Joyce," *Metalsmith* 24, no. 2 (Spring 2004): 18–19.

CEREMONY

Michael Gross

94. "Michael Gross," in "Wisconsin Potters," *Studio Potter* 16, no. 1 (December 1987): 73.

John Garrett

95. Quoted in Jan Janeiro, "John Garrett," *American Craft* 61, no. 2 (April/May 2001): 51–52.

Todd Hoyer

96. Artist survey, AoA files.

97. Artist's statement, AoA files; see also *Expressions,* 90.

William Moore

98. Unpublished artist's statement, AoA files.

John McQueen

99. John McQueen, quoted by Ed Rossbach, "Containing and Being Contained," in *John McQueen: The Language of Containment,* exh. cat. (Washington, DC: National Museum of American Art, 1992), 22.

Peter Pierobon

100. Amy Forsyth, "Peter Pierobon: The Language of Form," *Woodwork,* no. 100 (August 2006): 87–92; Amy Forsyth, "Peter Pierobon," *American Craft* 63, no. 3 (June/July 2003): 72–73.

Tommy Simpson

101. For Simpson's place in the movement, see Edward S. Cooke Jr., Gerald W. R. Ward, and Kelly H. L'Ecuyer, with the assistance of Pat Warner, *The Maker's Hand: American Studio Furniture, 1940–1990,* exh. cat. (Boston: MFA Publications, 2003), 43–44, 137. See also Tommy Simpson, with an introduction by Pam Koob, *Two Looks to Home: The Art of Tommy Simpson* (Boston: Bulfinch Press, Little, Brown, 1999).

102. Simpson's invoice for the ladder, December 15, 1991; copy in AoA files.

Judy Kensley McKie

103. Edward S. Cooke, Jr., Gerald W. R. Ward, and Kelly H. L'Ecuyer, with the assistance of Pat Warner, *The Maker's Hand: American Studio Furniture, 1940–1990,* exh. cat. (Boston: MFA Publications, 2003), 96.

104. On McKie's work, see Joy Cattanach Smith, "Judy Kensley McKie," *American Craft* 43, no. 1 (December 1983–January 1984): 2–6; Gallery NAGA, *Judy Kensley McKie,* exh. cat. (Boston: Gallery NAGA, 1995); and Akiko Busch, "Judy McKie: Connecting to the World," *American Craft* 54, no. 6 (December 1994–January 1995): 32–35.

David Secrest

105. Barbara Brady, "David Secrest: The Man with the X-Ray Vision," *Metalsmith* 24, no. 2 (Spring 2004): 40–47.

Edward Eberle

106. Edward Eberle, "Edward S. Eberle," *Studio Potter* 29, no. 1 (December 2000): 85.

Marcus Tatton

107. Unpublished artist's statement, AoA files.

Don Reitz

108. Don Reitz, "Drawing from the Heart," *Studio Potter* 14, no. 1 (December 1985): 40–41. For a retrospective, see Jody Clowes, *Don Reitz: Clay, Fire, Salt, and Wood,* exh. cat.

(Madison: Elvehjem Museum of Art, University of Wisconsin-Madison, 2004).

109. Clowes, *Don Reitz;* Joan Falconer Byrd, "Don Reitz: Clay, Fire, Salt, and Wood," *American Craft* 66, no. 2 (April/May 2006): 48–49.

110. Sarah Tanguy, "Don Reitz," *American Craft* 61, no. 4 (August/September 2001): 97–99.

Richard DeVore

111. See, for example, Suzanne Ramljak, with an introduction by Darrel Sewell, *Crafting a Legacy: Contemporary American Crafts in the Philadelphia Museum of Art* (Philadelphia: Philadelphia Museum of Art, 2002), 34, and Janet Koplos, *Richard DeVore: Bodylandscapes* (pamphlet, about 2003), copy in AoA files.

112. Quoted in Robert Kushner, *Beauty without Regret* (Santa Fe: Bellas Artes, 2001), 13.

Sebastian Blackie

113. For more on Blackie's thoughts on Leach, see Sebastian Blackie, *Dear Mr. Leach: Some Thoughts on Ceramics* (London: A&C Black, 2004).

114. Sebastian Blackie, "Making Sense," *Ceramics Technical* 19 (2004): 11.

ORGANIC

David Groth

115. *Expressions,* 11–12.

116. Matthew Kangas, "Sculptural Heritage and Sculptural Implications: Turned-Wood Objects in the Wornick Collection," in *Expressions,* 26.

117. Quoted on the artist's Web site; http://www.david-groth.net/studio.htm, accessed August 18, 2006; copy in AoA files. For a step-by-step illustration of his process in making a related work, see "David Groth's Abstract Chain Saw Sculptures," in *Wood Art Today: Furniture, Vessels, Sculpture* by Dona Z. Meilach (Atglen, PA: Schiffer Publishing, 2004), 188–91. See also Matthew Kangas, *Craft and Concept: The Rematerialization of the Art Object* (New York: Midmarch Arts Press, 2006), 338–41.

Liv Blåvarp

118. Marjorie Simon and Gunnar Sørensen, *Liv Blåvarp: Jewelry, 1984–2001,* exh. cat. (Kristiansand, Norway: Art Museum of South Norway, 2001).

Matthew Harding

119. E-mail communication from the artist, September 15, 2006, copy in AoA files.

Stephen Hughes

120. Hughes's work is well represented in the Wornick Collection; see *Expressions*, 94–99. *Manta* is illustrated on 96.

121. Matthew Kangas, "Sculptural Heritage and Sculptural Implications: Turned-Wood Objects in the Wornick Collection," in *Expressions*, 25–26.

122. "Huon pine, one of the oldest plants on Earth." Hobart, Tasmania:Parks and Wildlife Service Tasmania, 2003. Copy in AoA files; available at http://www.parks.tas.gov.au/factsheets/plants/huon pine.pdf.

Robert Howard

123. A related example in the Bohlen Collection is published in Bonita Fike, with Mike Mendelson, *The Fine Art of Wood: The Bohlen Collection*, exh. cat. (New York: Abbeville Press and Detroit Institute of Arts, 2000), 64. For Howard's early career, including illustrations of his furniture, see Rodney Hayward, "Poetry in Wood: Robert Howard," *Craft Arts International*, no. 38 (1996–97): 52–56.

124. Fike, *Fine Art of Wood*, 24.

Wendell Castle

125. Wendell Castle has been referenced in nearly every publication on American studio furniture. For a synopsis of his early career, see Edward S. Cooke, Jr., Gerald W. R. Ward, and Kelly H. L'Ecuyer, with the assistance of Pat Warner, *The Maker's Hand: American Studio Furniture, 1940–1990*, exh. cat. (Boston: MFA Publications, 2003), and Davira S. Taragin, Edward S. Cooke Jr., and Joseph Giovannini, *Furniture by Wendell Castle*, exh. cat. (New York: Hudson Hills Press, in association with the Founders Society, Detroit Institute of Arts, 1989).

126. "Wendell Castle: Seeing Stars," *Peter Joseph Gallery News* 7 (Fall 1995): 1–2; copy in AoA files.

127. The commission is documented in a series of letters between Ronald C. Wornick and Wendell Castle, May 1997 through December 1997; copies in AoA files.

Ron Fleming

128. Quoted in *Expressions*, 77.

William Hunter

129. *Expressions*, 100–101, which illustrates a *Cyclone Basket* of 1994, also in the Wornick Collection.

130. For an overview of Hunter's recent work, see *William Hunter: Rhythms and Transformation, 2003* (Los Angeles: Del Mano Gallery, 2003).

Ben Trupperbäumer

131. *Expressions*, 152.

Christian Burchard

132. See http://www.burchardstudio.com for detailed biographical information.

133. *Expressions*, 53. Burchard's small works are also represented in the collection; see 54–55. See also Christian Burchard, "Learning to Speak," *American Woodturner* 9, no. 1 (March 1994): 26–27.

Peter M. Adams

134. Peter M. Adams to Joy Cattanach, phone conversation, August 31, 1982, AoA accession file 1982.421.

135. Peter M. Adams to Jonathan L. Fairbanks, 1982, AoA accession file 1982.421.

136. Adams, "Should Life Influence Art?" *Turning Points* 17, no. 2 (Winter 2005): 27.

Honda Syoryu

137. Hollis Walker, "Honda Syoryu," *Art News* 104, no. 10 (November 2005): 190; see also Hollis Walker, "Review: Syoryu Honda," *American Craft* 65, no. 6 (December 2005/January 2006): 56.

Marvin Lipofsky

138. Jonathan L. Fairbanks et al., *Glass Today by American Studio Artists*, exh. cat. (Boston: Museum of Fine Arts, 1997), 40.

Dale Chihuly

139. Dale Chihuly, 1992, quoted in *Chihuly: Form from Fire* (Seattle: Portland Press; Daytona Beach, FL: Museum of Arts and Sciences, 1993), 45.

140. Tina Oldknow, "An Ancient Legacy," in *Chihuly Persians* (Seattle: Portland Press, 1997), 7.

Daniel Clayman

141. Earlier stages in Clayman's career are aptly analyzed by Matthew Kangas in "Daniel Clayman: The Object Is the Image," in *Craft and Concept: The Rematerialization of the Art Object* (New York: Midmarch Arts Press, 2006), 226–29.

Maria Lugossy

142. *Maria Lugossy, Zoltán Bohus*, exh. cat. (Madrid: Museo de Arte en Vidrio de Alcoron, Castillo de San José de Valderas, 2004), with an essay by Márta Kovalovszky.

Albert Paley

143. The literature on Paley is substantial. For an overview, see Edward Lucie-Smith, *The Art of Albert Paley: Iron & Bronze & Steel* (New York: Harry N. Abrams, 1996).

144. The lamp was first published in an unpaged catalogue: *Albert Paley* (Washington, DC: Maurine Littleton Gallery, 2000). Other lighting forms are illustrated in the same catalogue.

Helen Shirk and William C. Leete

145. Tim McCreight and Nicole Bsullak, in *Color on Metal: 50 Artists Share Insights and Techniques* (Madison, WI: Guild Publishing, 2001), 106, contains a description of Shirk's methods.

146. E-mail communication from William C. Leete, September 7, 2006; copy in AoA files.

Peter Voulkos

147. On early recognition of Voulkos's work, see "New Talent in the U.S.A. 1959: Sculpture," *Art in America* 47, no. 1 (1959): 36–37; and Peter Voulkos, *Peter Voulkos: Sculpture*, exh. cat. (Los Angeles: Los Angeles County Museum of Art, 1965). For surveys of his career, see Rose Slivka, *Peter Voulkos: A Dialogue with Clay* (Boston: New York Graphic Society, 1978); Garth Clark, *American Potters: The Work of Twenty Modern Masters* (New York: Watson Guptill Publications, 1981); and Rose Slivka and Karen Tsujimoto, *The Art of Peter Voulkos*, exh. cat. (New York: Kodansha International, in collaboration with the Oakland Museum, 1995).

148. Garth Clark, "Otis and Berkeley: Crucibles of the American Clay Revolution," in Jo Lauria, ed., *Color and Fire: Defining Moments in Studio Ceramics, 1950–2000*, exh. cat. (Los Angeles: Los Angeles County Museum of Art, in association with Rizzoli, 2000), 136.

ILLUSION

Michael Lucero

149. Mary Houlihan, "With Craft as Art: Lucero's Inspiration Makes Quite a Yarn," *Chicago Sun Times*, October 28, 2005; copy in AoA files.

Tom Eckert

150. *American Heritage Dictionary of the English Language*, 4th ed. (2000), s.v. "chimera."

Michal Zehavi

151. "Michal Zehavi," *Ceramics Monthly* 51, no. 7 (September 2003): 59.

Jean-François Escoulen

152. Terry Martin, "An Eccentric Turner," *Craft Arts International*, no. 41 (1997–98): 36–38; quotations by Escoulen on 37. A twenty-eight-minute DVD presentation on Escoulen's work is also available.

153. The Wornick Collection piece is included as an example of "the constructed vessel" in *Contemporary Turned Wood: New Perspectives in a Rich Tradition* by Ray Leier, Jan Peters, and Kevin Wallace (Lewes, England: Guild of Master Craftsmen Publications, 2000), 74.

154. Terry Martin, "The Renaissance of French Turning," *Woodwork*, no. 77 (October 2002): 46–55.

Ron Gerton

155. All quotations are from the artist's statement at http://www.exoticburl.com/webfront/artistbio.php?artistid=27, accessed August 27, 2006. A copy is in the AoA files.

156. Step-by-step images of Gerton making such a large example are published in *Wood Art Today: Furniture, Vessels, Sculpture* by Dona Z. Meilach (Atglen, PA: Schiffer Publishing, 2004), 177–78.

Michael James Peterson

157. Kevin V. Wallace, "A Sculptor's Natural Dialogue," *Craft Arts International*, no. 60 (2004): 28–33. The quotation by Peterson is from his artist's statement, prepared for a vessel of his in the Arroyo series, in the collection of the Museum of Fine Arts, Boston (1993.655). Peterson's bleaching technique is described by him in "Bleaching Bowls," *Fine Woodworking*, no. 70 (May/June 1988): 110–11.

158. Quoted in Wallace, "A Sculptor's Natural Dialogue," 32.

George Peterson

159. See the curator's statement in *Wood Now*, exh. cat. (St. Louis: Craft Alliance, 2006), 4–5; quotations on 5. Peterson's works, including *Arch*, are illustrated on 23–27.

160. Artist's statement http://www.circlefactory.com/newresume.html, accessed September 14, 2006; copy in AoA files.

David Ellsworth

161. John David Ellsworth, "Hollow Turnings: Bent Tools and Total Concentration," *Fine Woodworking*, no. 16 (May/June 1979): 62–66. See also his "Exploring the Dimensions of Green and Distressed Wood," *Turning Points* 13, no. 2 (Summer 2000): 22–23.

162. All quotations from the artist taken from his Web site, http://www.ellsworthstudios.com/david/solstice/html, accessed September 15, 2006; copy in AoA files.

Giles Gilson

163. Giles Gilson to Julie M. Muñiz, e-mail conversation, September 25, 2006; copy in AoA files.

Stephen Johnson

164. Artist's statement http://www.delmano.com/artists/fiber/sJohnson/biography.htm, accessed August 18, 2006; copy in AoA files. See also D. Wood, "Stephen Johnson: The Material Defines the Basket," *Fiber Arts* 32, no. 1 (Summer 2005): 16–17. Johnson refers to Rossbach's work *Baskets as Textile Arts* (New York: Van Nostrand Reinhold, 1973), re-issued in a revised and enlarged edition as *The Nature of Basketry* (Atglen, PA: Schiffer Publishing, 1986). The first chapter (15–63) is titled "Temporary Baskets."

John Cederquist

165. Sharon K. Emanuelli, *John Cederquist: Deceptions*, exh. cat. (Los Angeles: Craft and Folk Art Museum, 1983); Arthur C. Danto and Nancy Princenthal, *The Art of John Cederquist: Reality of Illusion*, exh. cat. (Oakland: Oakland Museum of California, 1997); and Pamela Blotner, "The Wizardry of John Cederquist," *Woodwork*, no. 50 (April 1998): 20–29.

Gord Peteran

166. Gord Peteran, as quoted in Glenn Adamson, *Gord Peteran: Furniture Meets Its Maker*, exh. cat. (Milwaukee, WI: Milwaukee Art Museum/University of Wisconsin Press, 2006), 108.

Michael Hosaluk

167. Michael Hosaluk, "Personal Statement," http://www.functionart.com/AM/Artists/HosalukM/HosalukM.html, accessed March 14, 2006, copy in AoA files; Katherine Winick, "Wood Turner Wins Canada's Bronfman Award," *Fine Woodworking*, no. 180 (December 2005): 26.

Garry Knox Bennett

168. On Bennett's career and reputation, see "Decoration vs. Desecration," *Fine Woodworking*, no. 24 (September/October 1980): 92; John Kelsey, "How to Be Garry Knox Bennett: The Bad Boy of Oakland Continues to Surprise, Annoy, and Delight," *Woodwork*, no. 71 (October 2001): 32–35; Cheryl White, "Garry Knox Bennett," *American Craft* 61, no. 5 (October/November 2001): 60–63, 84; Ursula Ilse-Neuman, ed., *Made in Oakland: The Furniture of Garry Knox Bennett*, exh. cat. (New York: American Craft Museum, 2001).

169. Garry Knox Bennett, business card, about 1986, AoA files.

Hank Murta Adams

170. John Perreault, "Hank Murta Adams," *American Craft* 63, no. 6 (December 2004/January 2005): 48–51.

Fabiane Garcia

171. David Meiland, "Fabiane Garcia: The Art of the Absurd," *Woodwork*, no. 51 (June 1998): 48–53; quotation on 52.

Diane Cooper

172. Artist's statement, AoA files.

173. Artist's statement. The Genten series has been discussed in Judy Prisoc, "Diane Cooper's Genten Series," *Chicago Women's Caucus for Art* (Fall 1997); copy in AoA files. See also the artist's Web site, http://www.dianecooper.org, accessed April 5, 2007.

SELECTED BIBLIOGRAPHY

The following list is restricted primarily to books and cata-
logues that deal with three-dimensional art in craft media dur-
ing the last few decades; a few works that cover the earlier
years of the studio craft movement are also included. For ref-
erences on the individual artists included in this catalogue, see
the notes following each entry. Many artists in the Wornick
Collection and many of the galleries that sell their work also
maintain Web sites containing detailed biographical informa-
tion that is updated frequently. In addition, the Department
of the Art of the Americas maintains both object and artist
files (AoA files) that may be consulted by appointment.

Many periodicals and journals cover this field of activity,
often bringing new work and new artists to light for the first
time. A partial list of these includes *American Ceramics,
American Craft, American Woodturner, American Wood-
working, Art in America, Art News, Australian Wood Review,
Australian Woodworker, Ceramic Art, Ceramics in America,
Ceramics Monthly, Contemporary Craft Review, Crafts Arts
International, Crafts Magazine, Fiber Arts, Fine Woodworking,
Glass Magazine, Metalsmith, New Glass, Sculpture Magazine,
Studio Potter, Turning Points,* and *Woodwork.*

*500 Wood Bowls: Bold & Original Designs Blending Tradition
& Innovation.* New York: Lark Books, 2004.

Adlin, Jane. *Contemporary Ceramics: Selections from the
Metropolitan Museum of Art.* New York: Metropolitan
Museum of Art, 1998.

Adlin, Jane. *Studio Glass in the Metropolitan Museum of Art.*
New York: Metropolitan Museum of Art, 1994.

Beard, Geoffrey. *International Modern Glass.* New York:
Charles Scribner's Sons, 1976.

Burgard, Timothy Anglin. *The Art of Craft: Contemporary
Works from the Saxe Collection.* Exh. cat. San Francisco: Fine
Arts Museum of San Francisco, 1999.

Cooke, Edward S., Jr., Gerald W. R. Ward, and Kelly H.
L'Ecuyer, with the assistance of Pat Warner. *The Maker's Hand:
American Studio Furniture, 1940–1990.* Exh. cat. Boston: MFA
Publications, 2003.

Craft in the '90s: A Return to Materials. Deer Isle, ME:
Haystack Mountain School of Crafts, 1991.

Defining Craft I: Collecting for the New Millennium. New
York: American Craft Museum, 2000.

Del Vecchio, Mark. *Postmodern Ceramics.* New York: Thames
and Hudson, 2001.

Diamonstein, Barbaralee. *Handmade in America:
Conversations with Fourteen Craftmasters.* New York: Harry
N. Abrams, 1983.

Dietz, Ulysses Grant. *Great Pots: Contemporary Ceramics from
Function to Fantasy.* Exh. cat. Newark, NJ: Newark Museum;
Madison, WI: Guild Publishing, 2003.

Dormer, Peter, ed. *The Culture of Craft.* Manchester and New
York: Manchester University Press, 1997.

Eidelberg, Martin, et al. *Designed for Delight: Alternative
Aspects of Twentieth-Century Decorative Arts.* Exh. cat.
Montreal, Quebec, Canada: Montreal Museum of Decorative
Arts, 1997.

Explorations: The Aesthetics of Excess. Exh. cat. New York:
American Craft Museum, 1990.

*Expressions in Wood: Masterworks from the Wornick
Collection.* Exh. cat. Oakland, CA: Oakland Museum of
California, 1996.

Fairbanks, Jonathan L., and Kenworth W. Moffett. *Directions
in Contemporary American Ceramics.* Exh. cat. Boston:
Museum of Fine Arts, 1984.

Fairbanks, Jonathan L., Pat Warner, et al. *Glass Today by
American Studio Artists.* Exh. cat. Boston: Museum of Fine
Arts, 1997.

Fariello, M. Anna, and Paula Owen, eds. *Objects and
Meaning: New Perspectives on Art and Craft.* Lanham, MD,
and London: Scarecrow Press, 2004.

Fike, Bonita, with Mike Mendelson. *The Fine Art of Wood:
The Bohlen Collection.* Exh. cat. New York: Abbeville Press
and Detroit Institute of Arts, 2000.

Frantz, Susanne K. *Contemporary Glass: A World Survey from
the Corning Museum of Glass.* New York: Harry N. Abrams
and The Corning Museum of Glass, 1989.

Glass: Material Matters. Exh. cat. Los Angeles: Los Angeles
County Museum of Art, 2006.

Greenhalgh, Paul, ed. *The Persistence of Craft: The Applied
Arts Today.* London: A&C Black; New Brunswick, NJ: Rutgers
University Press, 2002.

Herman, Lloyd E. *American Glass: Masters of the Art.* Exh. cat.
Washington, DC: Smithsonian Institution Traveling Exhibition
Service in association with the University of Washington Press,
Seattle and London, 1998.

Herman, Lloyd E. *Art That Works: The Decorative Arts of the
Eighties, Crafted in America.* Exh. cat. Seattle and London:
University of Washington Press, 1990.

Herman, Lloyd E., and Matthew Kangas, with an introduc-
tion by John Perreault. *Tales and Traditions: Storytelling in
Twentieth-Century American Craft.* Exh. cat. St. Louis: Craft
Alliance, St. Louis, 1993. Distributed by University of
Washington Press, Seattle and London.

Hosaluk, Michael. *Scratching the Surface: Art and Content in
Contemporary Wood.* Madison, WI: Guild Publishing, 2002.

Kangas, Matthew. *Craft and Concept: The Rematerialization of the Art Object*. New York: Midmarch Arts Press, 2006.

Klein, Dan. *Glass: A Contemporary Art*. New York: Rizzoli, 1989.

Kuspit, Donald. "Craft in Art, Art as Craft." *New Art Examiner* 23, no. 8 (April 1996): 14–19ff.

Lane, Peter. *Studio Ceramics*. London: William Collins, 1983.

Larsen, Jack Lenor. *The Tactile Vessel: New Basket Forms: An Exhibition of Works from the Collection of the Erie Art Museum*. Exh. cat. Erie, PA: Erie Art Museum, 1989.

Lauria, Jo, et al. *Color and Fire: Defining Moments in Studio Ceramics, 1950–2000*. Exh. cat. Los Angeles: Los Angeles County Museum of Art, in association with Rizzoli, 2000.

Leach, Mark Richard, ed. *Turning Wood into Art: The Jane and Arthur Mason Collection*. New York: Harry N. Abrams in association with the Mint Museum of Craft + Design, 2000.

Lier, Ray, Jan Peters, and Kevin Wallace. *Contemporary Turned Wood: New Perspectives in a Rich Tradition*. 1999; reprint, Lewes, England: Guild of Master Craftsmen Publications, 2000.

Living with Form: The Horn Collection of Contemporary Crafts. Little Rock: Arkansas Arts Center in association with Bradley Publishing, 1999.

Lynn, Martha Drexler. *Clay Today: Contemporary Ceramists and Their Work*. Exh. cat. Los Angeles: Los Angeles County Museum of Art; San Francisco: Chronicle Books, 1990.

Lynn, Martha Drexler, with contributions by Barry Shifman. *Masters of Contemporary Glass: Selections from the Glick Collection*. Exh. cat. Indianapolis: Indianapolis Museum of Art in cooperation with Indiana University Press, 1997.

Lynn, Martha Drexler. *Sculpture, Glass, and American Museums*. Philadelphia: University of Pennsylvania Press, 2005.

MacNaughton, Mary Davis, et al. *Revolution in Clay: The Marer Collection of Contemporary Ceramics*. Exh.cat. Claremont, CA: Ruth Chandler Williamson Gallery, Scripps College, in association with University of Washington Press, Seattle and London, 1994.

Manhart, Marcia, Tom Manhart, and Carol Haralson, eds. *The Eloquent Object: The Evolution of American Art in Craft Media since 1945*. Exh. cat. Tulsa, OK: Philbrook Museum of Art, 1987.

McCreight, Tim, and Nicole Bsullak. *Color on Metal: 50 Artists Share Insights and Techniques*. Madison, WI: Guild Publishing, 2001.

McFadden, David Revere, et al. *Dual Vision: The Simona and Jerome Chazen Collection*. Exh. cat. New York: Museum of Arts & Design, 2005.

Meilach, Dona Z. *Wood Art Today: Furniture, Vessels, Sculpture*. Atglen, PA: Schiffer Publishing, 2004.

Metcalf, Bruce. "Replacing the Myth of Modernism." *American Craft* 53, no. 1 (February/March 1993): 40–47.

Monroe, Michael W., and Barbaralee Diamonstein. *The White House Collection of American Crafts*. Exh. cat. New York: Harry N. Abrams, 1995.

Nordness, Lee. *Objects: USA*. New York: Viking Press, 1970.

Oldknow, Tina. *Pilchuck: A Glass School*. Seattle: Pilchuck Glass School in association with University of Washington Press, Seattle, 1996.

Peterson, Susan. *Contemporary Ceramics*. New York: Watson-Guptill, 2000.

Pulleyn, Rob, ed. *The Basketmaker's Art: Contemporary Baskets and Their Makers*. Asheville, NC: Lark Books, 1986.

Ramljak, Suzanne, and Darrel Sewell. *Crafting a Legacy: Contemporary American Crafts in the Philadelphia Museum of Art*. Philadelphia: Philadelphia Museum of Art, 2002.

Ruffner, Ginny, Ron Glowen, and Kim Levin. *Glass: Material in the Service of Meaning*. Exh. cat. Tacoma, WA: Tacoma Art Museum in association with the University of Washington Press, Seattle and London, 1992.

Skilled Work: American Craft in the Renwick Gallery. Washington, DC: Smithsonian Institute Press, 1998.

Smith, Cyril Stanley. *A Search for Structure: Selected Essays in Science, Art, and History*. Cambridge, MA: MIT Press, 1981.

Smith, Paul and Edward Lucie-Smith. *Craft Today: Poetry of the Physical*. Exh. cat. New York: American Craft Museum and Weidenfeld & Nicolson, 1986.

Smith, Paul, ed. *Objects for Use: Handmade by Design*. Exh. cat. New York: Harry N. Abrams in association with the American Craft Museum, 2001.

Strauss, Cindi. *Crafting a Colleciton: Contemporary Craft in the Museum of Fine Arts, Houston*. Exh. cat. Houston, TX: Museum of Fine Arts, Houston, 2006.

Taragin, Davira, et al. *Contemporary Crafts and the Saxe Collection*. Exh. cat. Toledo, OH: Toledo Museum of Art and Hudson Hills Press, 1993.

Turned Wood Now: Redefining the Lathe-Turned Object IV. Exh. cat. Tempe: Arizona State University, 1997.

Ulmer, Sean, ed. *Nature Transformed: Wood Art from the Bohlen Collection*. Exh. cat. Ann Arbor: University of Michigan Museum of Art in association with Hudson Hills, 2004.

Venturi, Robert. *Complexity and Contradiction in Architecture*. New York: Museum of Modern Art, 1966.

Venturi, Robert, Denise Scott Brown, and Steven Izenour. *Learning from Las Vegas*. Cambridge, MA: MIT Press, 1972.

Wood Turning in North America since 1930. Exh. cat. New Haven, CT: Wood Turning Center and Yale University Art Gallery, 2001.

Yelle, Richard Wilfred. *Glass Art from UrbanGlass*. Atglen, PA: Schiffer Publishing, 2000.

Yelle, Richard Wilfred. *International Glass Art*. Atglen, PA: Schiffer Publishing, 2003.

INDEX OF ARTISTS

Adams, Peter M. 128

Adams, Hank Murta 169

Bauermeister, Michael 80

Bean, Bennett 64

Bennett, David 42

Bennett, Garry Knox 168

Bernstein, Alex Gabriel 75

Blackie, Sebastian 111

Blank, Martin 46

Blåvarp, Liv 116

Borowski, Stanislaw 93

Boyadjiev, Latchezar 43

Brady, Robert 59

Burchard, Christian 127

Castle, Wendell 123

Cederquist, John 165

Chardiet, José 73

Chihuly, Dale 132

Clayman, Daniel 136

Cook, Lia 150

Cooper, Diane 172

Cooper, Robert 68

de Amaral, Olga 62

De Staebler, Stephen 37

DeVore, Richard 110

Dowling, Gaynor (and Malcolm Martin) 78

Eberle, Edward 106

Eckert, Tom 148

Ellsworth, David 161

Escoulen, Jean-François 156

Federighi, Christine 55

Fleming, Ron 124

Fortescue, Donald 82

Frey, Viola 34

Garcia, Fabiane 171

Garrett, John 96

Gerton, Ron 157

Gilson, Giles 162

Grebe, Robin 47

Gross, Michael 94

Groth, David 114

Harding, Matthew 117

Hlava, Pavel 137

Hlavicka, Tomáš 72

Holzapfel, Michelle 154

Horn, Robyn 79

Hosaluk, Michael 167

Howard, Robert 121

Hoyer, Todd 98

Hughes, Stephen 120

Hunter, William 125

Isupov, Sergei 90

Johnson, Stephen 163

Jolley, Richard 45

Joyce, Tom 87

Kaneko, Jun 69

Kirpatrick, Joey (and Flora C. Mace) 48

Larocque, Jean-Pierre 56

Latven, Bob "Bud" 77

Leete, William C. (and Helen Shirk) 141

Lipofsky, Marvin 131

Lucero, Michael 147

Lugossy, Maria 138

Mace, Flora C. (and Joey Kirkpatrick) 48

Martenon, Thierry 81

Martin, Malcolm (and Gaynor Dowling) 78

McKie, Judy Kensley 104

McQueen, John 101

Minkowitz, Norma 152

Moore, William 100

Morris, John 54

Nash, David 83

Paley, Albert 139

Pappas, Marilyn R. 49

Perkins, Danny 71

Peteran, Gord 166

Peterson, George 159

Peterson, Michael James 158

Petter, Gugger 149

Pierobon, Peter 102

Rainey, Clifford 38

Regier, Arlie 85

Reitz, Don 108

Richard, Paul 170

Ries, Christopher 135

Rosol, Martin 140

Sakwa, Hap 70

Scott, Mike "Chai" 97

Secrest, David 105

Shirk, Helen (and William C. Leete) 141

Silberberg, Brad 86

Simpson, Tommy 103

Singleton, Gib 57

Syoryu, Honda 130

Tagliapietra, Lino 74

Takamori, Akio 50

Tatton, Marcus 107

Toubes, Xavier 36

Trupperbäumer, Ben 126

Urruty, Joël 58

Vallien, Bertil 41

Van Cline, Mary 52

Vaughan, Grant 119

Voulkos, Peter 143

Wahlen, Hervé 65

Wolff, Ann 44

Woodman, Betty 66

Youn, Soonran 53

Zehavi, Michael 153

FIGURE CREDITS

(Page 9) The Wornicks at home, 2007. Photo: Peter Marcus/San Francisco.

(Page 12) Interior of the Wornicks' house in Napa Valley, showing *Canyon Catcher* by Christine Federighi (page 55) at left and *Cesta Lunar 64* (*Lunar Basket 64*) by Olga de Amaral (page 62) at center. Photograph © 2007 Mert Carpenter.

MATERIAL MATTERS/Mattthew Kangas

1. Harvey Littleton (American, born in 1922), *Torso*, Corning, New York, 1942. Vycor multiform fused glass. H. 28.6 cm, w. 12.7 cm (H. 11¼ in., w. 5 in.). The Corning Museum of Glass; Gift of Dr. and Mrs. Fred A. Bickford (78.4.38).

2. Robert Arneson (American, 1930–1992), *From L and R*, Benicia, California, 1988. Conte on paper. H. 120 cm, w. 79.4 cm (H. 47¼ in., w. 31¼ in.). The Wornick Collection; promised gift to the Museum of Fine Arts, Boston.

3. Edris Eckhardt (American, 1907–1998), *Uriel*, Cleveland, Ohio, 1968. Glass cast in a *cire-perdue* mold. H. 25.1 cm, w. 20 cm (H. 9⅞ in., w. 7⅞ in.). The Corning Museum of Glass; Gift of the artist (68.4.28).

4. Carl Andre (American. born in 1935), *The Way North, East, South, and West*, New York, 1975. Western red cedar. Four units, H. each 30.5 cm, w. each 30.5 cm, d. each 91.4 cm (H. each 12 in., w. each 12 in., d. each 36 in.). Private collection. Courtesy Paula Cooper Gallery, New York; photograph by Geoffrey Clements.

(Page 18) Living room of the Wornicks' Napa Valley home, showing (left to right) *Untitled* by Robert Howard (page 121) and *Table* by Michael Gross (pages 94–95). Photograph © 2007 Mert Carpenter.

TRADITION TRANSFORMED/Julie M. Muñiz

5 Wendell Castle (American, born in 1932), *Leotard Table*, Rochester, New York, 1969. Reinforced plastic. H. 32.4 cm, w.176.2 cm, d. 44.5 cm (H. 12¾ in., w. 69⅜ in., d. 17½ in.). Museum of Fine Arts, Boston; Gift of Daphne Farago (2002.629).

6. Michael Graves (American, born in 1934), The Portland Building, Portland, Oregon, 1982. Photograph courtesy of Michael Graves & Associates.

7. Michael Graves (American, born in 1934), *Tea & Coffee Piazza*. Manufactured by Fratelli Alessi (active 1921–), Italy, 1983. Silver, off-white and black plastic, blue enamel. Photo: © George Kopp.

8. Christian Burchard (American, born in West Germany, 1955), *vessel*, Ashland, Oregon, 1987. Turned maple burl. H. 33 cm, w. 57.8 cm, d. 57.8 cm (H. 13 in., w. 22¾ in., d. 22¾ in.). The Wornick Collection; promised gift to the Museum of Fine Arts, Boston.

9. Betty Woodman (American, born in 1930), *Pillow Pitcher*, New York, 1980. Earthenware. H. 48.3 cm, d. 55.9 cm, diam. 31.8 cm (H. 19 in., d. 22 in., diam 12½ in.). Museum of Fine Arts, Boston; Gift of Betty Woodman and Helen Williams Drutt (1981.424).

10. Garry Knox Bennett (American, born in 1934), *Nail Cabinet*, Oakland, California, 1979. Paduak, glass, lamp parts, copper. H. 188 cm, w. 61 cm, d. 43.2 cm (H. 74 in , w. 24 in., d. 17 in.). Collection of Garry and Sylvia Bennett.

SUBSTANCE AND STRUCTURE/Gerald W. R. Ward

11. *High chest of drawers*, Massachusetts, probably Boston, about 1700–1720. Maple, walnut, walnut veneer, burl maple veneer, pine. H. 161 cm, w. 101.6 cm, d. 54.3 cm (H. 63⅜ in., w. 40 in., d. 21⅜ in.). Museum of Fine Arts, Boston; Gift of Hollis French (40.607).

12. Wharton Esherick (American, 1887–1970), *three-panel folding screen*, Paoli, Pennsylvania, 1927. Walnut, ebony. H. each panel 19 cm, w. each panel 30.5 cm, d. each panel 2.5 cm (H. each panel 66½ in., w. each panel 12 in., d. each panel 1 in.). Museum of Fine Arts, Boston; Henry H. and Zoe Oliver Sherman Fund (2006.1891).

13. Dominick Labino (American, 1910–1987), *Emergence in Polychrome with Gold and Silver Veiling*, Grand Rapids, Ohio, 1970. Glass, mahogany base. H. 21.6 cm, w. 10.8 cm, d. 2¼ cm (H. 8½ in., w. 4¼ in., d. 2¼ in.). Museum of Fine Arts, Boston; Gift of Mr. and Mrs. James A. Saks (1983.294).

14. Robert Arneson (American, 1930–1992), *Bill Wyman, Ceramic Artist, 1922-1980*, Benicia, California, 1981. Glazed stoneware. H. 36.8 cm, w. 33 cm, d. 16.5 cm (H. 14½ in., w. 13 in., d. 6½ in.). Museum of Fine Arts, Boston; Gift of Sandra Shannonhouse (1993.952).

15. Peter Voulkos (American, 1924–2002), *Camelback Mountain*, probably Berkeley, California, 1959. Stoneware. H. 115.6 cm, w. 49.5 cm; d. 51.4 cm (H. 45½ in., w. 19½ in., d. 20¼ in.). Museum of Fine Arts, Boston; Gift of Mr. and Mrs. Stephen D. Paine (1978.690).

16. Toshiko Takaezu (American, born in 1922), *Three-Quarter Moon*, Quakertown, Pennsylvania, 1985. Stoneware. H. 48.3 cm, w. 50.8 cm, d. 50.8 cm (H. 19 in., w. 20 in., d. 20 in.). Museum of Fine Arts, Boston; Gift of Mary-Louise Meyer in memory of Norman Meyer (1985.100).

17. Robert M. Hamada (American, born in 1921), *vessel*, Kapaa, Kauai, Hawaii, 1990. Milo wood. H. 45.1 cm, w. 58.4 cm, d. 53.3 cm (H. 17¾ in., w. 23 in., d. 21 in.). Museum of Fine Arts, Boston; Gift of The Seminarians and Edwin E. Jack Fund (1991.386).

All other photographs reproduced in this catalogue © 2006 Lee Fatherree, except photograph on page 69, which is reproduced courtesy of The Laura Russo Gallery, Portland, Oregon.